Step-by-Step
Clay Modelling

Greta Speechley

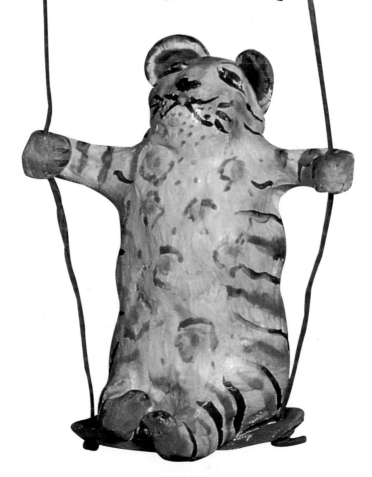

Search Press

First published in Great Britain 2000
Search Press Limited
Wellwood, North Farm Road,
Tunbridge Wells, Kent TN2 3DR

Reprinted 2001

Text and ceramic/pottery designs copyright © Greta Speechley 2000

Photographs by Search Press Studios

Photographs and design copyright © Search Press Ltd. 2000

ISBN 0 85532 914 9

Readers are permitted to reproduce any of the ceramic pottery designs in this book for their personal use, free of charge and without the prior permission of the Publishers. Any use of the ceramic pottery designs for commercial purposes is not permitted without the prior permission of the Publishers.

The Publishers and author can accept no responsibility for any consequences arising from the information, advice or instructions given in this publication.

Suppliers

If you have difficulty in obtaining any of the materials and equipment mentioned in this book, then please visit the Search Press website for details of suppliers: www.searchpress.com

Alternatively, you can write to the Publishers at the address above, for a current list of stockists, which includes firms who operate a mail-order service.

Acknowledgements

The Publishers would like to thank Christie's Images Ltd. for permission to reproduce the photograph on page 5.

Colour separation by Graphics '91 Pte Ltd., Singapore
Printed in Italy by L.E.G.O.

For my family: my daughter Thea, who has brilliant ideas; my son Jess, who has no idea; and my husband David, who is my 'big' idea!

I would like to thank the team at Search Press, for their help and encouragement in the making of this book – in particular, Editorial Director Roz Dace, Editor John Dalton, Designer Tamsin Hayes and Photographer Lotti de la Bédoyère.

• • • • • • • • • • • • • • • • • • •

The Publishers would like to say a huge thank you to Jeremy Thornby, Helena Parkes, Daisy Taylor, Jessika Kwan, Martin Baker, Emma Tapp, Isobel Hallett and Amanda Philip.

Special thanks are also due to Southborough Primary School, Tunbridge Wells.

When this sign is used in the book, it means that adult supervision is needed.

REMEMBER!
Ask an adult to help you when you see this sign.

Contents

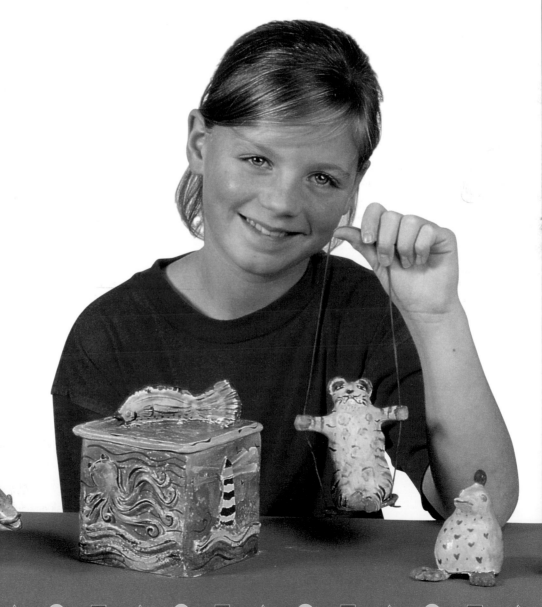

Introduction

People have been modelling clay for thousands of years, and pottery fragments have been found that date back as far as 1200 BC. These early pots were baked in bonfires and, because the heat was not very intense, they were very fragile. As a result, only broken pieces of some of the vessels have survived to the present day. Some pots and models have been discovered in tombs and burial places, and you can see wonderful collections of these in many museums. Lots of these ancient vessels were highly decorated with painted figures and animals, which tell wonderful stories of how life used to be. The methods used by craftspeople in those far-off days were simple. Items were hand-modelled and moulded into useful and decorative shapes, just like they are today.

I have taken my inspiration from nature, the world around us, and the simple techniques used by our ancestors to show how easy it is to create colourful and fun models, zany pots, crazy containers and painted tiles. Each project shows a different way of using clay and suggests how you can paint your finished pieces with poster or acrylic paints. You might want to copy each one exactly to start off with, but I am sure that once you have done this, you will want to create your own unique pot or model.

It is a good idea to start using a sketch book or to keep a scrap book so that you can keep a note of the colours you like and use them on your models. Cut out bits of fabric, or snippets from magazines. Think about texture – do you want a smooth finish, or would you prefer a rough surface? Look at pottery and sculpture from different countries and decide which you prefer. My favourite pieces come from Mexico and South America. I love the little figures and curious animals that cover these pots, and they are always painted in such lovely vibrant colours.

I have used air-drying clay for all the projects in this book. It is easy to use and is available from most craft shops. There are quite a few different types. Try to find one that is squidgy when you poke it, rather than being hard. Clay is wonderful to work with – if it does not look quite right, you can just squash it up and start all over again, and it can be used to make almost anything. I am sure you will come up with lots of ideas of your own and have great fun clay modelling. The only limit is your imagination. Have fun!

Note If you have access to a kiln, you can use real clay for all the projects except the solid swinging tiger on pages 16–17. You must ask an adult to use the kiln for you.

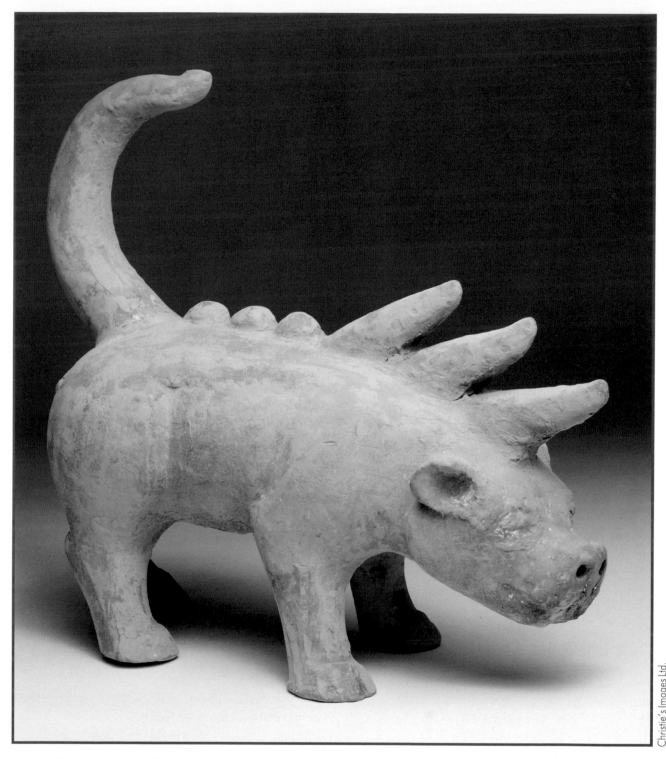

No-one knows who made this pottery mythical beast, but they were very skilful because they succeeded in making a simple model look almost life-like. The model, which is about 30cm (11¾in) long, was made in China over 1,500 years ago, when the country was ruled by the emperors of the Han dynasty.

Materials

Apart from clay itself, many of the things you need to get started on clay modelling can be found in your own home. Clay can be messy so it is a good idea to work on a wooden surface or cover your work space with an oilskin cloth.

Air-drying clay is used in this book and you can buy it in packs at craft shops. If it starts to crack and crumble when you are modelling with it, wrap it in clingfilm with a few drops of water and it will soften up. The manufacturer's instructions will tell you how to dry and harden it.

Buy a pack of **plastic modelling tools** from your local art shop. They are cheap and include a variety of shapes for modelling and texturing.

Sponges are used to smooth and finish a clay surface, and to paint finished models.

A **wooden rolling pin** is best for rolling out slabs of clay – clay tends to stick to glass and marble ones. Two **lengths of wood** 0.8cm (5/16in) thick will help you roll out even slabs of clay. Roll the clay out on a piece of **cotton cloth** or an old shirt to create a smooth surface. Use heavily-textured fabric or a piece of hessian if you want to create interesting patterns or textures in the clay.

Clay squeezed though a **garlic press** or sieve makes lovely 'hair' for your models.

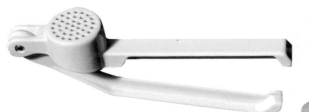

Pastry cutters can be used to cut out whole shapes or to create surface patterns on clay.

A small **kitchen knife** is used to cut out clay shapes. Ask an adult to help you do this.

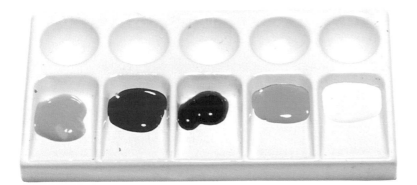

A **palette** is useful for paints, but an old china plate will do just as well. **Acrylic paints** are ideal for painting your models and they come in a huge range of colours. Acrylic paint is tough, it dries to an attractive sheen and it does not need to be varnished. If you decide to use **poster paints** instead, you will need to seal the clay surface with an **acrylic varnish**. Some clays come with recommendations about what paints and varnishes to use, so check the instructions carefully.

Patterns at the back of the book can be photocopied on to **paper**. Use **scissors** to cut them out. A **ruler** and **pencil** are useful for measuring and drawing straight lines. A pencil can also be used to create lines and texture in the clay.

Paint can be applied with a **paintbrush** or a sponge. A stiff paintbrush o. old toothbrush can be used to create a random spattered effect.

Clingfilm is used to line moulds to stop the clay from sticking to them.

Techniques

Clay is really easy to work with. You can model straight from a ball of clay, you can coil up long thin sausages, or you can make flat slabs which can be used to build boxes and containers. Practise these techniques before you start the projects.

Pinching out shapes

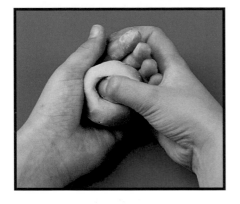

This very simple modelling technique is great for making small pots and bowls, and for modelling animals.

Hold a small ball of clay in one hand and press your thumb into the clay to make a hole.

Gently squeeze the clay between your thumb and fingers and work evenly round the ball of clay to open up the shape. Stop from time to time to see how your shape is progressing.

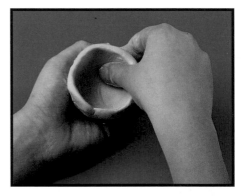

Note Before you start working on a project, always soften the clay by kneading it in your hands.

Rolling coils

You can use long clay sausages (coils) to build pots of any size and shape. The coils are made by rolling out the clay with your hands. For small pots, coils need to be about the thickness of your finger – make them a bit thicker for larger pots.

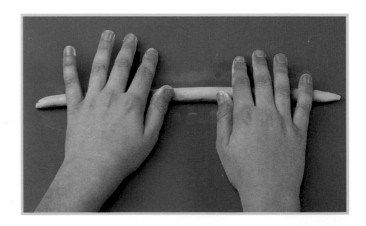

Making slabs

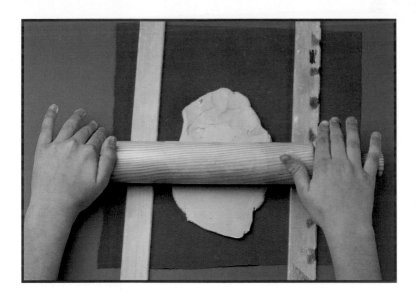

Flat slabs of clay can be used for tiles or for building boxes and containers. You will need a piece of cotton cloth (old cotton sheeting is ideal), a rolling pin and two lengths of wood. Place a ball of clay between the wooden lengths and flatten it with the rolling pin. The thickness of the wood controls the thickness of the slab.

Note It is much easier to roll out several small slabs than to try and roll out one huge one.

Cutting out shapes

Use a paper pattern and a knife to cut out your design. Leave the clay to harden slightly before moving it, otherwise you may distort the shape.

You can use pastry cutters to make fun shapes which you can stick on to your pots.

Knives are sharp. Ask an adult to help you cut out the shapes.

9

Creating patterns

Wonderful patterns can be made in slabs of soft clay by rolling the clay over textured cloth or leaves, for example. Designs can be scratched into the surface with a modelling tool, the end of a pencil or even a stick. You can also impress objects into the clay to make patterns.

Joining and attaching

When joining coils or attaching small pieces of clay to larger pieces, the clay surfaces should be scored then moistened with water before being pressed and smoothed together. Allow all slab pieces to harden slightly first, so that they can be handled without losing their shape.

Note Pieces of air drying clay can be glued together with strong adhesive if you decide you want to add something to your model or pot after it is dry.

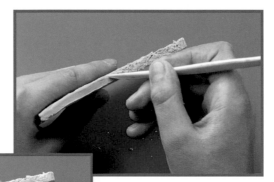

 Use a modelling tool to score (roughen) all the edges to be joined.

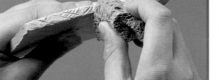

2 Moisten the scored edges with a damp sponge.

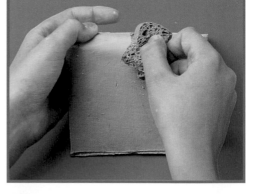

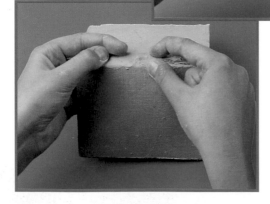

3 Press the two edges together firmly, then use your fingers or a modelling tool to smooth the joins.

 Finally, use a damp sponge on large pieces to create a really smooth finish.

Drying and painting

Before you paint your model, allow it to dry completely. The manufacturer's instructions will tell you how long you should wait, although it does depend on how warm your working environment is. If it is cold or damp, the drying time will be longer. Some instructions may tell you that you can speed up the process by drying the clay in the oven. This will harden the clay completely and make it more durable, but only do this if the instructions say so, and always get an adult to use the oven for you.

Acrylic paints are used for all the projects in this book. Poster paints can also be used, but you will need to seal them with acrylic varnish. The colours can be sponged on or you can use a brush to paint patterns and add fine details. An old toothbrush is ideal for spattering paint over surfaces. This creates lots of interesting effects, especially if you use several different colours.

Note Acrylic paints dry very quickly and paintbrushes and sponges must be cleaned immediately after use or they will be ruined.

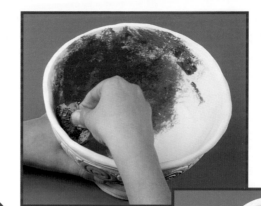
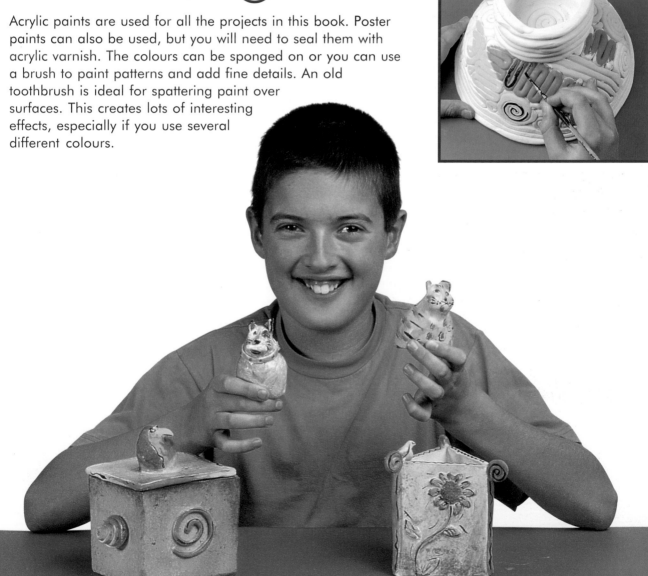

Wobbly Pot

YOU WILL NEED
Air-drying clay
Sponge
Modelling tool
Acrylic paints
Paintbrushes

The pinching technique can be used to make a simple pinch pot like the one featured in this project. Throughout time, and in many different cultures, this style of pot has been used for various purposes. A good example is the diva pot used to hold small lights during the Hindu festival of Diwali.

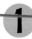

Use the pinching technique (see page 8) to create a simple pot shape.

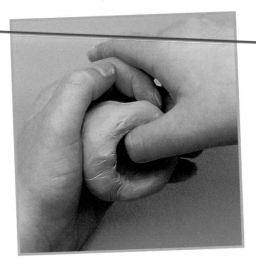

2 Squeeze the top of the pot to create a wavy edge. Leave it for half an hour to dry slightly.

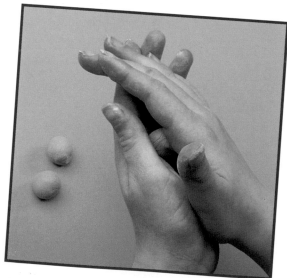

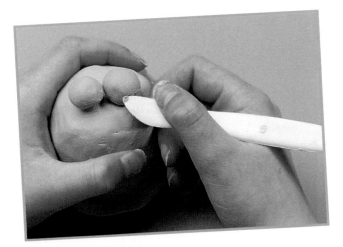

3 Roll three small balls of clay.

4 Score and moisten the surfaces to be joined (see page 10), then gently press each ball on to the base of the pot to form 'feet'. Smooth around the joins with a modelling tool. Leave to dry (see page 11).

5

Use a sponge to add large wavy stripes of paint around the pot.

6

Dip a stiff paintbrush or old toothbrush into acrylic paint, then hold it over the pot and rim and pull back the bristles with your finger. This will create a spattered paint effect. Wash your hands immediately afterwards.

FURTHER IDEAS

You can make wide and narrow pots – egg cups too. Decorate them with spots, stars or diamonds.

Fat Cat

In this project, coils of clay are used to make the collar, flower and tail for the cat. The eyes and ears are pinched out of small amounts of clay. Animal sculptures by the artist Picasso could be used as inspiration. You can model lots of animals by just squeezing and stretching the basic pinch pot. The cat can be changed into a penguin or a mouse in an instant!

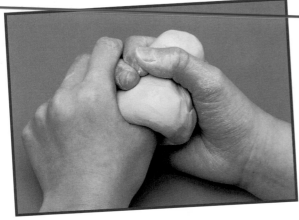

1 Make a basic pinch pot (see page 12). Turn it upside down and gently shape the head with your thumb.

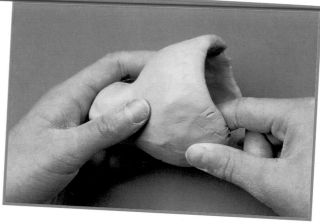

2 Squeeze the sides of the body, making it fatter than the head. Shape a nose and cheeks, then press in two eye sockets.

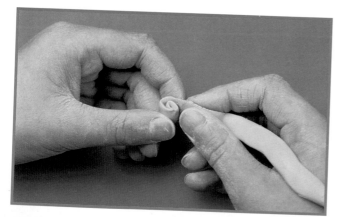

3 Roll out a coil of clay (see page 8) then flatten one end. Loosely spiral the flattened clay then pinch one end to form a flower head. Break off the flower then neaten the edge. Use the rest of the clay to make a collar and tail from coils, then two eyes and ears.

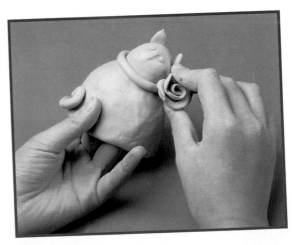

4 Attach the eyes, ears, tail and collar to the cat then add the flower to the collar (see page 10).

5

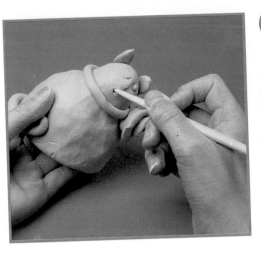

Use a pointed modelling tool to make a neat hole for the cat's mouth. Leave to dry.

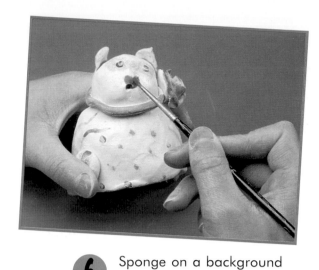

6 Sponge on a background colour and then use a paintbrush to add patterns to the body, the collar and the facial features.

FURTHER IDEAS

Try joining two simple pinch pots together and experiment to make other interesting animal models.

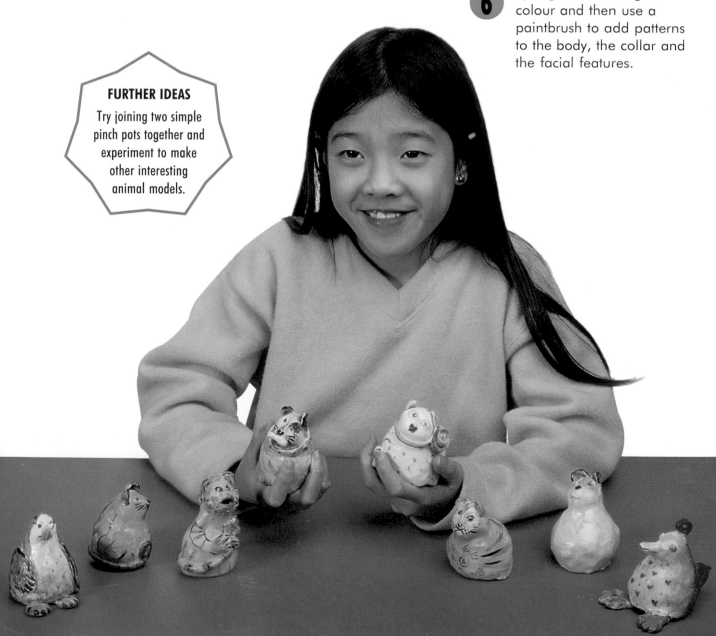

Swinging Tiger

Fun models like this tiger can be made from a solid lump of clay. Instead of pinching the clay into a pot shape, you simply roll it out and then pull out the arms and legs. Remember that the more clay you use, the longer it will take to dry. The smooth, pinched shapes of these models resemble the shapes of some African and Mexican sculpted creatures.

YOU WILL NEED

Air-drying clay
Modelling tool
Sponge • Acrylic paints
Paintbrushes
String or garden wire

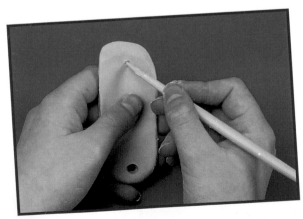

1 Roll out a fat clay sausage, shape a head and nose, then carefully pull two arms out from the sides of the body.

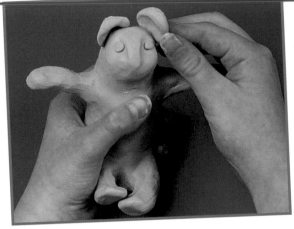

2 Model the bottom of the body and pull the legs out towards you. Add the eyes and ears.

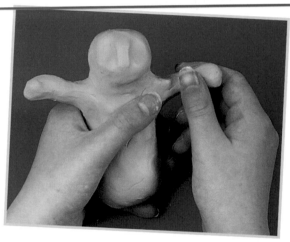

3 Model the swing seat from a slab of clay. Use the point of the modelling tool to make two small holes for the string or garden wire.

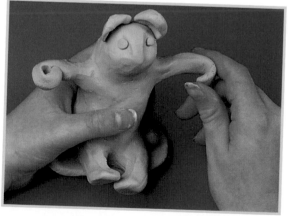

4 Attach the tiger to the seat. Bend the ends of its arms to form hands, leaving a hole in the middle of each for the string or garden wire to be pulled through. Leave to dry.

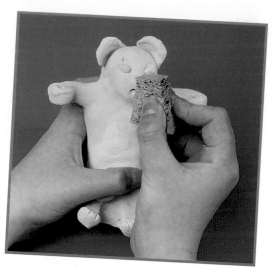

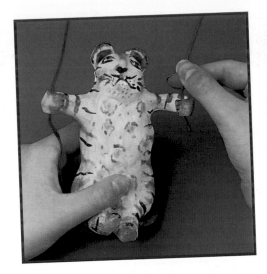

 6
Thread the string or garden wire through the hands and seat, then knot the ends.

5 Sponge paint all over the model, then add stripes and facial features using a paintbrush.

FURTHER IDEAS

Try making your pet or even your best friend using this technique. You can add hair and facial features for people, then paint on colourful clothes.

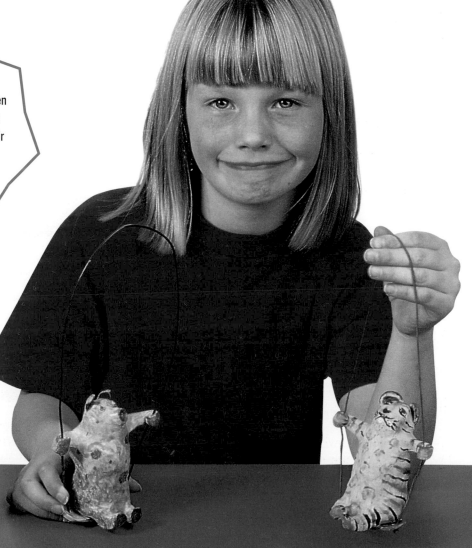

Flower Pot

The technique of coiling is ideal for building up round symmetrical shapes like these flower pots. If you want your pot to be perfectly even, it is important to keep the coils the same thickness, and to continually turn the pot as you join and smooth the coils together. Look to artists and sculptors for ideas about what to paint on to or mould into the clay to decorate the flower pot. Inspiration for the flowers could be taken from famous paintings such as Van Gogh's 'Sunflowers'.

YOU WILL NEED

Air-drying clay
Modelling tool • Pastry cutter
Garden or florist's wire
Pebbles • Moss
Acrylic paints
Paintbrushes

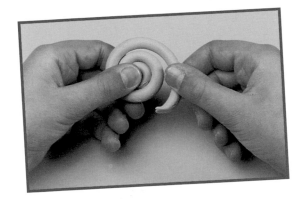

1 Roll out a coil of clay and use it to make a base. Smooth the coil flat.

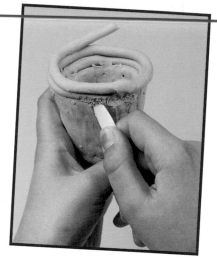

2 Start to build up the walls of the pot using long, thin coils. Smooth the inside and outside surfaces with a modelling tool as you work upwards.

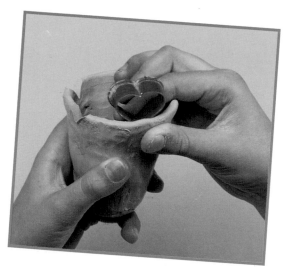

3 When the pot is tall enough, smooth the top of the rim, then use part of a pastry cutter to create a fancy edge.

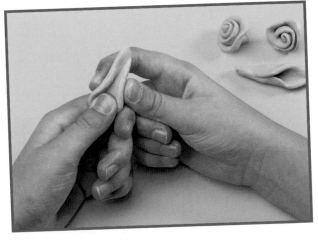

4 Roll out a piece of clay and use the technique shown on page 14 to make small flower heads. Squeeze pieces of clay between your fingers and model them to form longer flower heads.

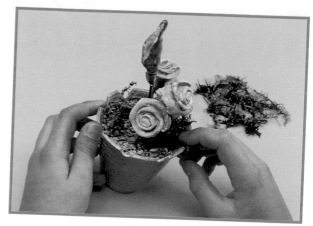

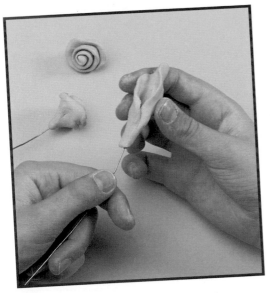

6 Paint the flowers, stems and pot then leave to dry. Arrange the flowers in the pot and use small pebbles to hold the wire stems in position. Finally, cover the top of the pebbles with some moss.

5 Push lengths of garden or florist's wire into each flower head then leave to dry.

FURTHER IDEAS

Air-drying clay is not waterproof, but you could build up the coils around a small glass jar, so you can then fill it with water and real flowers.

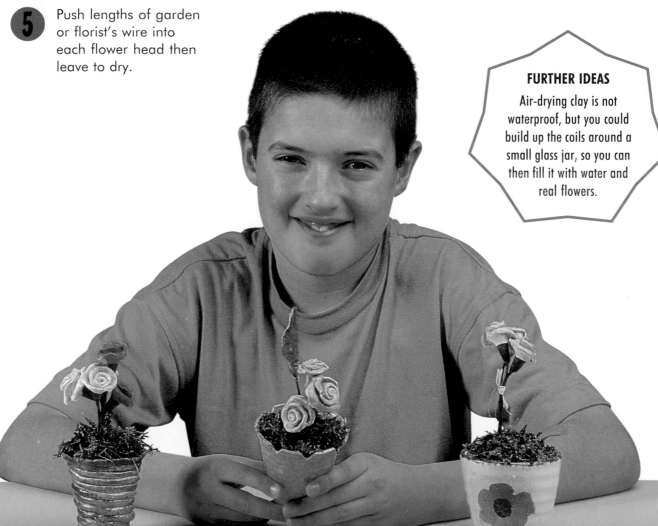

Squiggly Bowl

Coil pots used to be made by ancient cultures such as Native Americans. The coils provide an instant decoration which can then be painted in vivid colours. By using different thicknesses of coil and varying the shape of the coil you can experiment to produce different patterns and textures. In this project, a bowl lined with clingfilm acts as a mould, and coils are built up on the inside of the bowl. You can use any shape as a mould, provided that the top is wider than its base so that it is easy to remove the finished piece.

YOU WILL NEED
Air-drying clay
Mould (bowl)
Clingfilm • Sponge
Modelling tool
Acrylic paints
Paintbrushes

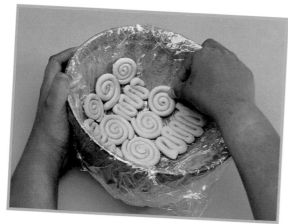

1 Line the inside of the mould with clingfilm, then lay squiggles and coils of clay inside the bowl.

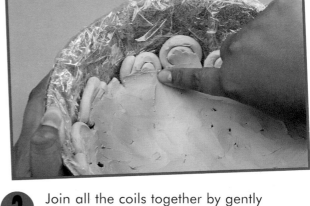

2 Join all the coils together by gently smoothing the inside surface with your fingers. Do not press too hard, as you want the coil pattern to remain on the outside.

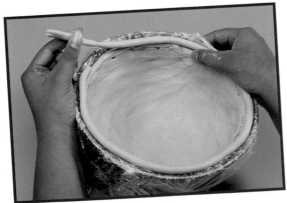

3 Lay two long coils of clay around the top of the bowl to form a rim. Allow the pot to harden slightly before removing it from the mould.

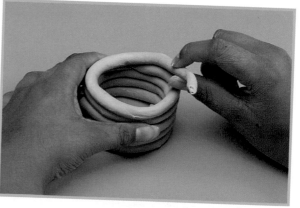

4 Make a base from long coils of clay. Smooth the inside of the coils together to make it stronger.

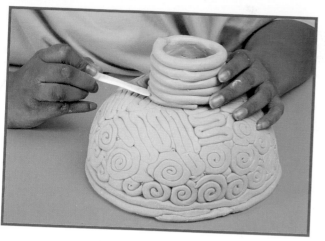

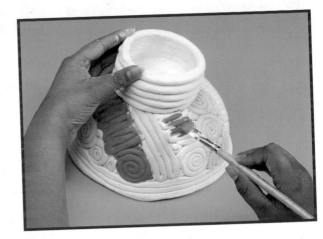

5 Turn the pot upside down and carefully attach the base (see page 10). Gently smooth the join with a modelling tool or your finger.

6 Allow the pot to dry completely, then paint the coils.

(see page 10)

FURTHER IDEAS

Make two bowls then place one on top of the other to make a person's head like the one shown here. You could also make a model of the Earth using this technique.

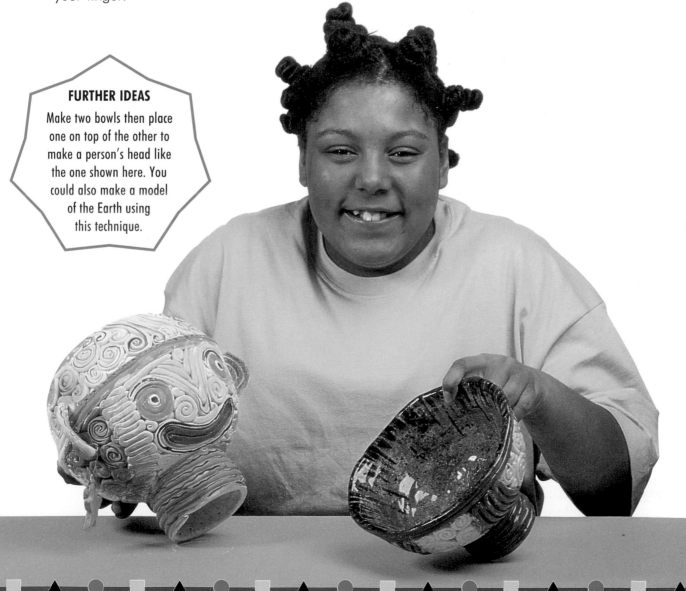

Fish Tile

The simple tile in this project is created by rolling the clay into a slab and then decorating it with cut-out shapes and paint. Look for different examples of tiles for inspiration. You may find them in your own home, or in most religious buildings. You can also look at the work of the Spanish artist, Gaudi, to see all the amazing things that can be done with tiles.

YOU WILL NEED

Air-drying clay
Knife • Rolling pin
Two lengths of wood • Sponge
Modelling tool • Acrylic paints
Paintbrushes • Scissors
Piece of wood

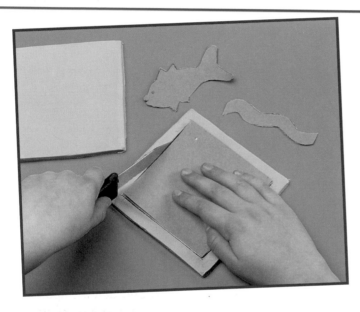

1

Photocopy the square, border, fish and wave patterns on page 31. Cut them out and then place them on a slab of clay. Use a knife to cut around the shapes then set them aside and allow to harden slightly. Roll a few tiny balls of clay to form bubbles.

Knives are sharp. Ask an adult to help you cut out the shapes.

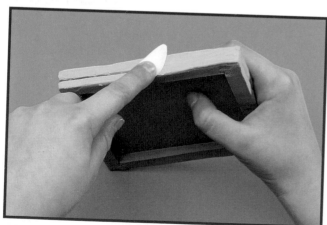

2 Attach the border to the square base (see page 10). Smooth the edges of the joins with a modelling tool.

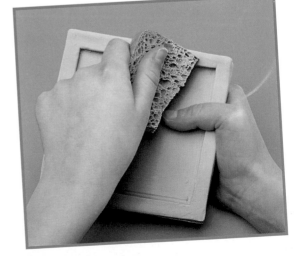

3 Use a sponge to smooth over the edges further, and to smooth over the front of the border.

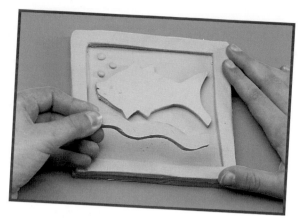

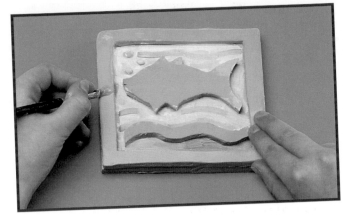

4 Attach all the pieces to the tile. Leave to harden slightly, then place a piece of wood on top to keep everything flat. Leave to dry thoroughly.

5 Paint the sea first, then apply a base colour to the fish, the wave and the border.

FURTHER IDEAS

You can use this technique to make a clock like the one shown here. Buy the clock mechanism first so that you know how big to make the hole in the clock face.

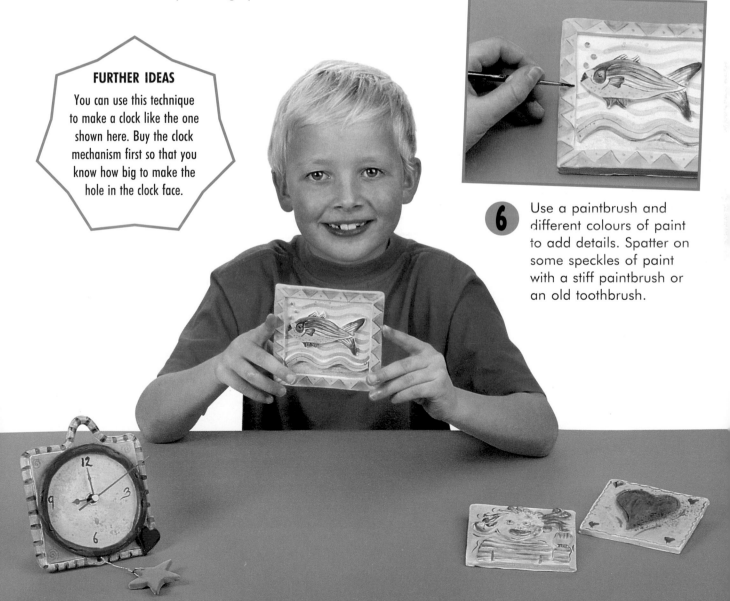

6 Use a paintbrush and different colours of paint to add details. Spatter on some speckles of paint with a stiff paintbrush or an old toothbrush.

Treasure Box

The decorations for this box are attached by scoring and moistening the two pieces of clay then joining them together. You could also explore other methods of decoration such as carving in shapes using modelling tools.

1

Photocopy the square patterns for the Treasure Box on page 31, then cut them out from slabs of clay. Allow the slabs to harden slightly then use a modelling tool to score the surfaces that will be joined.

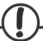

Knives are sharp. Ask an adult to help you cut out the shapes.

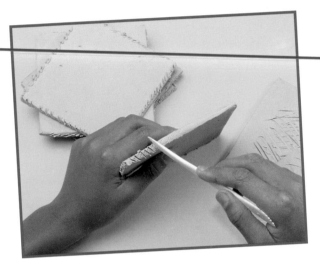

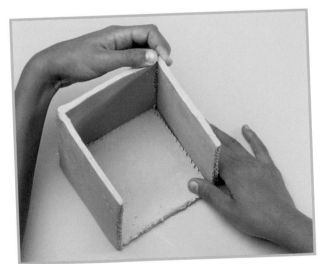

2 Moisten the edges with a sponge then assemble the box as shown, with the scored edges touching one another. Leave off one side for the moment. Pinch and squash the clay pieces together then smooth over the outer joins.

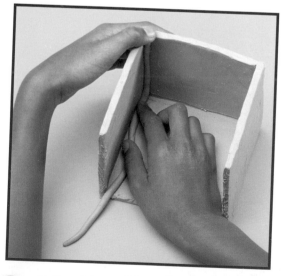

3 Roll out long thin coils, then press and smooth these over the inside joins to strengthen them. Attach the remaining side then carefully strengthen that with a coil.

24

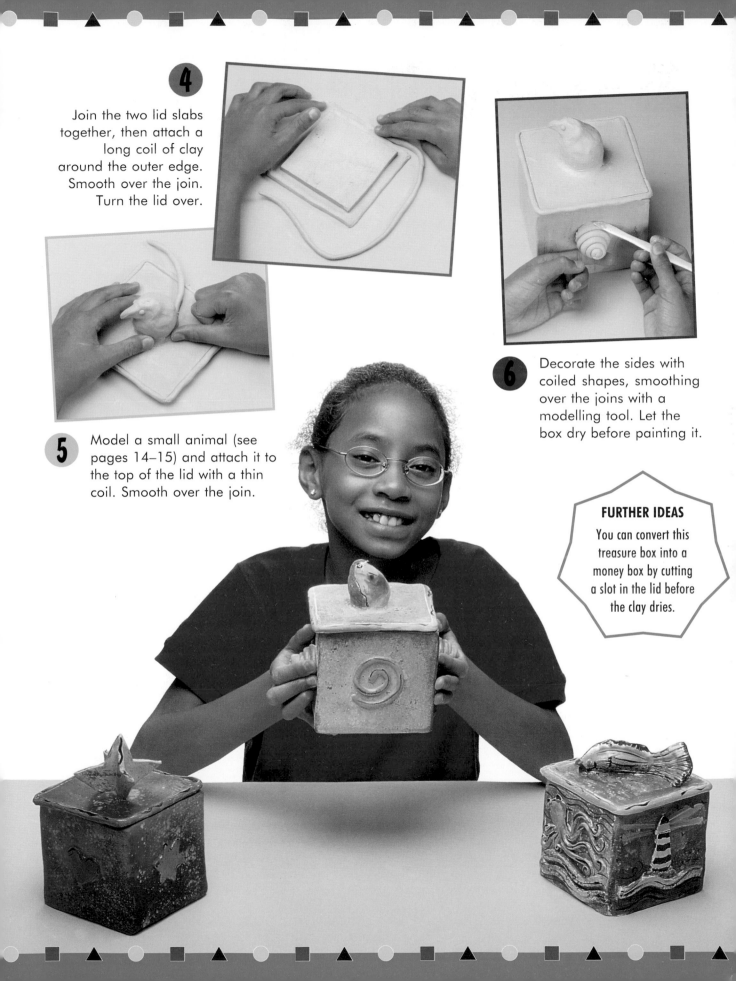

4 Join the two lid slabs together, then attach a long coil of clay around the outer edge. Smooth over the join. Turn the lid over.

5 Model a small animal (see pages 14–15) and attach it to the top of the lid with a thin coil. Smooth over the join.

6 Decorate the sides with coiled shapes, smoothing over the joins with a modelling tool. Let the box dry before painting it.

FURTHER IDEAS
You can convert this treasure box into a money box by cutting a slot in the lid before the clay dries.

Pencil Holder

Clay is an important material in the production of practical items, as well as being useful for producing decorative ornaments. The techniques used in this project are the same as those for the Treasure Box on pages 24–25, but the joins are strengthened on the outside rather than the inside.

YOU WILL NEED
Air-drying clay
Knife • Rolling pin
Two lengths of wood
Modelling tool
Pastry cutters • Sponge
Acrylic paints
Paintbrushes

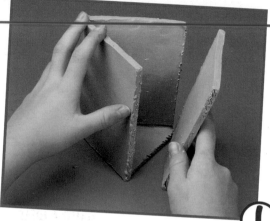

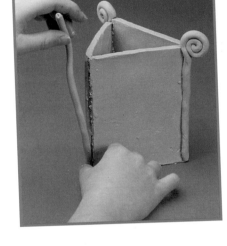

1 Photocopy the patterns on page 30, then cut them out from slabs of clay. Allow the slabs to harden slightly, then assemble the triangle and three rectangles to form the basic pot shape.

(!) Knives are sharp. Ask an adult to help you cut out the shapes.

2 Roll out three long coils of clay, then smooth them on to the outside edges to strengthen the holder.

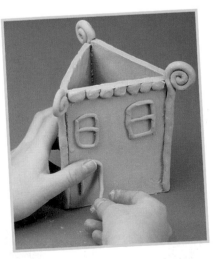

3 Decorate one side of the pencil holder using thin coils of clay to create windows, roof tiles, a door and even a milk bottle on the doorstep.

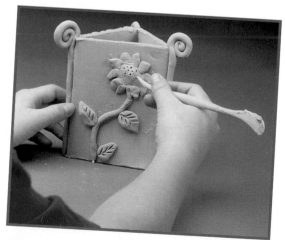

4 Use a coil and small pieces of clay to add a sunflower on one of the other sides. Use a pointed modelling tool to add veins to the leaves and seeds to the flower head.

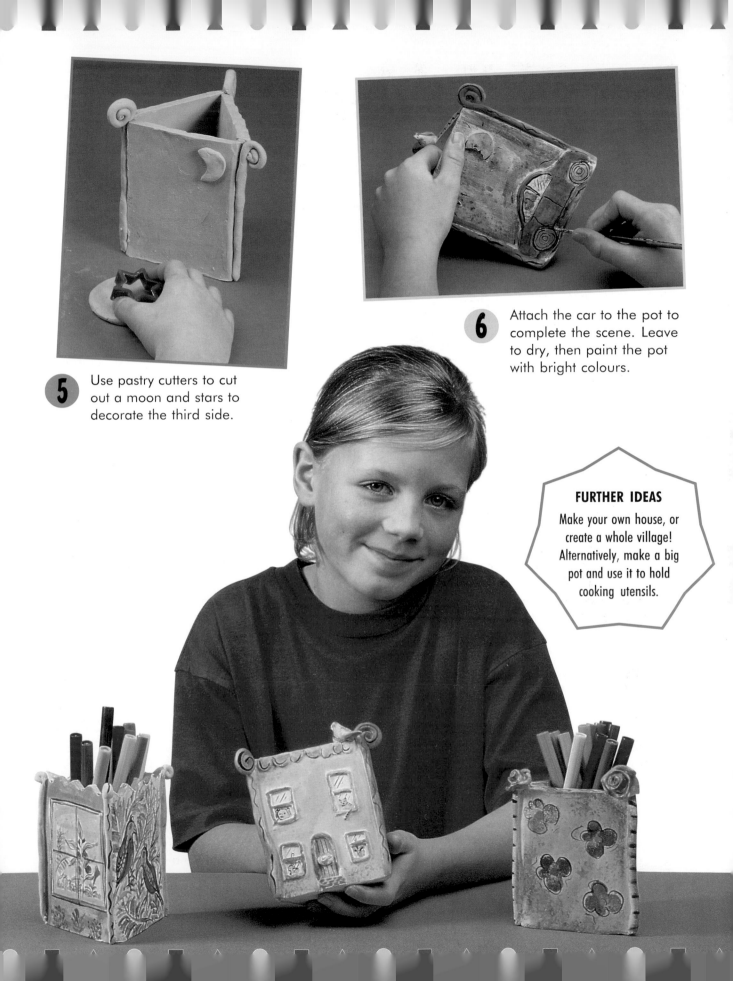

5 Use pastry cutters to cut out a moon and stars to decorate the third side.

6 Attach the car to the pot to complete the scene. Leave to dry, then paint the pot with bright colours.

FURTHER IDEAS
Make your own house, or create a whole village! Alternatively, make a big pot and use it to hold cooking utensils.

Lion Dish

Your imagination can really run wild with this dish. I show you how to make a lion, but all kinds of shapes can be produced to make a variety of fantastic creatures. Use a mixture of decorative techniques to finish it off, including moulding, attaching clay shapes or creating patterns using clay tools.

YOU WILL NEED
Air-drying clay
Rolling pin • Two lengths of wood
Mould (dish) • Clingfilm
Sponge • Modelling tool
Garlic press or sieve
Acrylic paints
Paintbrushes

1 Cover the mould with clingfilm. Roll out the clay, then lay it over the mould. Gently ease the clay down using a sponge.

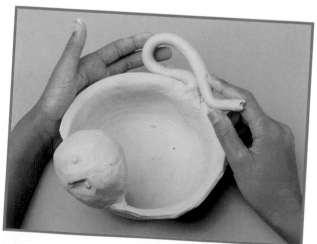

2 Trim off excess clay with a modelling tool. Allow the clay dish to harden slightly, then remove it from the mould.

3 Model a head and tail then attach them to the rim of the dish. Shape two ears and attach them to the head. Smooth over the joins with your fingers.

4 Squeeze a ball of clay through a garlic press or sieve to create the lion's mane and tail.

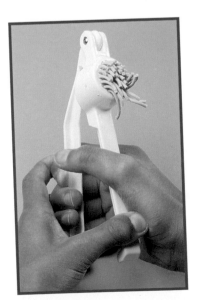

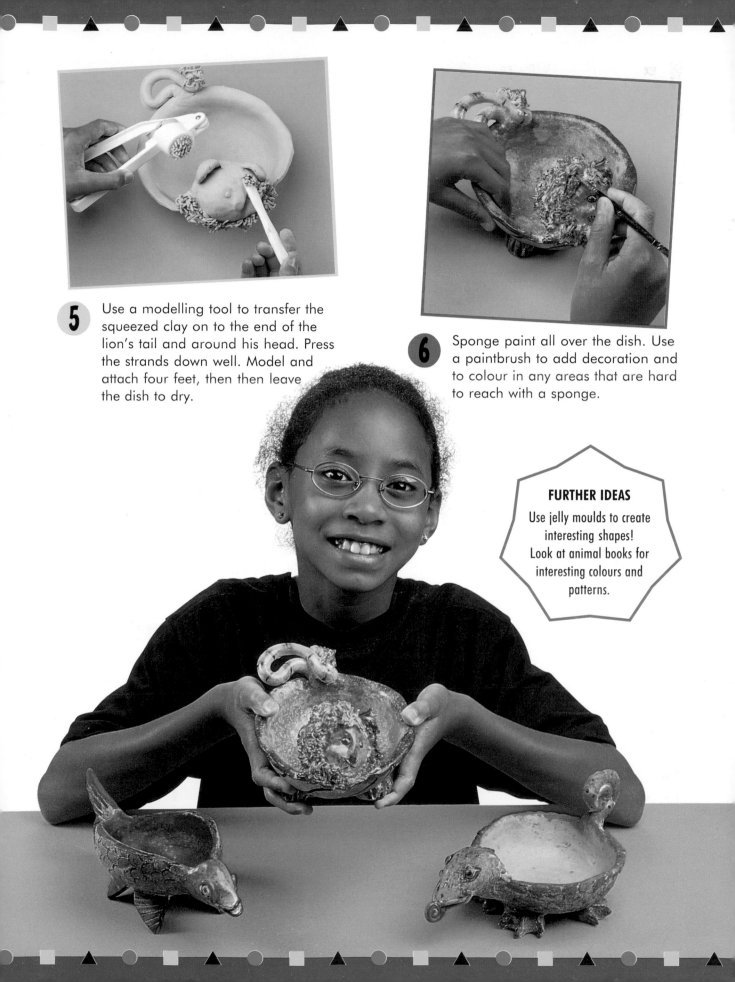

5 Use a modelling tool to transfer the squeezed clay on to the end of the lion's tail and around his head. Press the strands down well. Model and attach four feet, then then leave the dish to dry.

6 Sponge paint all over the dish. Use a paintbrush to add decoration and to colour in any areas that are hard to reach with a sponge.

FURTHER IDEAS
Use jelly moulds to create interesting shapes!
Look at animal books for interesting colours and patterns.

Patterns

The patterns on these two pages are the size that I used them for the projects, but you can make them larger or smaller on a photocopier if you wish. Once you have photocopied the patterns, you can cut them out and then place them over your clay and cut around the outline with a knife.

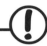

Get an adult to help you photocopy the patterns.

You will also need an adult to help you cut out the clay shapes.

Patterns for the Pencil Holder featured on pages 26–27. You will need three rectangular slabs of clay, one triangular slab and one car shape.

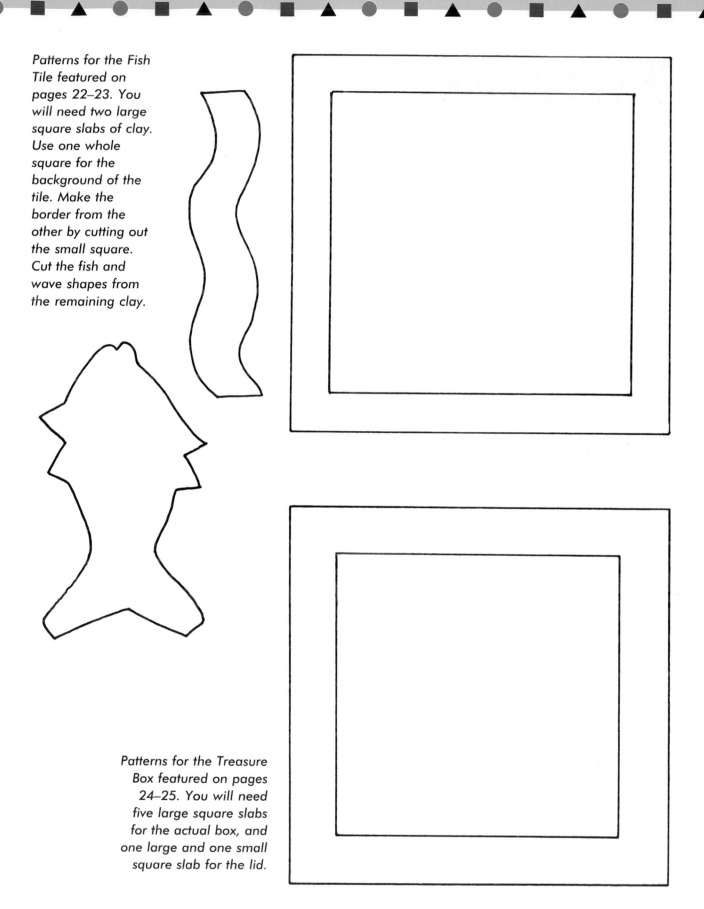

Patterns for the Fish Tile featured on pages 22–23. You will need two large square slabs of clay. Use one whole square for the background of the tile. Make the border from the other by cutting out the small square. Cut the fish and wave shapes from the remaining clay.

Patterns for the Treasure Box featured on pages 24–25. You will need five large square slabs for the actual box, and one large and one small square slab for the lid.

Index

of the WEST

Supervising Editor: Jack McDowell
Coordinating Editor: Sherry Gellner
Design Consultants: Fetzer-Conover Graphics
Layout: Henry Rasmussen, Alan May
Cartography: Ells Marugg, Basil C. Wood

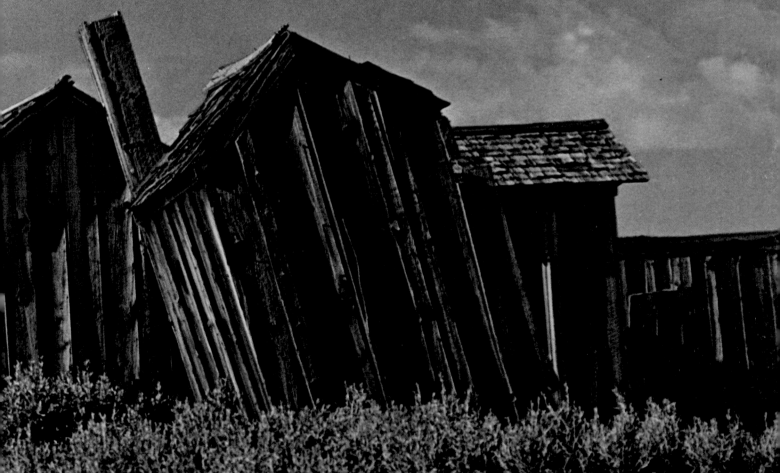

MENLO PARK, CALIFORNIA

CONTENTS

"THE CASTLE," VIRGINIA CITY, NEVADA

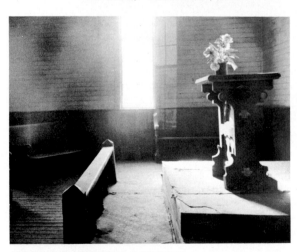

METHODIST CHURCH, BODIE, CALIFORNIA

SILVER MILL, ELKHORN, MONTANA

RESIDENCE, GILMORE, IDAHO

HOUSE, NEAR MOGOLLON, NEW MEXICO

ROCKY MOUNTAIN SPREADING FEVER

Tent Towns and Boarding Houses • Telltale Details •
Commerce • Reliving the Hard-rock Boom • Wyoming's
Wild Ones • Old Mills of Montana • Utah's Mountain
Ghosts • Tourist Towns of the Rockies • Getting High
on Incomparable Colorado • Georgetown's Hotel de Paris •
Ladies Had Their Day

THE NORTHWEST WAS SOMETHING ELSE

Ho! For Oregon! • Life and Death of Farm Towns •
Offbeat Oregon • The Other Idaho • Signs of
the Times • Ghosts of Northern Washington and
Southern British Columbia • Ghosts of the
Far North

THE SOUTHWEST—TOO TOUGH TO DIE

Ghosts of Northern New Mexico • The Indian Threat
to the Mining Camps • Fun Was Where You Found It •
Ghosts of Southwestern New Mexico • Ghosts of
Southeastern Arizona • Good Guys, Bad Guys •
Ghost Markers

ACKNOWLEDGMENTS

Front Cover: Grafton, Utah. Back Cover: Bodie, California. Title Page: Bodie, California.

Illustrations: Basil C. Wood.

All photographs, except those listed below, are by William Carter.

Arizona Pioneers Historical Museum: 192, 193 (bottom left, bottom right), 212 (top, bottom right), 213. Bancroft Library: 38 (top left, center left, bottom right), 68 (right), 142. Dorothy Benrimo: 218 (top left, top right), 219 (top right). British Columbia Department of Travel Industry: 178 (top). British Columbia Provincial Archives: 168 (top). California Division of Mines and Geology: 35. California Historical Society: 34. California State Library: 16, 22, 23 (top), 30, 38 (top right). Carla Cannon: 90, 114 (bottom). Betty Carter: 71 (top). Colorado Department of Public Relations: 124, 131, 132. John N. DeHaas, Jr.: 7 (right), 105 (bottom), 117, 118. Denver Public Library Western Collection: 96, 100 (top right, bottom), 101, 109 (bottom), 138, 139 (right), 146. Richard Dillon Collection: 68 (left). Richard Harrington: 177, 180, 181. Huntington Library: 23 (bottom). Bob Iacopi: 26. Idaho Historical Society: 100 (top left), 108 (bottom right), 150 (top), 158. Bob Johnson: 163. Karl Kernberger: 9 (bottom), 191, 198, 218 (bottom left). Ralph Looney Collection: 196, 197, 218 (bottom right). Los Angeles County Museum of Natural History: 24. Gar Lunney: 179. Mackay School of Mines: 67. Ells

Marugg: 19 (bottom). Metropolitan Museum of Art: 39. Montana Historical Society: 108 (left), 113 (bottom). Museum of New Mexico: 139 (left), 184, 193 (top left, top right), 199 (bottom), 212 (bottom left). Tom Myers: 19 (top), 47 (top). National Archives: 17 (top). Nevada Historical Society: 58, 72, 73. Hugh Paradise: 154 (top left, bottom). Michael Parfit: 165. Archie Satterfield: 178 (bottom). Society of California Pioneers: 17 (bottom). Sutro Library: 25. University of Oregon Special Collections: 150 (bottom). Utah State Historical Society: 109 (top). Todd Webb: 62, 218 (top right). Robert Weinstein Collection: 12. Norman D. Weis: 114 (top).

Page 190: Quotation from Jenkinson, Michael, *Ghost Towns of New Mexico.* Albuquerque, New Mexico. The University of New Mexico Press, 1967, p. 32.

Editor, Sunset Books: David E. Clark

First Printing April 1978

Can We Protect Our Ghost Towns?

For many years the jerry-built Western ghost towns moldered in neglect. As late as the 1940's you could still find plates on the tables, bottles on the saloon shelves, crumpled boots and ore carts in silent mineshafts. Always, too, there were winter snows and desert twisters, packrats and termites. Roofs sagged ever lower, and if they collapsed, the walls were often quick to follow. Bit by bit the weeds and earth reclaimed their own.

Then man came back. Having long dismissed the ghost towns as worthless reminders of burnt-out hopes, he began to revalue them as curiosities. In them and their lonely environs he began to seek a respite from the gray sameness of his urban life. Hunting for roots, he became intrigued by these ghosts as if they were his own.

Yet, goaded by an inner rage, some gleefully pried the structures apart, board by complaining board, or tossed a match at their tinder-dry flanks. Others leveled buildings without sentiment to save on taxes, or to dig new mines, or to scour the cellars and privies for old coins and bottles. Sad to say, among the more prominent destroyers were the U.S. Forest Service and the Bureau of Land Management.

Positive interest continued to rise, however. Ghost town books and articles proliferated. So did four-wheel-drive vehicles—enabling lots of ordinary folks to reach dead communities once protected by forbidding terrain. Fanning out in every direction, the back-country-and-old-artifact buffs seemed to be catching at the tattered fringes of long-gone dreams.

A few set their hearts on saving what was left. As early as the 1930's Mr. and Mrs. Charles Bovey recognized the historic value of Montana's pioneer places and things. Their long efforts to preserve, restore, and relocate have given us that state's Virginia City and Nevada City. With Bannack, these comprise a veritable outdoor museum of Montana history for the period 1864-1900.

In Southern California, Walter Knott rounded up buildings from old farms and villages throughout the West. He supplemented these with imitations and midway amusements to create the profitable tourist sites of Ghost Town (only 11 of whose 44 structures are genuine) and Calico (site of a defunct mining camp).

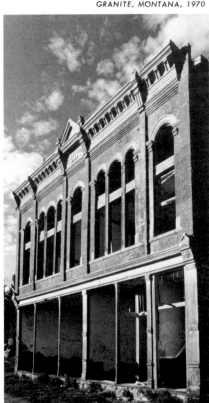

MINERS UNION HALL, GRANITE, MONTANA, 1970

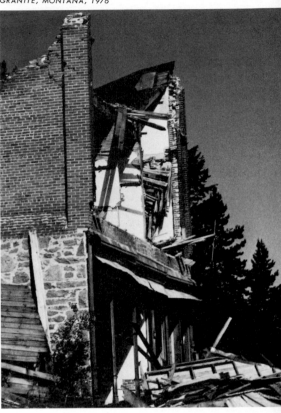

MINERS UNION HALL, GRANITE, MONTANA, 1976

The approaches were, in fact, as varied as the complex mineral claims which sometimes underlay the structures. Citizens of more substantial communities that had declined but not really died—places like Jacksonville, Oregon, or Georgetown, Colorado, or Nevada City, California—worked hard to preserve a style and mood that have made such towns havens of history and beauty. At Bodie, California, the handful of surviving residents shooed away vandals long enough for this fine ghost to be taken over by the State Park System under the formula "arrested decay."

Among the strangest stories is that of Stanton, Arizona. In the 1950's the *Saturday Evening Post* bought this scraggly ghost, intending to make it a tourist attraction—then changed its mind and gave away the town in a jingle contest. Since then, Stanton has withered to a state of extreme dilapidation.

In 1971 we appealed to readers of the first edition of this book to leave the towns as they found them, so that others could enjoy these frail remnants of our common heritage. Seven years later we observe some minuses and some pluses. Theft and vandalism have kept pace with the times, and so has the weather. The photos above show how winter snows have collapsed the roof and fine facade of the Miners Union Hall at Granite, Montana. Yet the nearby Weir House was treated to a substantial new roof by enthusiastic volunteers from the Montana Ghost Town Preservation Society.

Other preservation has been achieved by the Colorado Ghost Town Club, local historical societies, the National Trust, and similar groups. An upwelling of interest in the "living history museum" concept has inspired such worthy efforts as Pioneer Arizona (north of Phoenix), the Pioneer Village at Bakersfield, California, and the Pioneer Village north of Salt Lake City.

With real hope, then, we repeat the tenet: *The past belongs not to us alone.*

THE WESTERN GHOST TOWN

EXCITEMENT ...THEN A STEEP DECLINE

FORMER COURTHOUSE, VIRGINIA CITY, NEVADA

We're a young, restless people. America's momentum toward an ever-new frontier profoundly affected our outlook, our habits, our communities. Among the most visible signs of this restlessness are the hundreds of ghost towns strewn across the western states. As one authority pointed out, deserted communities are nothing new in the world, but only the American West propagated them in wholesale quantities.

How were these towns born, and why did they die? Most were mining towns. Of the many factors which prompted Americans to head west in the 1800's, none held such glittering promise as the continuing news of gold and silver strikes. Prior to the California gold rush of 1848, the westward movement was a relatively gradual affair: patient explorers, trappers, and missionaries were followed by farmers, herdsmen, and small tradesmen. But gold was an explosive fuse, sparking a dramatic growth of population and shattering the trends of earlier settlement. The miner's eye, agleam with the

STORE, VIRGINIA CITY, NEVADA

RESIDENCE, HILLSBORO, NEW MEXICO

prospect of quick cash, also gleamed with thoughts of the goods and services his "poke" could buy. Totally different in character from the slow-going farmer, who came west to be self-sufficient, the restless Forty-niner and his successors demanded saloons and hotels, banks and stagecoaches, noise and excitement. In answer to his needs, rowdy boomtowns blossomed, creating what has been aptly termed an urban frontier.

Yet these instant towns soon proved anew that "mining is a good way to pioneer a territory, but a poor way to hold it." The boomers' roots went only as deep as the high-grade ore. When that began to give out, they were always ready to run off after some new bonanza, sending the mining camp into a steep decline that often turned it into a ghost. Only mining could create such high-priced towns in the wilderness —and only mining could deplete their economic base so quickly. The footloose character of the prospectors, and the seeming endlessness of the virgin frontier, reinforced the up-and-down process repeated hundreds of times across the early West.

Also running counter to the earlier trends of pioneer settlement was the tendency of the mining frontier to move from west to east during its prime phases. When California's placer deposits dwindled in the 1850's, a new bonanza east of the Sierra, in Nevada's Comstock, lured hordes of "Old Californians," as they were called, into the little-known Great Basin area. Then gold was discovered in Colorado, and the Pike's Peak rush was on. From Colorado the miners fanned out into the other Rocky Mountain territories. (The Northwest lacked any clear trend, and the Southwest was last to be developed because of special problems.)

As the nineteenth century progressed, many of the early mining areas, having all but died, got a second lease on life as a result of advancing technology and transportation. While the early miners took out what they could by simple methods, the advent of the railroad, growing financial sophistication, and the industrial revolution made profitable the extraction of more refractory, hard-rock ores. In this phase, many old towns were revitalized and many new ones born. Yet these, too, dwindled in time; and many of today's best-

preserved ghost towns and mining camps derive from this ~~second stage~~ of the mining frontier, which stretched well into the twentieth century.

Americans have not stopped being restless, and ghost towns have not stopped being made. It is true that today's miner often lives in a trailer camp or large town and drives to work, and that while company towns are still built in certain remote areas, they are seldom merely abandoned when the job is done. Yet at least one good-sized copper town—Bisbee, Arizona—now appears headed toward ghost-town status. By 1971, its population had declined from 25,000 to 8,000 as one huge mine after the next was being closed.

Large-scale population movements are still going on, too. Between 1960 and 1971, Nevada's population mushroomed by 71%, Arizona's by 36%. At the same time, hundreds of small agricultural towns in the Great Plains were dying. In Sheridan County, North Dakota, which lost 26% of its population during the 1960's, Lincoln Valley became a total ghost town, with others not far behind; there were towns with similar stories all the way south to the Mexican border. Yet the scenic Rocky Mountain States, adjoining the Plains States on the west, were enjoying a rural land boom. And in an era when Federal legislation was priming the development of new communities throughout America, the construction of some was halted by court order because of pollution problems—creating, in effect, ecological ghost towns. The dizzy rate of these changes would seem astonishing to any people other than Westerners.

Though still young and restless, we Westerners have begun to feel a need for roots—for a sense of the past. One indication is a deepening interest in old buildings and artifacts. Suddenly, ghost towns nobody wanted have come to seem a valuable heritage, priceless remnants of the rollicking frontier. Nowadays, ghost towns come in a variety of packages, suited for almost any temperament. There are the highly restored and commercialized versions such as Columbia, California, or Tombstone, Arizona; there are the dustblown, "pure" ghosts like Bodie, California, or Garnet, Montana; and there are many shades in between.

Just what constitutes a ghost town is inevitably a subjec-

COURTHOUSE, VIRGINIA CITY, NEVADA

METHODIST CHURCH, VIRGINIA CITY, NEVADA

SALOON AND RESTAURANT, SHAKESPEARE, NEW MEXICO

tive question. A few purists argue that the place must have a population of zero. But so rigorous a definition would exclude many depopulated towns of interest to the average person. One authority proposes a looser concept, saying that a ghost town must simply be "a shadow of its former self"—as good a working concept as we've found. We have avoided those towns of which nothing, or almost nothing, remains; and we have stressed those in which there was a high proportion of unoccupied buildings of distinctive character. We've been as accurate as possible as of 1978. But, as has been pointed out, the Western landscape is changing rapidly, and no one can say what may happen to any of these quaint communities in years to come. The reader is strongly advised to use prudence in visiting any ghost town, being sure to make local inquiries as to safety, property ownership, and trespass laws.

How fortunate that photography was invented less than twenty years before James Marshall discovered gold in California! The photographer's art grew up alongside the mining frontier, and our most vivid impressions of those zany times are preserved in the silvered images housed in precious collections throughout the West. Ghost towns are also good targets for modern shutterbugs. In addition to the normal lens, a wide-angle lens—such as a 28mm lens on a 35mm camera —is quite useful in ghost town shooting; and don't overlook the uses of macro lenses and other close-up devices. For color under wide-open skies and at higher elevations, use a skylight or UV filter to correct excessive bluishness. Dawn and dusk offer particularly expressive possibilities in all outdoor photography.

Finally, whether you go out into the field or stay in an armchair, we hope you'll find the same thing a young Montana diarist found in 1864: that "truth and the marvelous go hand in hand when Young America finds a good gold gulch."

SEEKING THEIR FORTUNES in the newly discovered gold fields, a motley throng of restless adventurers poured into California. They built wild mining camps which quickly became ghost towns when the gold ran out.

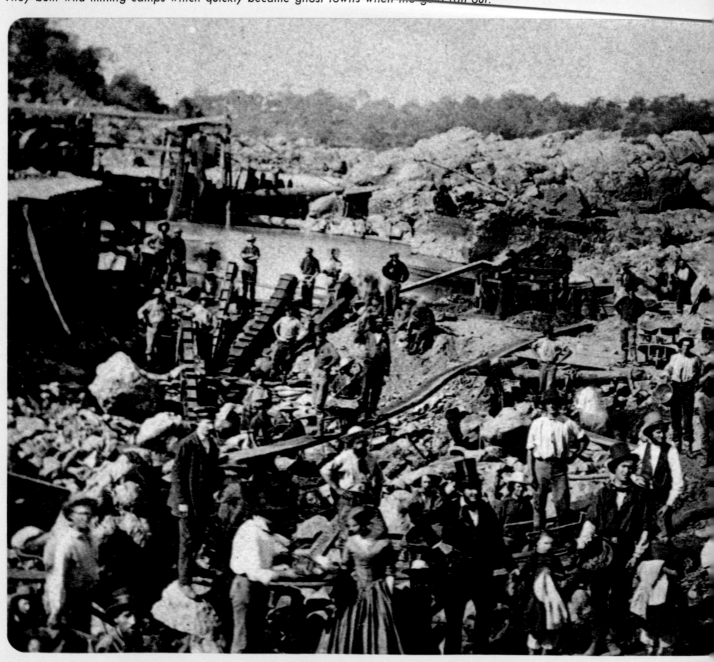

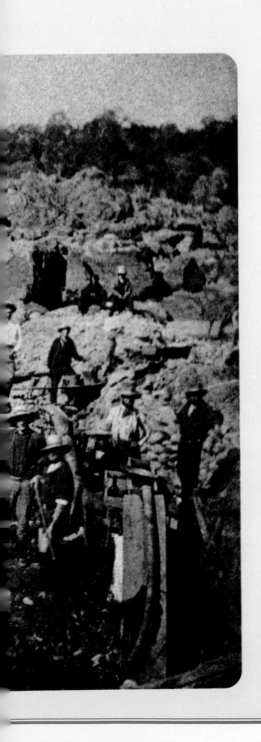

CALIFORNIA EXPLODES!
1848...

A JANUARY MORNING, CRISP AND CLEAR. The sawmill foreman was up early. He was a loner—moody, and hard to get along with. But he was a good builder, anxious to complete the new structure. While his men dallied over breakfast, he was already busy down at the river. Each day the men cut the mill race ditch deeper, and each night the foreman let the river rush through it to sweep away the debris. Soon the current would be strong enough to power saws. James Marshall closed the sluice gate and waded down the drained, muddy ditch, checking its depth. Then something caught his eye. Stooping, he reached into the shallow water. What he found changed the course of American history.

"Boys," he later told the men, "I believe I have found a gold mine."

"Gold!" shouted storekeeper Sam Brannan, galloping through the streets of San Francisco, waving his hat. "Gold from the American River!" Traces of gold had been found before in California, but had caused no stir. Now, in 1848, it was suddenly different. As one San Francisco newspaper lamented, "The field is left half planted, the house half built, and everything neglected but the manufacture of shovels and pickaxes." By fall, when the news reached eastern America, the whole country went wild. Gold-seeking "Argonauts" from all over the world poured into California, multiplying its population sixteen-fold in four years, and doubling the world's gold output.

Incredible camps and towns sprang up, with names such as You Bet, Lousy Ravine, Volcano, Bogus Thunder, and Git-Up-And-Git. Like the footloose men who founded them, the towns lived fast and often died young. Many were abandoned as suddenly as they had appeared. Others, jerry-built of canvas, wood, and whatever else lay handy, were devastated by raging fires, only to be reconstructed before the embers cooled. In a short time, the lawless frontier began to acquire more permanent buildings—brick and stone structures, often with iron doors and shutters that helped guard precious gold dust which had become the prime medium of exchange. But when, inevitably, the gold gave out, these more substantial towns, too, lost their populations and became ghosts which survive down to the present.

Most of California's ghost towns and semi-ghost towns are thus direct products of the gold rush. They lie in the regions known as the Mother Lode and Northern Mines, east of the Central Valley along the Sierra foothills. Because the area declined in importance but did not die completely, few of these historic settlements are "pure" ghosts; they remain, nonetheless, moody and charming remnants of the glory that once was.

Second in interest is an area farther north, around Mt. Shasta and Weaverville. Gold fever raged here at almost the same time as in the Mother Lode, and the style of many of the surviving buildings and artifacts is remarkably similar to that along Highway 49.

Though gold was actually found in small quantities in Southern California prior to the gold rush, and mining was reportedly under way in Death Valley as early as 1849, ghost towns lying east and southeast of the Sierra are the residue of mining rushes which occurred later in the century. Since the largest of these ghosts, Bodie, belongs topographically to the Great Basin area, it is treated in Chapter 2.

Around the turn of the century, the deserts of Southern California attracted sporadic little mining booms and busts, leaving some far-flung and very ghostly abandoned camps which hold much of the same somber fascination as the better-known ruins to the north.

𝕏 True Ghost Town: Population at or near zero; contents may range from many vacant buildings to rubble and a few roofless walls. Places where only traces remain are marked "site."

⊛ Partial Ghost Town: Disused structures and mining remnants mingle with modern elements.

★ Tourist Ghost Town: Living town has significant elements from mining rush or other historic era; old structures may be spruced up or rebuilt to promote tourist atmosphere.

⟨40⟩ Interstate Highways

⟨80⟩ U.S. Highways

⟨95⟩ State Highways & Secondary Roads

NOTE: Map is as accurate as present information permits. Refer to detailed maps for minor roads, and always inquire locally about road conditions.

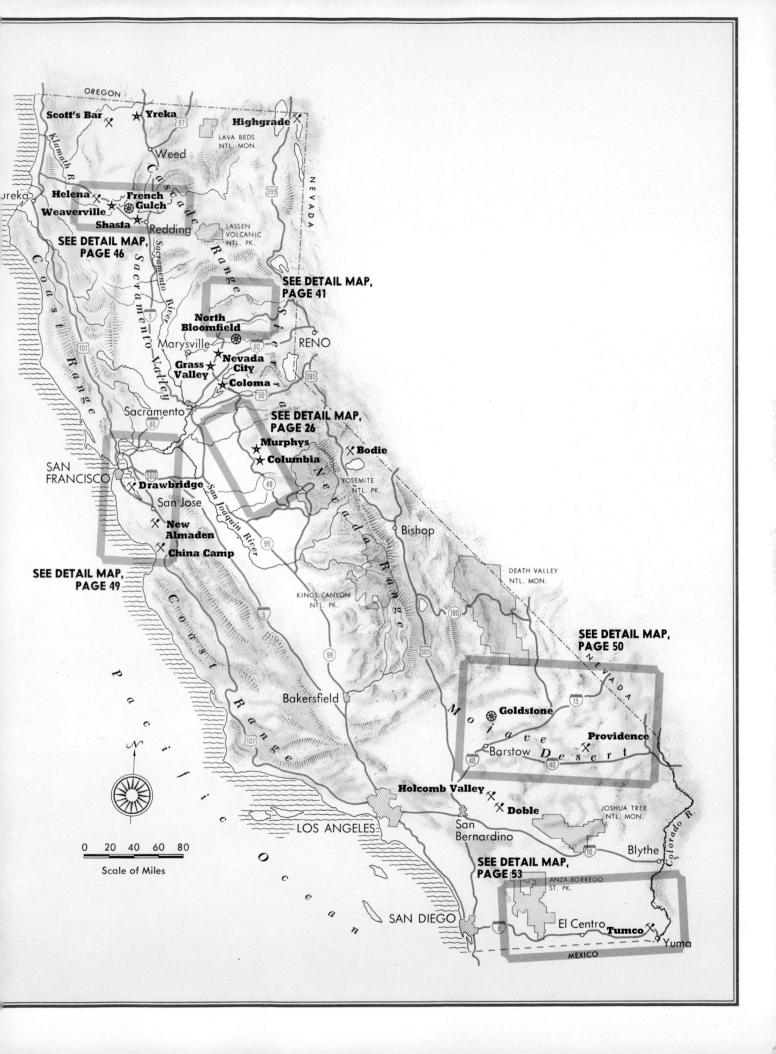

OREGON

Scott's Bar ✕ ★ Yreka
97
Highgrade ✕

Weed

LAVA BEDS
NTL. MON.

NEVADA

ureka

Klamath R.

Helena ✕ ★ French
Gulch
Weaverville ★ ⊛
Shasta ★

Redding

395

LASSEN
VOLCANIC
NTL. PK.

SEE DETAIL MAP,
PAGE 46

SEE DETAIL MAP,
PAGE 41

North
Bloomfield ⊛
5

Marysville
80

RENO

Grass ★ Nevada
Valley ★ City

Coloma ★
50

395

Sacramento
80

SEE DETAIL MAP,
PAGE 26

Murphys ★
Columbia ★
✕ Bodie

49

YOSEMITE
NTL. PK.

SAN
FRANCISCO

580
✕ Drawbridge

San Jose

San Joaquin River

✕ New
Almaden

China Camp

99

Bishop

DEATH VALLEY
NTL. MON.

SEE DETAIL MAP,
PAGE 49

5

KINGS CANYON
NTL. PK.

190

SEE DETAIL MAP,
PAGE 50

15

395

99

Bakersfield

40

Goldstone ⊛

Providence ✕

Barstow
Desert
40

Holcomb Valley ✕✕
✕✕ Doble

JOSHUA TREE
NTL. MON.

Colorado R.

LOS ANGELES

San
Bernardino

Blythe
10

SEE DETAIL MAP,
PAGE 53

ANZA-BORREGO
ST. PK.

8

El Centro
Tumco ✕

SAN DIEGO

Yuma

MEXICO

Pacific
Ocean

Coast Range

Sacramento Valley

Sierra Nevada Range

Mojave

101

N

0 20 40 60 80

Scale of Miles

Marshall's Find: TRIGGERING THE BOOMTOWN BOOM

Someone would eventually have discovered California's gold; fate chose James Wilson Marshall, the eccentric foreman of John Sutter's sawmill at Coloma to first see the glint that would inflame a continent.

Marshall's immediate action—like much of his subsequent life—was not noticeably consistent. He put the first few nuggets into his slouch hat and showed them to his workers. They seemed unimpressed, although one of them, Bigler, noted in his diary, "This day some kind of mettle was found in the tail race that looks like goald, first discovered by James Martial, the Boss of the Mill."

Not until four days later did Marshall become obsessed with secrecy. On January 28, he rode wild-eyed and dripping wet into Sutter's fortress-like ranchero in the Central Valley and told his startled boss that he wanted to see him alone. "My God!" yelled the almost paranoiac Marshall, when an unsuspecting clerk wandered in with some papers. "Didn't I tell you to lock the door!" He and Sutter bolted the door and shoved a wardrobe in front of it. But the word was already out.

Though it took months for the news to spread, the subsequent gold rush dogged both Sutter and Marshall with misfortune. Sutter's workers abandoned their jobs in a thunderous quest for instant wealth in the hills, leaving thousands of dollars worth of wheat and hides to rot. His original dream of an agricultural empire ruined, Sutter tried to profit from the gold rush in a variety of ways, but never really succeeded. In the end, he moved to Pennsylvania and died, heartbroken, in 1880.

Marshall became a folk hero to others but a failure to himself. Thought to have supernatural powers, he wandered through the hills looking for more gold, but with little success. Other prospectors nevertheless assumed he had the Midas touch, and infuriated Marshall by following him and digging wherever he dug. More and more embittered, he came to believe that all the gold in California was rightfully his. Rejected by most camps, Marshall moved to Kelsey, now an obscure ghost town just east of Coloma, where he lived on odd jobs and handouts until his death in 1885.

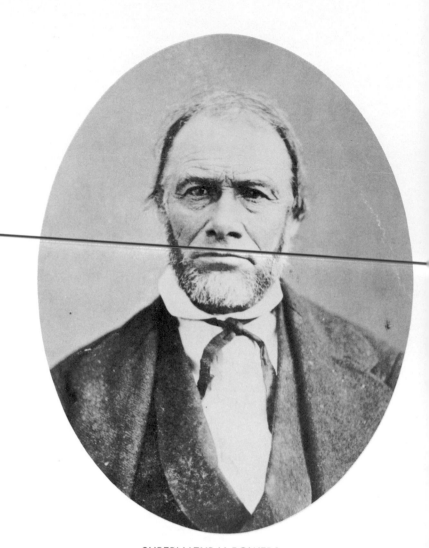

SUPERNATURAL POWERS were attributed to James Marshall because his discovery ignited the California gold rush. But Marshall did not prosper. Long after the other miners had gone off after new bonanzas, he wandered sadly through the deserted hills, a ghost among ghost towns.

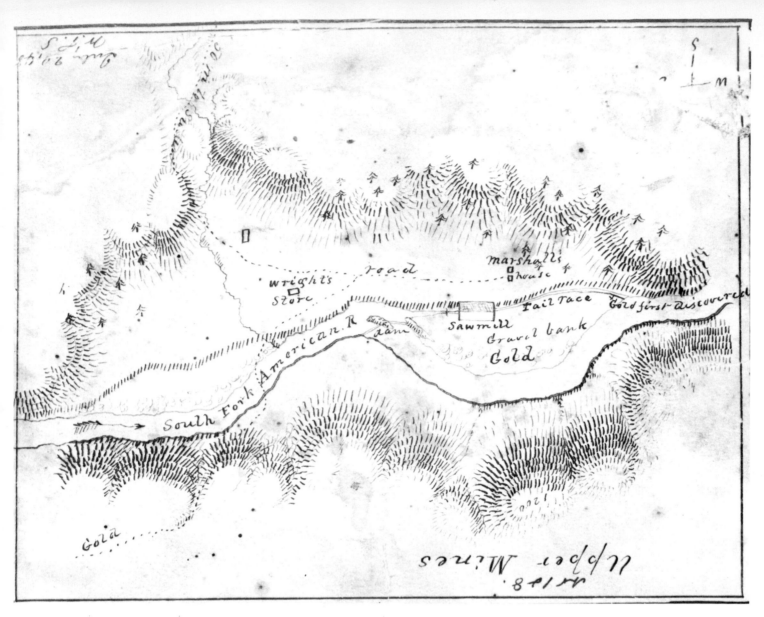

FAMOUS MAP, confirming California's gold discovery, was made in the summer of 1848 by William T. Sherman, then adjutant to California's military governor, later the famous Civil War general. Marshall's own map, probably made later, was childlike and fanciful.

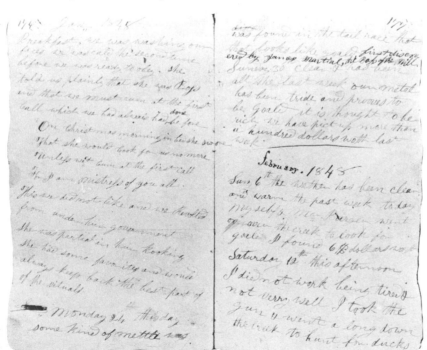

EXPERTS ARE CONVINCED of the truth of Marshall's story by the diary of Henry Bigler, a worker at Sutter's Mill. The entry of Jan. 24, 1848 reads: "This day some kind of mettle was found in the tail race that looks like goald, first discovered by James Martial, the Boss of the Mill."

CALIFORNIA 17

a GHOST TOWN worth seeing

From Auburn, on Interstate 80, head nineteen miles southeast on State 49. Coloma straddles the highway. Nearby towns of historical interest include Kelsey, Placerville, Georgetown, Volcanoville.

On the heels of James Marshall's find, Coloma sprang to bustling life. As the site of the earliest discovery, the town became a mecca and jumping-off point for the gold seekers who poured in from every corner of the globe. By 1849, thousands of residents milled through its narrow, sloping streets. Built in part with lumber cut at Sutter's Mill, scores of frame buildings went up, many of them wearing the false fronts which would soon typify mining camps throughout the West.

But of course the first strike was hardly the richest. The gold was soon gone from the picturesque little river canyon, and by 1851 Coloma was already moribund. Its population sank to two hundred by the 1870's. In contrast to the frantic early days, Coloma became, as one commentator observed, "a place of quiet serenity, of flower gardens and shaded lanes"—a character the community still possesses today.

There are a number of important things to see in this semi-ghost town which has been designated a State Park. The most apparent is Sutter's Mill, reconstructed in the original style of hand-hewn beams and mortise-and-tenon joints. Other worthwhile sights include Marshall's cabin, grave, and statue (on the hill near the two old churches); a number of authentic stone and brick buildings dating from the 1850's; and a shady park and museum, exhibiting pieces of old mining equipment.

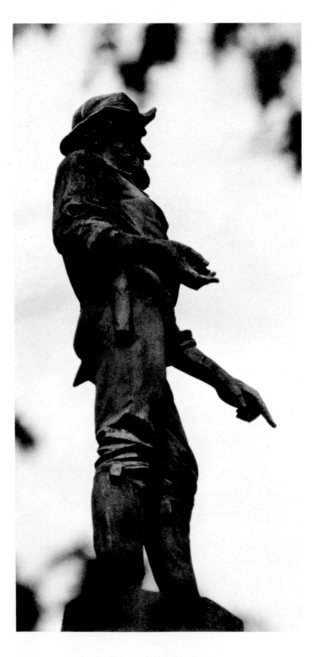

POINTING toward the site of the discovery of gold in California, this statue of James Marshall stands on a hill near the cabin where he lived.

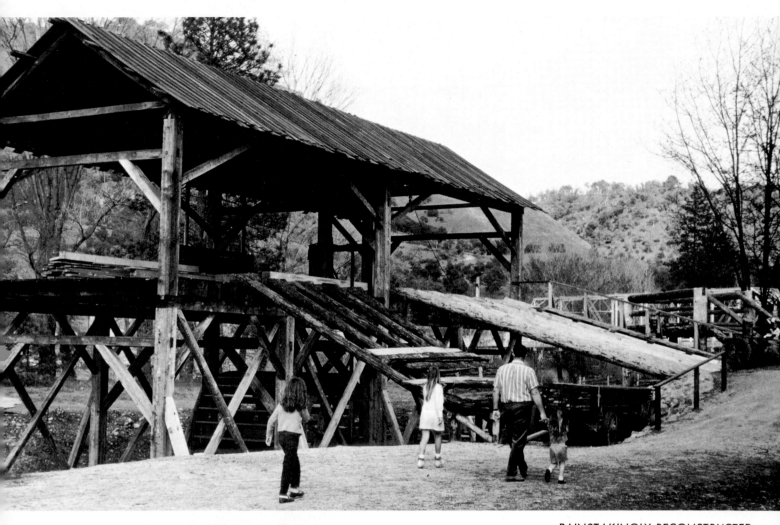

PAINSTAKINGLY RECONSTRUCTED
by the original hand methods, this exact
model of Sutter's Mill is a tourist highlight.
The river itself has changed its course
since the original discovery.

TRANQUILITY pervades the
once-rollicking gold camp.
The stone buildings were
occupied by Chinese, who
flocked to the gold rush in
great numbers.

a GHOST TOWN worth seeing

From Stockton, take State 26 about thirty-four miles to State 12, four miles beyond Valley Springs, and turn right for four miles to San Andreas. Take State 49 eleven miles southeast to Altaville, turn left, go seven miles northeast to Murphys. Nearby spots of historical interest include Angels Camp, Sonora, Columbia, Copperopolis.

The bullet holes in the doorway are real, and so are the names in the register: Mark Twain, J. P. Morgan, Ulysses S. Grant, Black Bart. Today's visitor is invited to sign below. Upstairs, little plaques dedicate each room to some famous guest. Such touches of grandeur seem faintly incongruous, because the real charm of Murphys Hotel is its air of amiable roughness. Heart of the matter is a fifty-foot, dark wood bar fronted by a heavy brass rail, on which the locals bang their feet loudly while sending their cackling laughter to ricochet off the dingy recesses of a lofty ceiling. Nobody has bothered to lock the front door since it first opened in 1856.

Said to be the oldest continuously operated hotel in the United States, this iron-shuttered gem is a good point of departure for exploring the rest of the venerable town. For, although Murphys is no pure ghost, the presence of its roughhewn past is vivid.

Despite such tourist-conscious efforts as a well-stocked museum and an old bakery now converted to an antique shop, the town has avoided obvious commercialism. The single main street, heavily shaded with fine old locusts and elms, offers smooth-worn boardwalks, ancient benches, and a whole string of buildings dating from the 1850's—some vacant, but many still occupied. Murphys' rough splendors are crowned by two of the quaintest churches in the Mother Lode.

INDESTRUCTIBLE IRON shutters and safe of Murphys Hotel date from the lawless 1850's, when such stout defenses were a virtual necessity in the Mother Lode. Not far from here is a tomb-like cement jail.

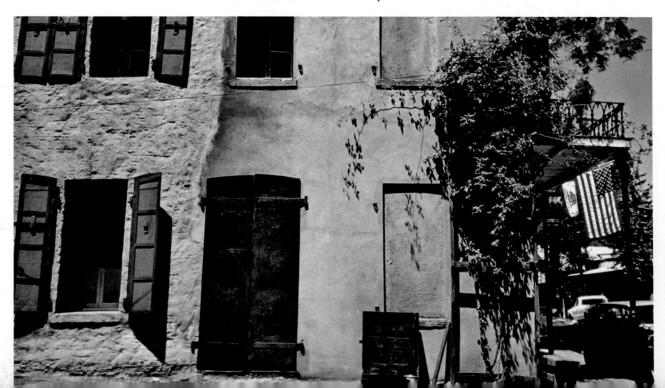

PATINA OF THE PRESENT barely covers Murphys' many-layered past. Stephens Bro's. Cheap Cash Store replaced Jones' Apothecary Shop and was itself eclipsed by an antique shop. This patrician view of the scarcely bustling main intersection of town is afforded from the balcony of Murphys Hotel.

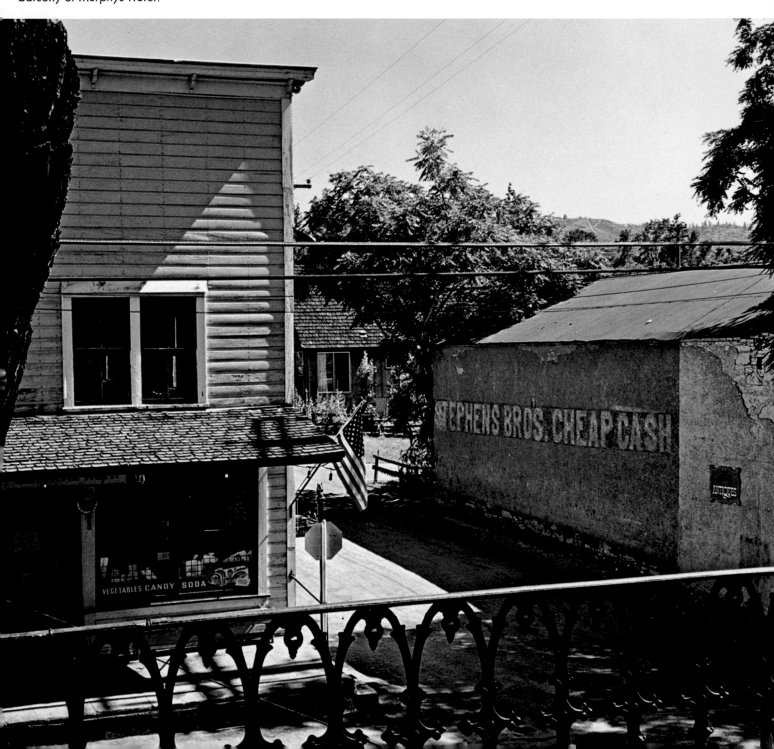

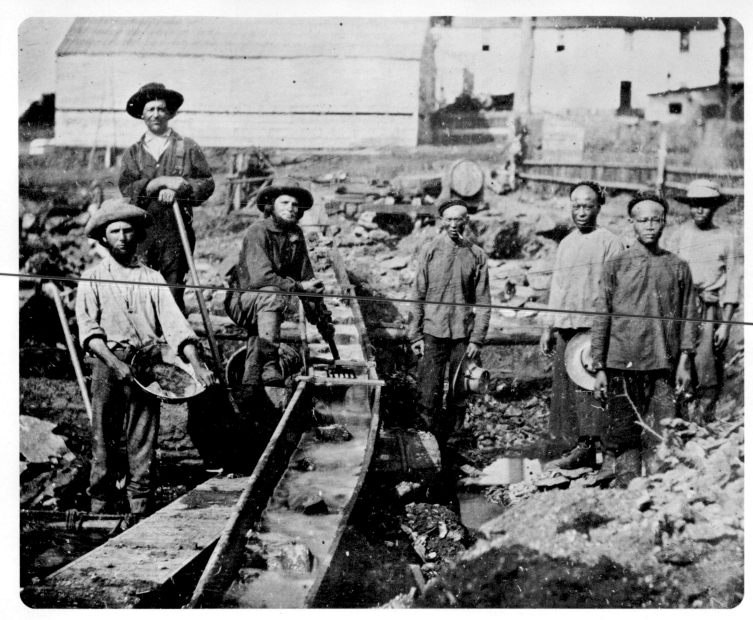

JOINED YET DIVIDED by a sluice box bubbling with placer gold, stone-faced Caucasian miners pose with their equally sober Chinese counterparts. This daguerreotype is believed to have been made at the head of Auburn Ravine in 1852.

SIDE BY SIDE, white and black Argonauts shovel pay-dirt into a device known as a "long tom." A number of runaway slaves found their way to the California gold fields.

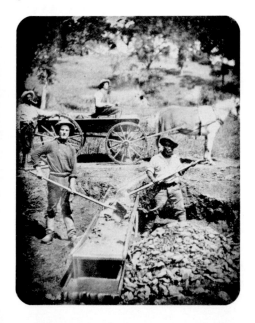

News of America's El Dorado reached Hawaii in June of 1848, Oregon in August, Mexico, Peru, and Chile by September. Almost immediately, boatloads of excited immigrants raced toward California. Americans from the eastern states did not arrive in any number before the middle of 1849. By then, an overland influx of Mexicans—or "Sonorans," as they were called in California—was well under way. Next came the Europeans, both from Europe itself and from England's penal colony in Australia. Last, but far from least, the Chinese appeared in the early 1850's.

Friction was immediate. The Mexicans and Latin Americans encountered so much hostility that they soon stopped coming entirely. The English, Scotch, Irish, and Welsh were accepted, and so were the Germans and Austrians; but the French were disliked because they kept to themselves, and became known as "Keskydees" because they kept asking "Qu'est-ce qu'il dit?" The native Indians were pushed aside.

The patient Chinese had the worst time of all. By 1852 some twenty thousand had settled in the gold area. Relegated to Chinatowns in the mining camps, and to the diggings nobody else wanted, they fought each other in tong wars and served as the white man's scapegoat. *Hutchings' California Magazine* reported that a dispute among the Indians as to whether or not the Orientals were an inferior kind of Indian was settled by a Chinese being pushed into a raging river. When he drowned, it was agreed that Chinese were not Indians, because all Indians could swim.

Misunderstandings there were, and yet the ability of the new frontier to assimilate differences—and capitalize on the varied mining experience of the immigrants—was impressive. Witness this contemporary account: "The principal street of Coloma was alive with crowds of moving men, passing and repassing, laughing, talking, and all appearing in the best of humor: Negroes from the Southern States swaggering in the expansive feeling of runaway freedom; mulattoes from Jamaica trudging arm-in-arm with Kanakas from Hawaii; Peruvians and Chilians claiming affinity with the swarthier Mexicans; Frenchmen, Germans, and Italians fraternizing with one another and with the cockney fresh from the purlieus of St. Giles; an Irishman, with the dewdrop still in his eye, tracing relationship with the ragged Australian; Yankees from the Penobscot chatting and bargaining with the genial Oregonians; a few Celestials scattered here and there, their pigtails and conical hats recalling the strange pictures that took my boyish fancy while studying the geography of the East; last of all, a few Indians, the only indigenous creatures among all these exotics, lost, swallowed up. . . . It was a scene that no other country could ever imitate."

EXTREMELY RARE daguerreotype shows what appear to be American Indians working in the mines.

Mining Camp Life: LONELINESS AND HILARITY

Whether he came by land or by sea, the typical 49'er was exhausted and nearly broke by the time he reached California. And he was in for some surprises. Our hero soon discovered that making his way from San Francisco to the mines—whether by riverboat, stagecoach, or foot—was an ordeal in itself. Once there, he was astonished by unbelievable prices ($3 for one egg) and wildly overcrowded hotels and boarding houses featuring straw mattresses only two feet wide. His naive inquiries about where to look for the precious nuggets he'd heard of were greeted with cackles, free-floating rumors, and the plaintive song, "When I got there, the mining ground was staked and claimed for miles around."

Learning that "seeing the elephant" meant going after the gold, he went out to learn how it was done. As witnessed by one visitor to Hangtown in 1851: "Along the whole length of the creek, as far as one could see, on the banks of the creek, in the ravines, in the middle of the principal and only street of the town, and even inside some of the houses, were parties of miners, numbering from three or four to a dozen, all hard at work, some laying into it with picks, some shoveling the dirt into the 'long toms,' or with long-handled shovels washing the dirt thrown in, and

throwing out the stones, while others were working pumps or bailing water out of the holes with buckets. There was a continual noise and clatter, as mud, dirt, stones, and water were thrown about in all directions; the men, dressed in ragged clothes and big boots, wielding picks and shovels, and rolling big rocks about, were all working as if for their lives. . . . "

Forced to grow up in a hurry, our 49'er did not easily get over feeling sorry for himself. Yet he lived it up when he could. After weighing his gold in a crude scale, he headed for the boomtown saloons. Ninety-two percent of California's population in 1850 was male, but the more prosperous camps featured "hurdy-gurdy girls"—pay-as-you-go dancing partners—and gaudy brothels. On Sunday, particularly, Argonauts thronged through the dusty, narrow streets, buying provisions, throwing away hard-earned "wages" at gaming tables, and watching bear-and-bull fights.

On Sunday nights the barbers would work late, panning their careful sweeping of whiskers and hair cuttings for traces of gold. And thick-fingered bartenders—who, in receiving "pinches" of the miners' dust had let traces of it sift onto the floor—would go home and pan the mud that clung to their shoes.

VENERABLE TECHNIQUE of gold panning depends on the fact that gold is quite heavy. As the miner swirls water around in the pan, the worthless dirt spills out while the gold granules sink to the bottom.

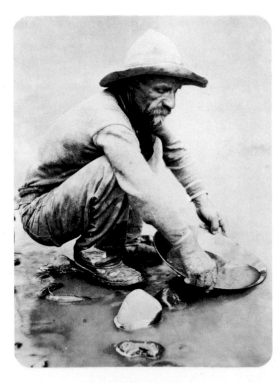

TREASURES FROM THE EARTH: HOW GOLD IS DEPOSITED

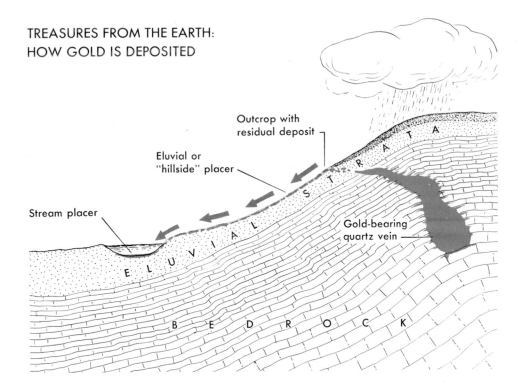

Outcrop with residual deposit

Eluvial or "hillside" placer

Stream placer

ELUVIAL STRATA

Gold-bearing quartz vein

BEDROCK

MOLTEN GOLD from deep in the earth flowed upward into fractures to form primary or vein deposits. As the earth's surface eroded, some veins were exposed as outcroppings. Further erosion disintegrated the outcroppings, tumbling the gold particles down along the hills and into streams.

VARIOUS MEANS of mining gold were depicted in this early letter-sheet. Below the idealized rendering was space on which the 49'ers wrote letters home.

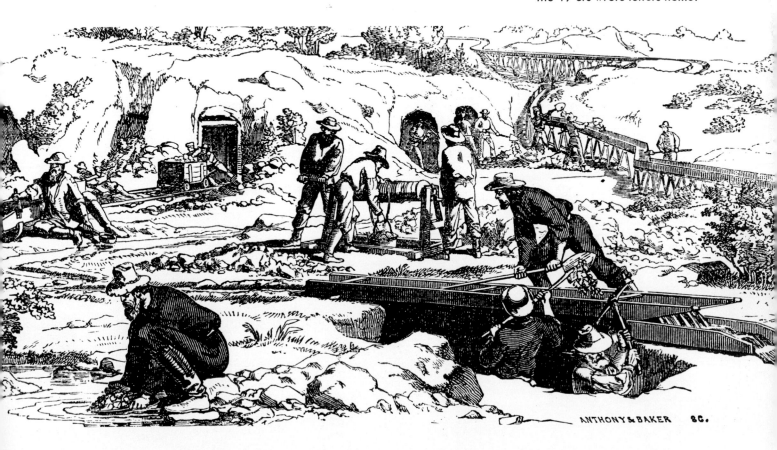

ANTHONY & BAKER SC.

Take the Low Roads:
SUN-BAKED ROUTES TO A BURNISHED PAST

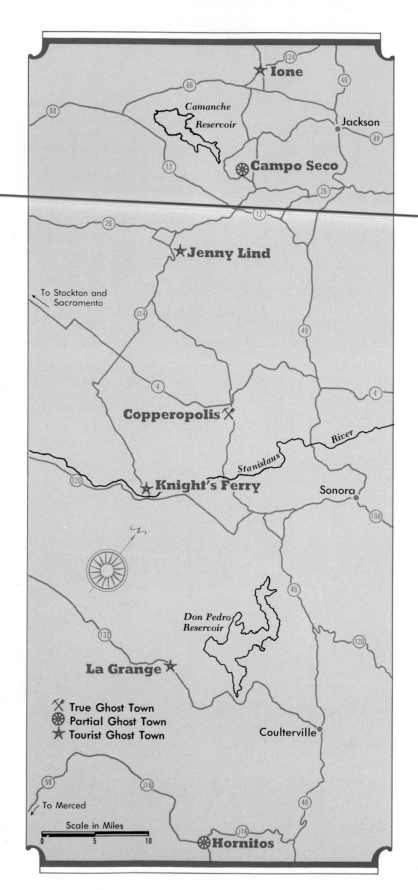

Ione

Camanche Reservoir

Jackson

Campo Seco

Jenny Lind

To Stockton and Sacramento

Copperopolis

River

Stanislaus

Knight's Ferry

Sonora

Don Pedro Reservoir

La Grange

✗ True Ghost Town
⊛ Partial Ghost Town
★ Tourist Ghost Town

Coulterville

To Merced

Scale in Miles
0 5 10

Hornitos

Though less glamorous than the Highway 49 area proper, the lower foothills are more ghostly. Prowling these sun-baked stretches is worth a trip in itself. They are also handy to visit on your way to or from the more touristed towns. Besides the faded villages, you occasionally spot venerable stone fences, discarded farm tools, and other reminders of bygone times. Ranchers are still finding old square nails and even abandoned mineshafts on their lands.

Hornitos is probably the town with the most to see. The fine cemetery up on the hill is a must; so are the Mexican-style central plaza (the town was founded by early-day miners from Mexico) and the ruins of the Ghirardelli store.

Campo Seco and Copperopolis come closer to being real ghosts. Both were copper producers in the 1860's, when a combination of unusual factors boosted copper quotes. And both collapsed when the price of copper did.

Formerly known as "Bedbug" and "Freezeout," Ione is a small, living town with several buildings still intact from the days when the town served as a stage stop and commercial crossroads for the gold rush. Knight's Ferry is famous for its covered bridge and historic ruins. Tiny Jenny Lind, once a gold dredging center, slumbers amid the old tailings, as does La Grange.

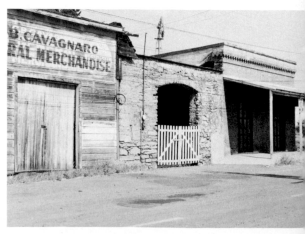

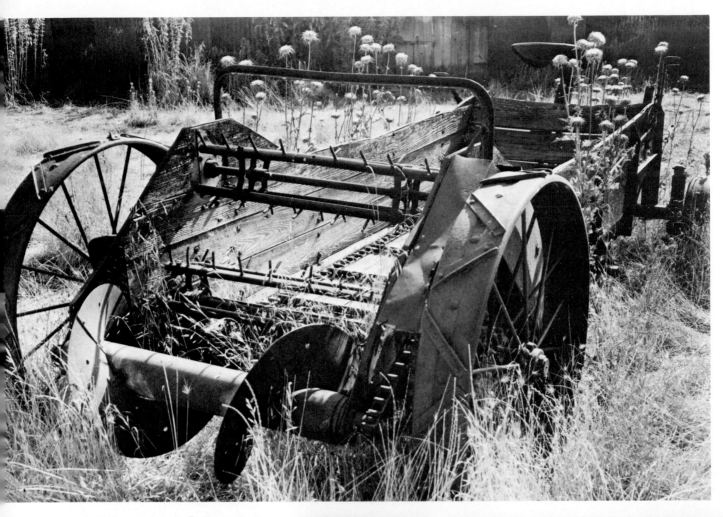

FORGOTTEN FIELDS throughout the lower Sierra foothills are strewn with the weathered remains of many eras, many enterprises. An old piece of farm machinery near Copperopolis is slowly engulfed by weeds (above). Ruins of a grist mill on the Stanislaus River frame a camper about to cross the covered bridge at Knight's Ferry (right).

SILENT STOREFRONTS mark the outskirts of Hornitos. Legend has it that the storekeepers on this side were such bitter rivals of those across the street (whose edifices are now also shuttered) that neither would admit to knowing the other existed.

IMPOSING MEMENTOS of the days when men looked to nearby fields for building materials are these rugged rock walls in the center of ghostly Campo Seco. A rich placer camp in the early years of the gold rush, the town became a copper center in the 1860's, after which it entered a long decline and never recovered. Tree fanciers take note: the largest cork oak in California grows at Campo Seco.

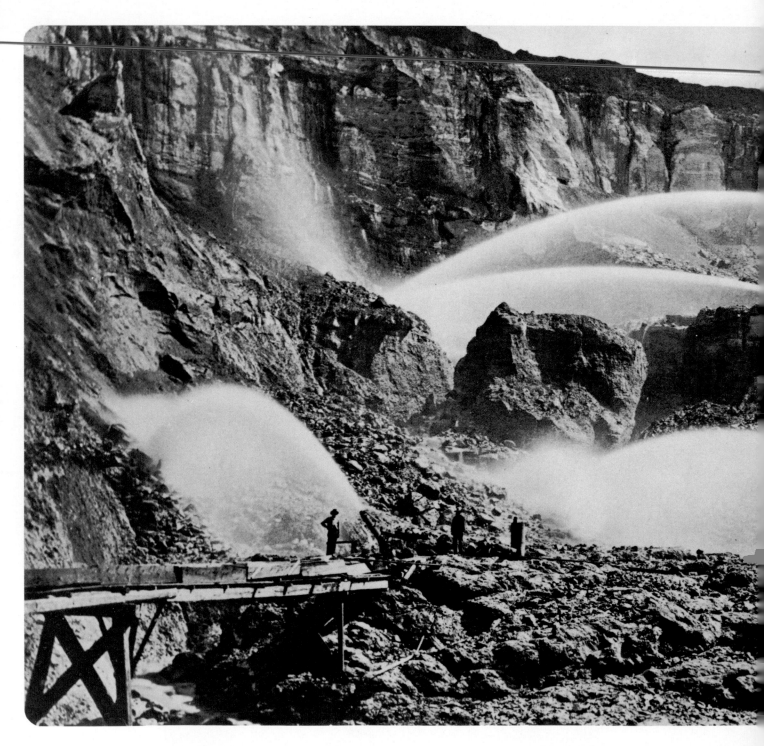

The Hydraulickers: RISE AND FALL OF AN UPSTART BREED

Figuring this land was their land, they tapped the water power of the mighty Sierra and aimed it at California's hills. Their high-pressure nozzles poured 270 million dollars of "color" into the sluice boxes—a sixth of the gold ever mined in the state—and washed away more dirt than was excavated from the Panama Canal.

AWESOME DISPLAY of the power of hydraulic mining was recorded in this view of the Malakoff Diggins, near Nevada City. Here as elsewhere, a torrent of debris clogged rivers, caused floods, and ruined farmlands until, in 1884, the practice was legally abolished. By attracting out-of-work miners up and down the gold country, hydraulicking created new camps which, in turn, became ghost towns (see following page).

FROM THE COOL GLOOM *under the boardwalk roof of North Bloomfield's general store, you look out at an old firehouse, bell, and other mementos of the town's golden era. The somnolent village, which still has a few residents, is being restored as a period piece.*

NORTH BLOOMFIELD, CALIFORNIA
IN HYDRAULICKING'S SHADOW

"Humbug!" somebody grunted, and the disappointed Argonauts figured it wasn't a bad name for the town itself. Some wandering, drunken miner had raved about all the rich gold to be found around the place, but when the experienced prospectors got there they found the deposits too low-grade to work. That was in 1851.

In the 70's things were different. The town had been appropriately rechristened, and the low-grade gravels were succumbing to the fantastic new method known as hydraulicking (see pages 30-31). Thousands of men were earning good wages erecting and maintaining the hundreds of miles of canals and flumes that channeled the water down from the High Sierra reservoirs. Many others operated the long lines of sluices, whose design was improved until they became one of the most efficient gold recovery systems in California. The mine was huge and rich; the North Bloomfield Gravel Mining Company shipped one bar of pure gold that weighed 510 pounds.

The town prospered. Then in 1884, after a bitter counterattack by farmers and other residents of the lower valleys, whose lands and rivers were being wrecked by hydraulicking, a U.S. Court prohibited the Company from dumping tailings into the State's water arteries. This injunction effectively killed hydraulic mining in California.

It also killed North Bloomfield. A picturesque little ghost town today, it is being gradually restored and might appropriately be seen after a visit to the Malakoff Diggins.

From Auburn, on Interstate 80, take State 49 twenty-nine miles north to Nevada City. Continue eleven miles farther on 49 and turn right at the Tyler Foote Crossing road. After eight miles, just beyond North Columbia, turn right on the Lake City road. Turn left at Lake City and go five miles to North Bloomfield.

a GHOST TOWN worth seeing

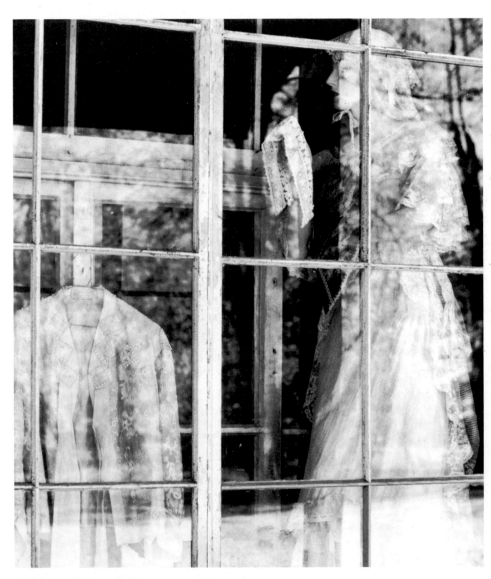

AS IF MUSING on bygone years, a figure dressed in a century-old wedding dress stands poised in the window of North Bloomfield's general store, which has long been closed to business.

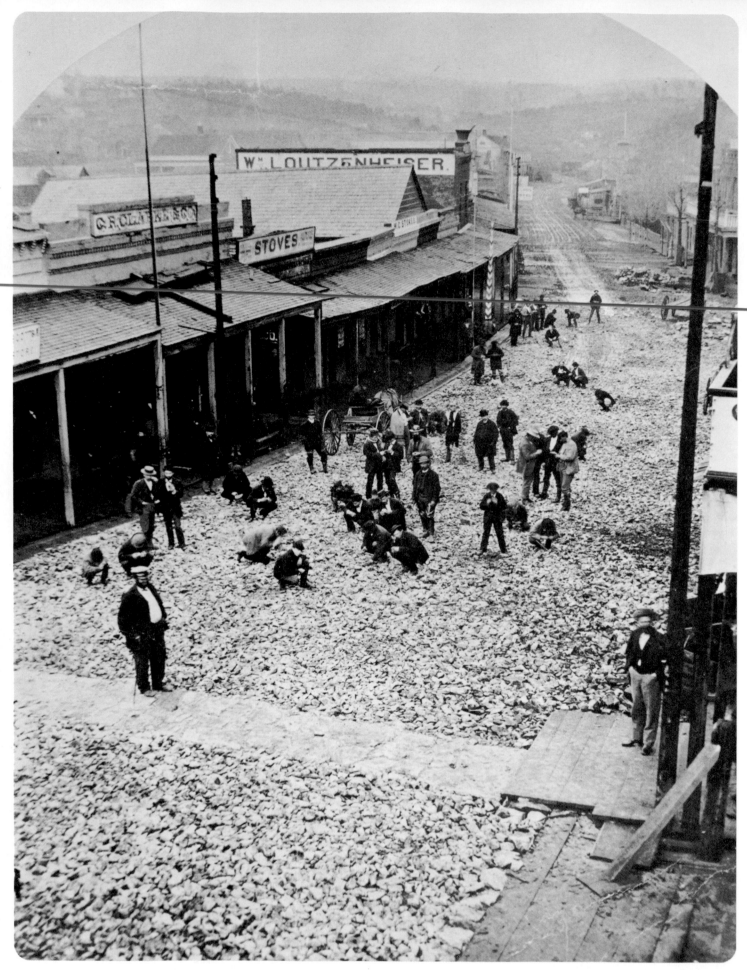

LITERALLY PAVED WITH GOLD when it was macadamized in 1873, Grass Valley's Main Street suddenly became the object of a frenetic search by grizzled miners looking for rocks containing a good grade of ore.

NEVADA CITY/GRASS VALLEY, CALIFORNIA
HARDROCK MINES BUILT GENTEEL COMMUNITIES

The term "ghost town" would have to be stretched very far to include Nevada City and Grass Valley. Yet these twins sum up the mature years of California gold mining. While the placer camps flared and fizzled, Nevada City and Grass Valley were taking root in the firmer soil of the industrial revolution. Their hardrock ores, crushed and melted in heavy machinery turned out by Nevada City's famous Miner's Foundry, supported a broadly-based economic development. Out of this grew these communities of astonishing grace and permanency.

Seeing them today, you sense that while Nevada City contributed the refinement, little, still-humming Grass Valley supplied more of the muscle. Grass Valley's gold mines—the Empire, Pennsylvania, North Star, Gold Center, and others—lie on the periphery of the town proper. Producing more than $100 million in just over a hundred years, they kept Grass Valley prosperous with a consistency unique in the West, even through the Depression of the 1930's. Outside the well-organized little museum is an immense Pelton wheel, which efficiently transformed available water energy into rock-crushing power.

Nevada City's great attraction is her beauty. She speaks with a faint New England accent, and the seasons bring dramatic changes to her lush hillside lanes, her steeples, her venerable business buildings, and her wonderful old homes. As a final touch, more than four score of gas lamps now grace the small downtown area, which is one of America's prettiest.

From Auburn, on Interstate 80, take State 49 twenty-four miles north to Grass Valley; Nevada City is five miles farther on, to the northeast. Most drivers use the freeway, but the old road, just north of the freeway, is more scenic and less hurried.

a GHOST TOWN worth seeing

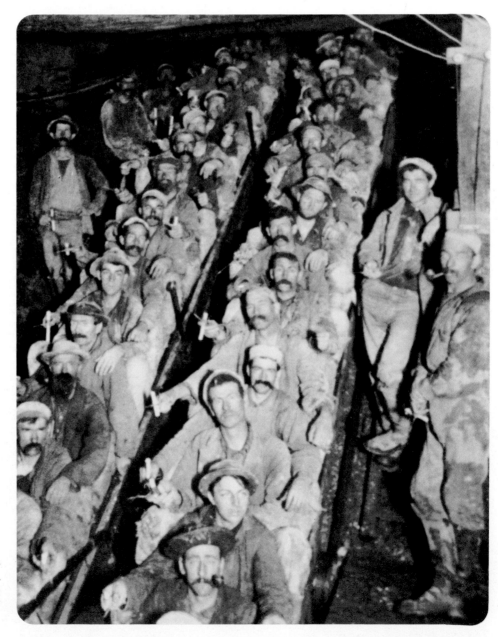

HOLDING CANDLES to light their way through the underground darkness, miners descend into the tunnels of Grass Valley's Empire Mine.

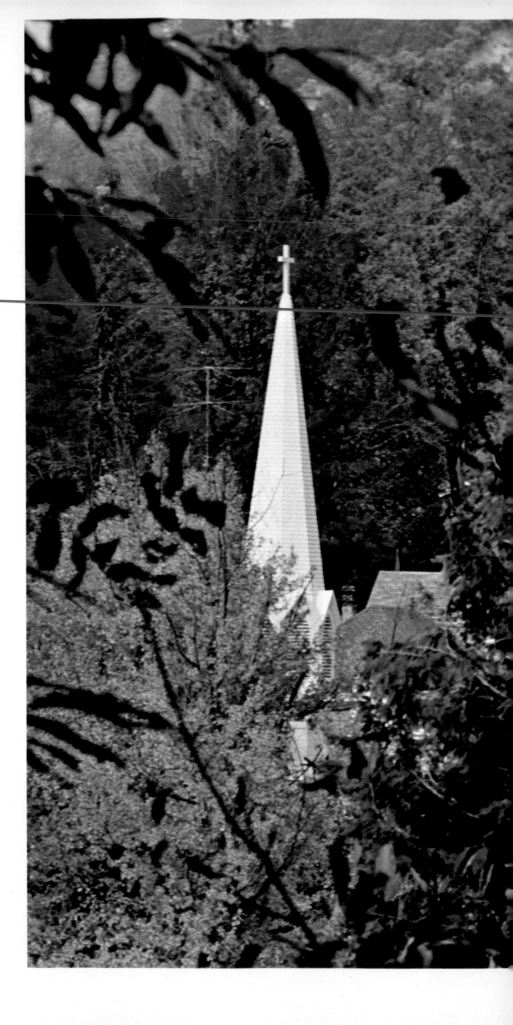

FALL COLORS bring a crowning glory to the stately homes and churches of Nevada City and Grass Valley. Nowhere else in California are such Eastern architectural motifs as widow's walks, garden gazebos, picket fences, and mullioned windows found in such rich abundance, or tended with such loving care. Far left: Nevada City's Trinity Episcopal Church, opened in 1873. Left: Marsh house, on Boulder Street, Boulder Hill, Nevada City. Below, left: The Red Castle, now a hotel, on Prospect Hill, Nevada City. Below, right: Bourn mansion, near Empire Mine, Grass Valley. Bottom: house on Boulder Street, Boulder Hill, Nevada City.

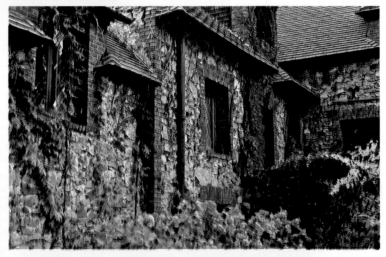

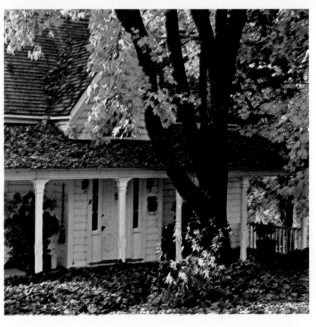

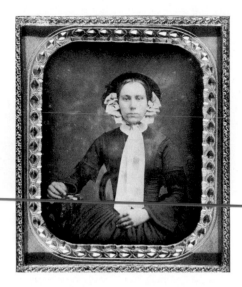

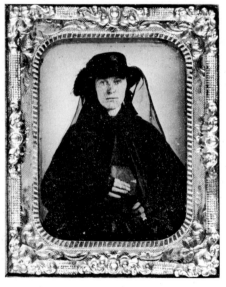

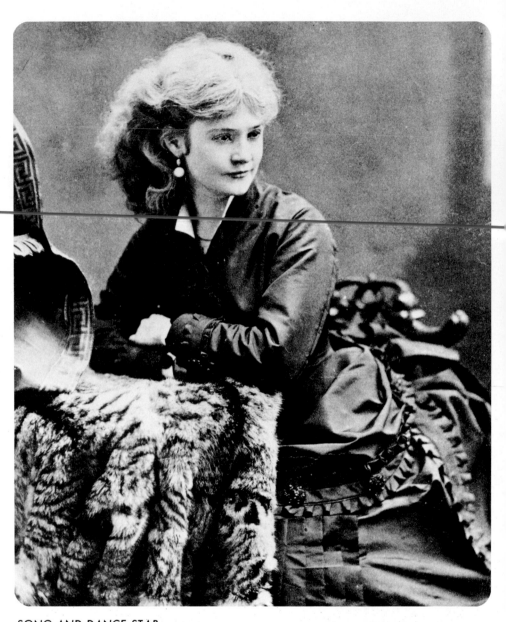

WIVES AND DAUGHTERS
of early California miners
had to be strong to adapt
to a rough-and-ready man's
world. Top: Emma Johnson,
daughter of a Hangtown
miner. Below: a miner's
widow mourns his death.

SONG-AND-DANCE STAR
Lotta Crabtree (above) was
trained and launched by
Lola Montez at the age of 7.
An overnight success, she
left Grass Valley to travel
throughout the gold country
and on to international fame.

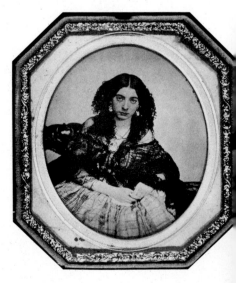

Woman in Town! ...AND THERE WERE THE SETTLERS

Tracking down vanished mining camps? Look for fruit trees. Many a pioneer housewife—whether she came jolting across the plains or bobbing around the Horn—brought along little bags of seeds to help civilize and feed the new communities.

Especially in the rugged terrain of the Northern mines, food supplies could be chancy; the lack of fresh fruit, vegetables, and other staples was a constant threat to health. Wrote housewife Shirley Clappe to her sister, "We have had no fresh meat for nearly a month! Dark and ominous rumors are also floating through the moist air, to the effect that the potatoes and onions are about to give out! But don't be alarmed, dear Molly. There is no danger of famine. For have we not got wagon loads of hard, dark hams, whose indurated hearts nothing but the sharpest knife and the stoutest arm can penetrate? Have we not got quintals of dreadful mackerel, fearfully crystalized in black salt? Have we not barrels of rusty pork. . . ? "

Many pioneer housewives' implements can be seen in the gold country today. A typical kitchen might contain a Dutch oven, camp kettle, frying pan (called a "spider"), coffee pot, tin plates and cups, iron spoons, knives and forks, rolling pin, bread pan, and milk or water can. Butcher knives were scarce. If there were no baking pan, the housewife speared slices of bacon or rolls of bread dough on sharpened willow switches, then held them over the open fire.

One of Mrs. Clappe's friends had a stove so badly designed that "the soot sifted through in large quantities, and covered us from head to foot, and though I bathed so often that my hands were dreadfully chapped and bled profusely, from having them so much in the water, yet in spite of my efforts, I looked like a chimney-sweep, masquerading in women's clothes."

Caring for the little ones was no picnic, either. Mrs. Clappe wrote that "This is an awful place for children; and nervous mothers would 'die daily,' if they could see little Mary running fearlessly to the edge of, and looking down in these holes—many of them sixty feet in depth—which have been excavated in the hope of finding gold, and of course left open." Another journal relates that when the father was away, "Mother kept her children close to the home all day. When evening came, she tucked them in their beds very early, then making sure that the window and door were well barred, she set herself to the task of sewing or darning the numerous little stockings. Many times the brave woman, alone in the solitary house, sat and worked well into the night while her babes slept near her side. Often the wild panther screamed near the window or a hungry bear roamed back and forth in front of the cabin. The mother was always glad, at these times, when morning came, and with it the cheering rays of sunlight."

Despite the hardships, a zestful love of life in the new land can be read between the lines of almost all the letters. And as the camps matured, life improved. In her final correspondence from the gold fields, Mrs. Clappe is perfectly sincere in advising her sister, "Really, everybody ought to go to the mines, just to see how little it takes to make people comfortable in the world."

WORLDLY BEAUTY, Lola Montez in her twenties was the mistress and enchantress of Europe's most famous men of culture. At 35 she came to California, failed as a theatrical performer, and set up housekeeping in Grass Valley. Still restless and unhappy, she returned to Europe and then New York, where she died in 1861, at the age of 43. Framed portrait at far left shows her in her younger years; casual pose at near left, closer to her death.

Backroad Haunts:
GHOSTS BEYOND HIGHWAY 49

Get off the main drag! The gold country's truest ghosts are on the smaller lanes leading back into the hills and beyond. The breezy trees and buzzing locusts will welcome you. So will these somnolent communities, scarcely brushed by tourism.

Detailed guides include the AAA map "Feather River and Yuba River Regions" and the Plumas and Tahoe National Forest maps. The greatest concentration of vanished camps occurs in the steep mountains northwest of Downieville. Be forewarned, however, that the roads wind tortuously and that there may be little left at many of the sites. Howland Flat and Scales are among the best—but please remember that their fascinating cemeteries, interesting old buildings, and mammoth slag piles are all private property.

VENERABLE CEMETERY broods on a windswept knoll overlooking the tiny hamlet of Chilcoot. Though it is within California, Chilcoot lies near Beckwourth Pass in an all-but-forgotten part of the state—east of Johnsville and northwest of Reno.

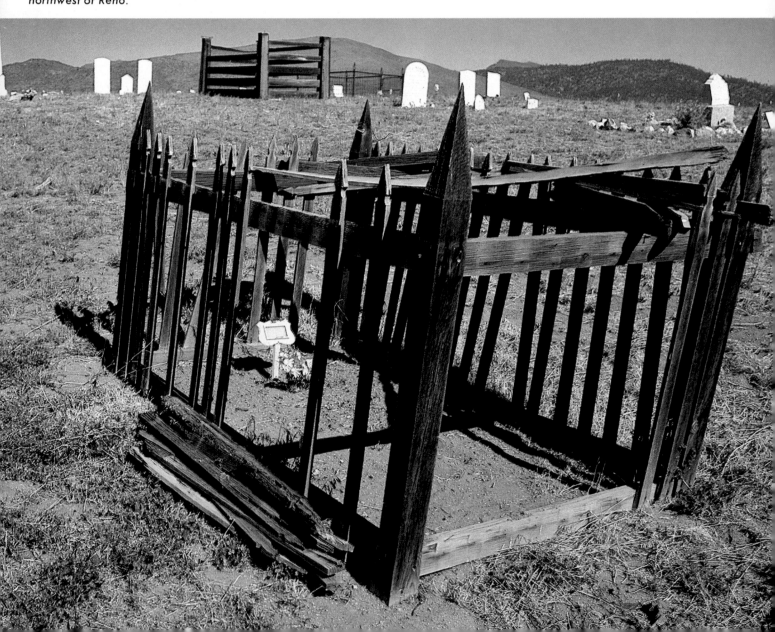

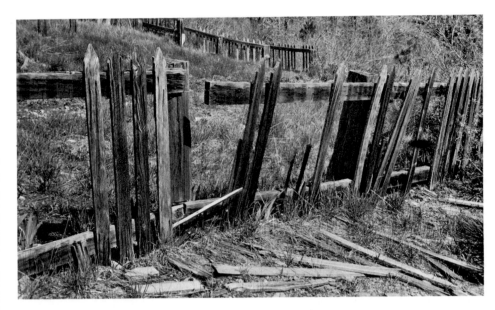

WEATHERED pickets are gradually trending toward the horizontal at the odd little semi-ghost of Forest. Vigilantly safeguarded by an aging couple who own part of it, the town shows glimmers of new life since the arrival of a few vacation residents.

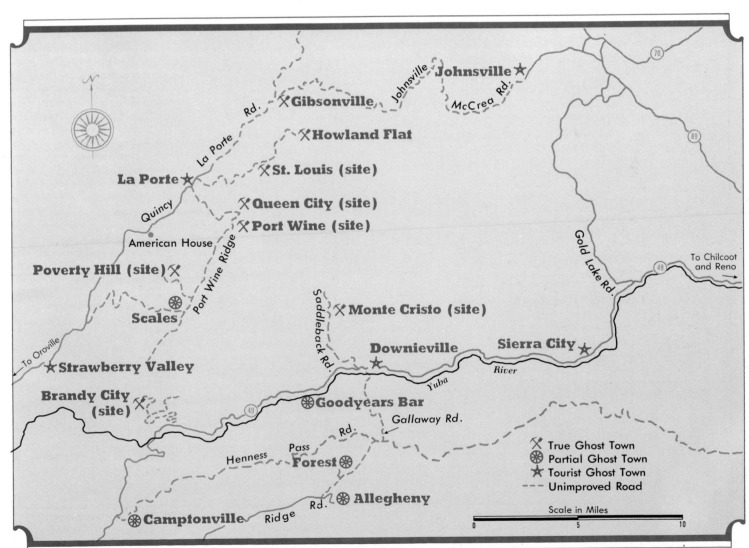

Gibsonville

Johnsville

Howland Flat

St. Louis (site)

La Porte

Queen City (site)

Port Wine (site)

American House

Poverty Hill (site)

Scales

Monte Cristo (site)

Downieville

Sierra City

Strawberry Valley

Brandy City (site)

Goodyears Bar

Forest

Allegheny

Camptonville

✕ True Ghost Town
⊛ Partial Ghost Town
★ Tourist Ghost Town
--- Unimproved Road

Scale in Miles
0 5 10

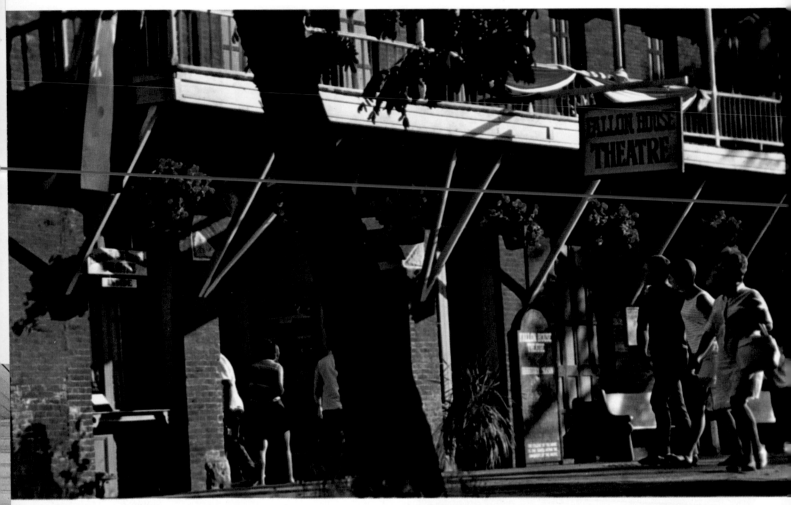

NUGGET of tourist interest, the restored
Fallon House Theatre presents live stage
performances. A repertory group of actors
from University of the Pacific spends the
whole summer in Columbia, living at
picturesque Eagle Cottage, an old boarding
house just down the street.

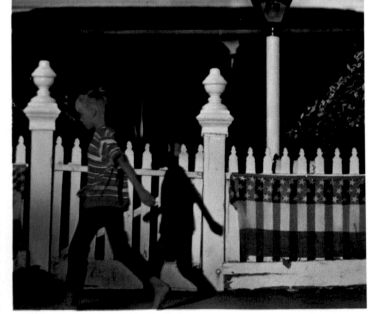

ABSORBED in his next
urgent amusement, a spirited
young'un passes the well-kept
home of one of Columbia's few
full-time residents. The bunting is
out in honor of Fourth of July,
a peak day for this tourist town.

COLUMBIA, CALIFORNIA
DRESS UP OR DOWN, AND BRING THE KIDS

There's plenty to do in Columbia—stage coach rides, the ice cream parlor, gold panning, saloons, a serious theater, and more. Although it slumbered for nearly a century after having once been the Mother Lode's top mining camp, Columbia makes no pretense of being a true ghost town. Meticulously restored by the State Park people, the old brick buildings wear full commercial regalia—banners, fresh paint, and Ye Olde signs. Besides the tourists, who come in droves, there are a few full-time residents. You can see their mail in the ancient post-office boxes, or shop at the general store with them, or even sit in on a genuine legal proceeding at the Main Street courthouse.

Like so many of the truer ghosts, Columbia teems with history. Her flat valley is blessed with a unique geological formation: a limestone bed, full of potholes which caught and held the gold flakes that washed down from the surrounding hills over thousands of years. Thus, the topsoil proved exceedingly rich, yielding—according to one estimate—about $87 million. In the early 1850's her fifteen thousand or more residents made Columbia the second or third largest city in California, with forty saloons and gambling halls, seventeen general stores, eight hotels, three churches, three theaters, two fire companies, and four banks.

From Manteca, off U.S. 50, take State 120/108 fifty-five miles east to Sonora. Then turn left, go seven miles northwest to Columbia. Sonora itself contains interesting gold rush mementos, as do Jamestown and Chinese Camp.

a GHOST TOWN worth seeing

CROWD PLEASING is Columbia's stock-in-trade, and that includes dancing in the street as well as loud shoot-outs, ragtime piano players in the saloons, stage coach rides, and red garter girls.

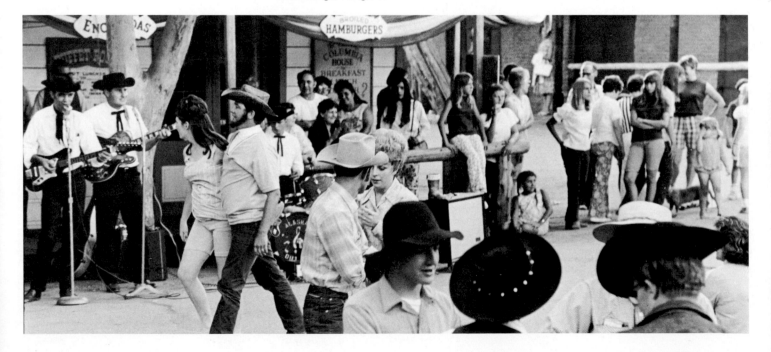

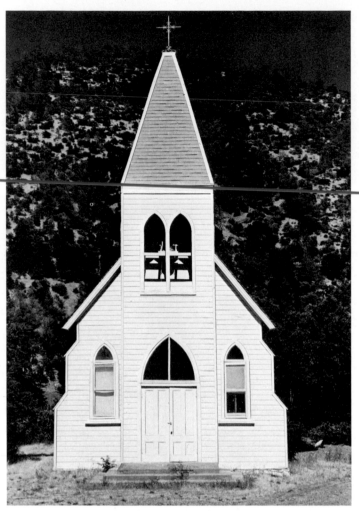

Above the Sacramento Valley lay a gold region that was in many ways the wildest of them all. Less publicized than the Mother Lode and Northern Mines, these boom camps clung to their rough-and-tumble ways longer. But here, too, the gold ran out, and one camp after another had to close its creaking doors.

Among things to see at Shasta are the hollow remains of what was once the longest row of brick structures in all of California. They were put up to prevent another holocaust such as leveled the camp's frame-built center in 1853. Weaverville is a living town with a fine museum and quite a number of early-day buildings and artifacts.

Tiny Helena, situated beside the Trinity River, holds a quieter charm. Its historic structures are benevolently watched over by a single family. Little-known Ingot's jumbled mass of mining wreckage derives from an expensive but ill-conceived effort to extract copper from some difficult ores.

French Gulch is a living village with the natural, informal atmosphere of yesteryear's small town U.S.A. Its mood is enhanced by an attractive cluster of early-day wooden and brick structures, some occupied, some not.

WELL-PRESERVED CHURCH is a highlight of French Gulch. Now a Historic Landmark, the camp was a big gold producer by 1851. Its mines had such names as the Brown Bear, Mad Mule, and Milkmaid. Some operated as late as the mid-twentieth century.

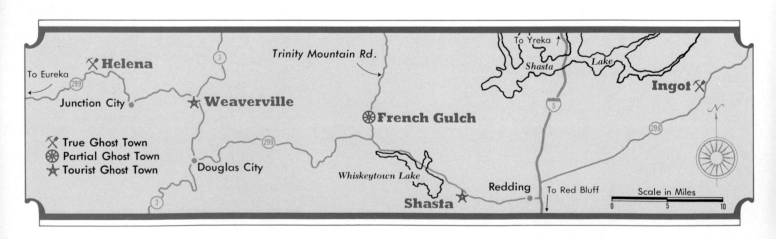

COURT'S COME TO ORDER, thanks to the restorer's art, in the old mining town of Shasta, whose rowdy habits once gave the judge plenty to worry about. Shasta's golden wealth and lonely isolation were tailor-made for outlaws with names like Rattlesnake Dick and Sheet-Iron Jack.

VARIED MEMORIES flicker in the silent shadows of this gold-rush ghost at Helena, California. Downstairs the stone-and-brick edifice housed a brewery, while the upstairs apparently served as a school by day and a brothel by night.

UNIFORM STRUCTURES of Camp Reynolds, the Army's West Garrison on Angel Island, are now tourist curiosities. The pretty island has had a long and colorful history. It is now a State Park, and there are plans to restore the interiors of these and other historic buildings, one of which is made of bricks carried around the Horn. On the opposite side of the island are the hulking remains of the East Garrison (Ft. McDowell), which served in various capacities until after World War II. Gun emplacements and an abandoned missile launching site are also scattered about Angel Island.

Golden Gate Ghosts:
SPRITES OF THE BAY AREA

Strange to say, there are ghost towns near San Francisco. Of earliest vintage is New Almaden, south of San Jose. Its cinnabar hill long provided the Indians with red pigment for their personal adornment. In the 1840's various companies vied for control of the mercury deposits, and after 1848 production soared because of the need for that metal in treating gold ores. Though the mining area remains inaccessible to the public, a once-magnificent twenty-room hacienda with wide balconies can still be visited. Known as Casa Grande, it served as the superintendent's residence. Now it houses a few desultory enterprises and a nightclub. Up the creek there's a small museum.

South of Santa Cruz, in the Forest of Nisene Marks State Park, are the decimated remains of China Camp. The settlement boomed in the early days of this century, when the surrounding redwood stands served as a prime source of lumber.

Near Concord is the recently created Black Diamond Mines Regional Preserve— site of vanished Somersville and Stewartsville. These were coal centers in an era when coal mining dominated the economy of Contra Costa County—roughly 1855 to 1885. Though virtually nothing remains of the towns themselves, there are hopes of reopening some of the 50 miles of underground tunnels to tourists.

There's most to explore at the old Army posts and quarantine stations on Angel Island (see photo at left) and at Drawbridge (below).

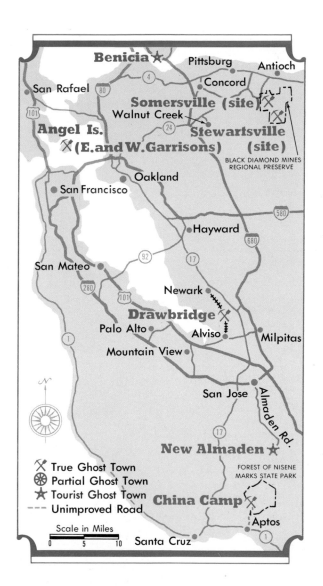

Benicia ★ Pittsburg Antioch
San Rafael Concord
Somersville (site)
Walnut Creek
Angel Is. **Stewartsville**
(E. and W. Garrisons) **(site)**
BLACK DIAMOND MINES REGIONAL PRESERVE
Oakland
San Francisco
Hayward
San Mateo
Newark
Drawbridge
Palo Alto Alviso Milpitas
Mountain View
San Jose
New Almaden ★
FOREST OF NISENE MARKS STATE PARK
China Camp
Aptos
Santa Cruz

✕ True Ghost Town
⊕ Partial Ghost Town
★ Tourist Ghost Town
--- Unimproved Road

Scale in Miles
0 5 10

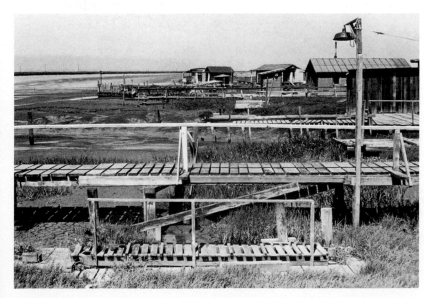

DOZING on a mud flat laced with catwalks is Drawbridge, one of the West's most unusual ghost towns. Built about 1880 as a duck-hunting and gambling retreat, Drawbridge hit its peak during Prohibition, when special trains hauled in hundreds of good-timers every weekend. But the Depression killed the town. To reach Drawbridge you walk about three miles along the tracks jutting into the bay.

Southern California:
GHOSTS OF THE GREAT DESERTS

The typical Mojave ghost town is not extensive. It sprang up not as part of a broad historical trend like the gold rush, but in lonely isolation. When the ore gave out, there was no way for people to make a living, so the camp died fast. Thus it became a purer and smaller ghost than its Northern California counterparts.

Less substantial to begin with, the town was soon ravaged by the elements—and eventually by vandals. Be sure to scour the ground in the vicinity of the townsite for unexpected finds. But beware of open mine shafts, especially if you have children or pets along. Be careful, too, of high-center roads and soft sand.

Our maps (below and on page 53) divide this huge area into northern and southern sectors. At the places marked "site," there's a limited amount remaining to be seen. For current road conditions, refer to the Automobile Club of Southern California's special maps of San Bernardino, Imperial, and San Diego counties, supplemented by local inquiry.

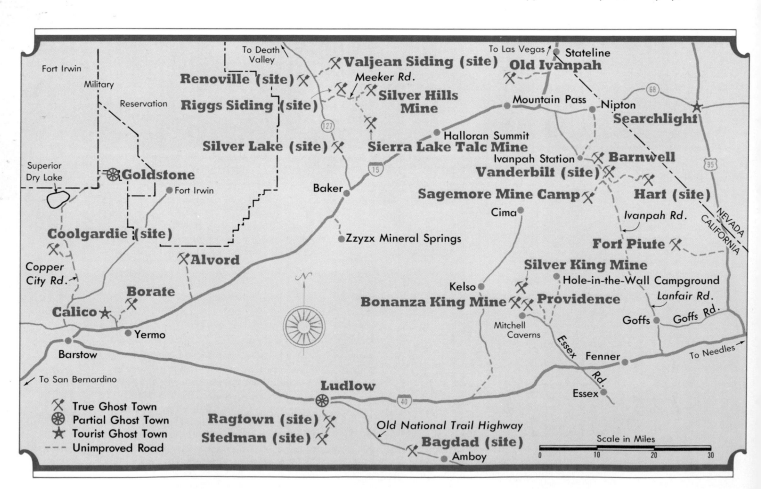

JAGGED STONE SHAPES dominate
Providence (above); several such ruins
comprise the former town. The magnificent
Bonanza King Mill and its mine are
just above. To the north is the Silver King
Mine, and to the south is Mitchell Caverns,
an important tourist stop. Only one strange
structure remains at Old Ivanpah (left).
The camp lies on the eastern flanks of
Clark Mountain and should not be confused
with the railway junction of Ivanpah, some
fifteen miles to the southeast.

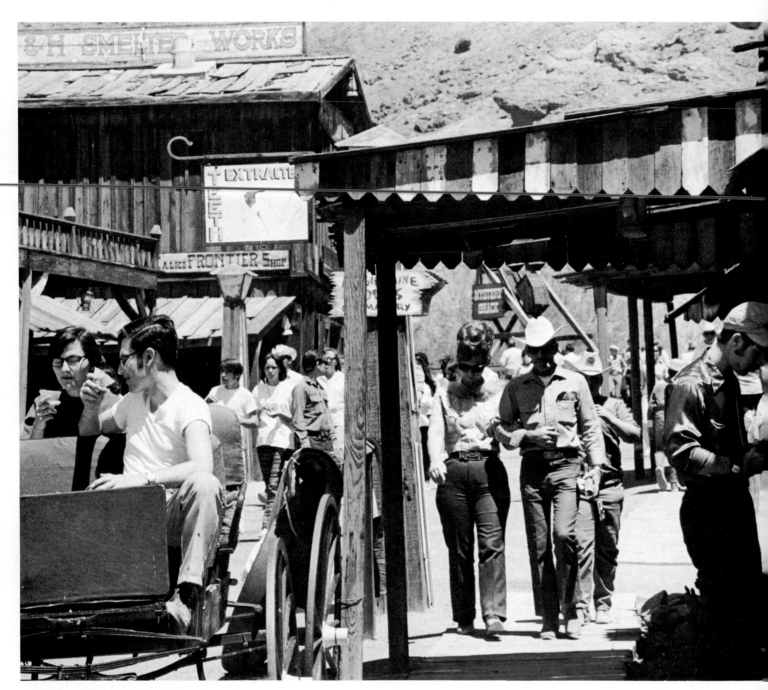

CROWD COMFORTS and make-believe mysteries are the goals of hundreds of Southern California pleasure seekers who pass many miles of open desert country each weekend to reach Walter Knott's tourist mecca of Calico.

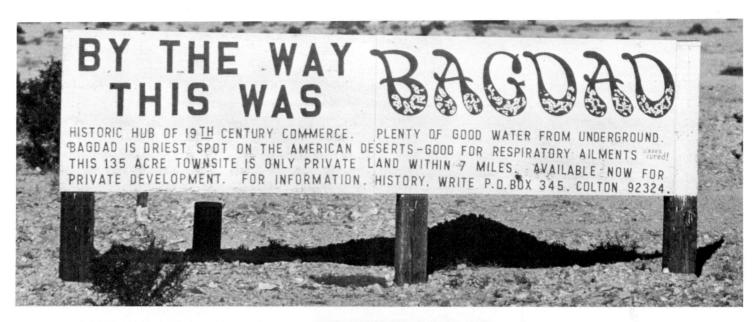

BY THE WAY THIS WAS BAGDAD

HISTORIC HUB OF 19TH CENTURY COMMERCE. PLENTY OF GOOD WATER FROM UNDERGROUND. BAGDAD IS DRIEST SPOT ON THE AMERICAN DESERTS—GOOD FOR RESPIRATORY AILMENTS cases cured! THIS 135 ACRE TOWNSITE IS ONLY PRIVATE LAND WITHIN 7 MILES. AVAILABLE NOW FOR PRIVATE DEVELOPMENT. FOR INFORMATION. HISTORY. WRITE P.O. BOX 345. COLTON 92324.

LONELY PROCLAMATIONS of the demise of desert towns range from the unconscious to the hopeful. Bagdad's story is spelled out to all passers-by on faded Route 66 (above). Vandals have obliterated the directions from non-existent Barnwell to anywhere else (left). But whoever succeeds in negotiating the bewildering network of awful roads leading to Goldstone will be grateful to learn that that Shangri-la is nearly at hand (far left).

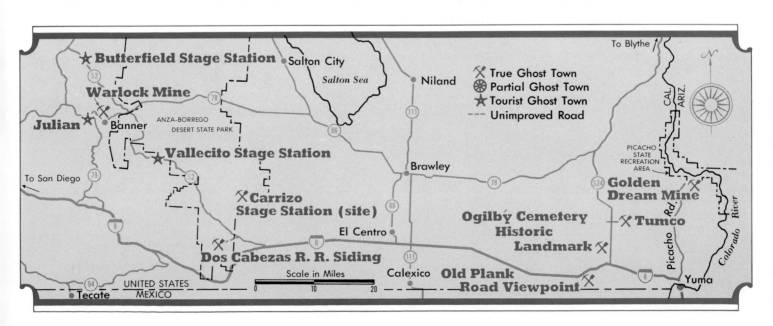

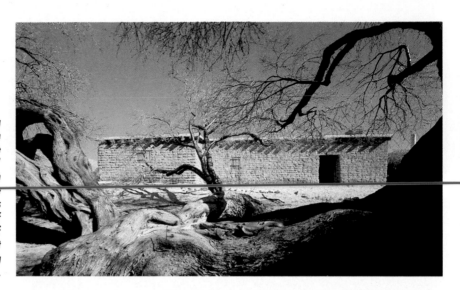

GUSSIED-UP GHOSTS or crumbling ruins? You can take your pick in southern Southern California. Not shown on the map (page 50) is the ''Ghost Town'' at Knott's Berry Farm in Buena Park, north of Long Beach, where gen-you-wine old-timers (far right) perform for swarms of tourists amid buildings a quarter of which are authentic. Out in the middle of nowhere are the restored stage station at Vallecito (right) and the disappearing vestiges of Tumco (below).

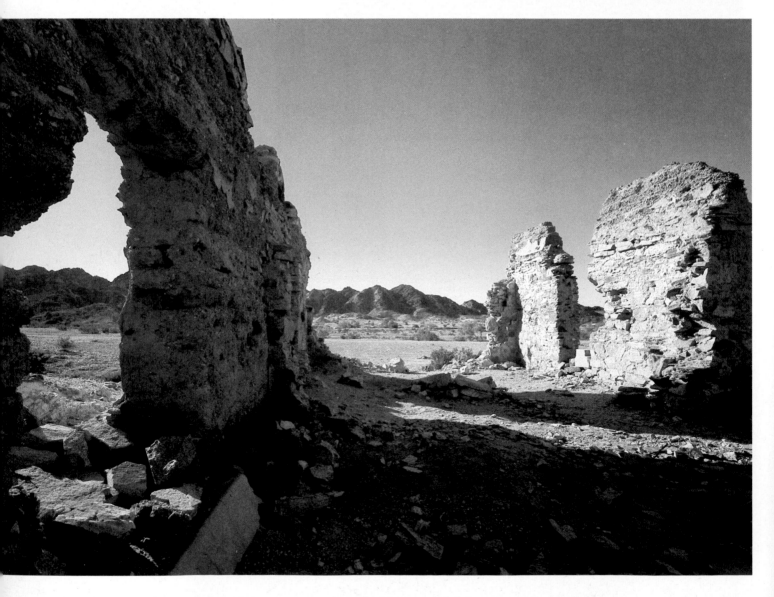

MORE GHOST TOWNS AND MINING CAMPS IN

THE WESTERN MOJAVE

Though the San Gabriel Mountains is the closest of any of the old mining areas to Los Angeles, that of the western Mojave remains the most accessible. The hills are full of old mines.

A wonderful collection of old-time memorabilia in several funky buildings can be seen at **Burton's Tropico Gold Mine and Museum.** There are also tours of the once-rich mine. But phone ahead, as hours are irregular. Nearby **Willow Springs** is a tiny, sleepy village with abandoned stores of Mexican heritage, stone fences, historical plaques, and a lineage from stagecoach and wagon train days.

The venerable, empty buildings of **Garlock** have been fenced to prevent further vandalism, but are worthy of passing note. **Sageland, Goler,** and **Atolia** are minor sites.

Elements of the genuinely offbeat are combined with self-conscious efforts to preserve and enhance the historic look of **Randsburg.** Though **Johannesburg** is more up-to-date, **Red Mountain** is more ghostly, with jagged mining structures and scars all over the surrounding hills.

SOUTHERN OWENS VALLEY

Though many of the remains are scanty, Death Valley and the southern Owens Valley produced a large number of defunct settlements. A useful reference is the Southern California AAA's *Guide to Death Valley.*

Interesting displays and helpful overviews are available at the **Eastern California Museum** at Independence and at the Interagency Visitor Center just south of Lone Pine. **Dolomite** mingles a few historic buildings with movie-company-applied false fronts, some of which blew away in a 1976 storm. Long a favorite of assayers of the offbeat, **Darwin** remains a semi-ghost. **Rhyolite** is featured on page 75. Rounding out the list of places most easily accessible to the average tourist are Death Valley's **Charcoal Kilns,** possibly the best of their kind in the West; the more dilapidated charcoal kilns south of Lone Pine; and the thick concrete walls and slag pile of the **Ashford Mill.**

More venturesome ghost-towners should search out **Schwab,** where the picturesque remains of a mining town that was born and died in 1907 are perched on a four-wheel drive high in the Funeral Mountains. An equally rough road leads to **Panamint City,** whose tall smokestack and squatters' dwellings dominate the scattered remnants of a 19th century boomtown. **Chloride City** comprises only some sagging wooden structures, a cemetery, and a few dwellings. The old silver district of **Cerro Gordo** is interesting in its own right and for the historic aerial tram along the spectacular road connecting this ghost with Keeler.

Out-and-out explorers will need topographical maps and specialized sources to reach fabled **Lookout. Coso** requires permission to visit because it is within the Naval Weapons Center. The **Phinney, Keane Wonder,** and **World Beater** mines are challenging destinations for four-wheel buffs. Those interested in history may enjoy seeing the sites of **Skidoo, Harrisburg, Leadfield, Kearsarge,** and the World War II Japanese internment camp of **Manzanar,** though very little remains of any of them.

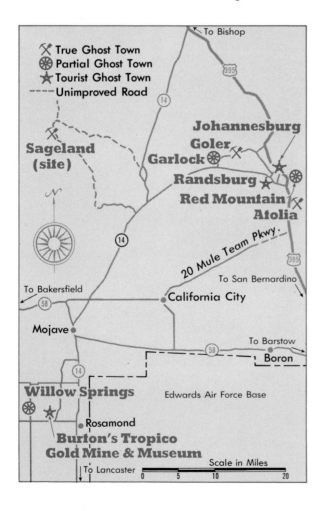

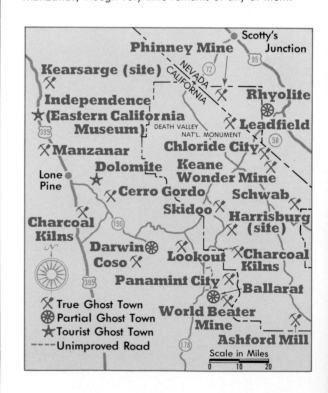

56 CALIFORNIA

California

HISTORIC HIGHWAY 49

From **Vinton** in the north to **Oakhurst** in the south, this route is a veritable museum of that granddaddy of western mining excitements, the California gold rush. While none of the towns are true ghosts, all evoke the spirit of forty-nine.

Good-sized towns with a fine heritage of substantial buildings dating from the mining years include **Downieville**, with its many stone, brick, and frame buildings going back to the 1860's or earlier; busy, spruced-up **Auburn**, whose Old Town is a National Historic Landmark; modernized **Placerville**, where searching will reward you with several historic buildings; **Jackson**, with its Kennedy Mine and pretty churches; **Angels Camp**, best known for its annual Jumping Frog Contest; bustling **Sonora**, dotted with evidence of its early-day role as Queen of the Southern Mines; **Coulterville**, with its Jeffery Hotel, Wells Fargo building, and other landmarks; and **Mariposa**, its incomparably beautiful county courthouse dating from 1854.

Smaller places with quaint, off-beat qualities are **Goodyear's Bar**, where a few frame buildings remain; **North San Juan**, with its cheek-by-jowl assortment of the dilapidated and current; **Fiddletown**, permeated by a delightfully shaggy atmosphere; antique-laden **Amador City**; **Sutter Creek**, which some consider the prettiest of gold rush towns; and shady, aged **Chinese Camp**.

Especially noteworthy for their period hotels, as well as for other reminders of past glories, are **Georgetown**, with several historic buildings amid modern surroundings; **Volcano**, which, never having "gone modern," remains perhaps the most charmingly interesting little gold rush town of all; and **Mokelumne Hill**, with many fine stone buildings and ruins.

Because they are of special importance, **Nevada City, Grass Valley, Coloma, Murphys,** and **Columbia** are treated individually on pages 34–37, 18–19, 20–21, and 44–45.

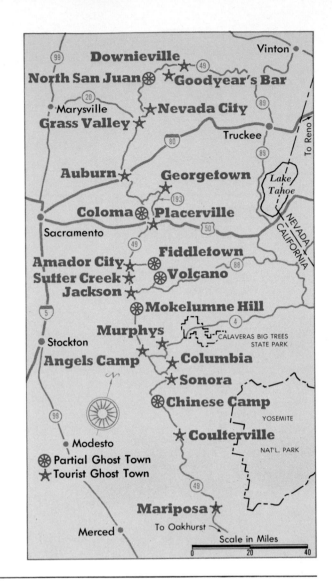

NORTHERN OWENS VALLEY

Walled off by the Sierra from the populous portions of the state, the Highway 395 region beckons the ghost-town buff with a mixture of straight tourist attractions, true ghost towns accessible by passenger car, and off-the-road rarities.

There is a wonderfully atmospheric set of occupied, old-time structures at the living town of **Benton Hot Springs**, which is also known simply as Benton. Probably the finest all-round center of historical interest in the area (except for **Bodie**—see pages 78–83) is the Railroad Museum and Historical Site at **Laws**, with its constantly expanding collection of buildings, trains, and artifacts. The recreation town of **Mammoth Lakes** still possesses some remnants of its mining era, as well.

The detailed map labeled "Toiyabe National Forest—South Sierra Division" is recommended for hardy ghost-towners who wish to visit little-known **Boulder Flat, Belfort,** and **Star City** in their four-wheel-drive rigs. The Toiyabe map is useful in finding the sites of vanished **Dogtown, Lundy,** and **Tioga,** as well as leveled-and-resuscitated **Aurora** and the interesting true ghost of **Masonic.**

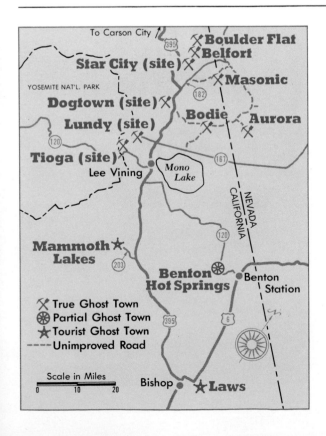

HURRYING TO CASH IN on the new bonanzas, the "boomers" built one instant town after the next across the bleak deserts of Nevada, eastern California, and western Utah. Shown here is the main street of Goldfield, Nevada, in 1904. Soon after, Goldfield entered a steep decline and joined many other mining camps of the Great Basin in heading toward ghost town status.

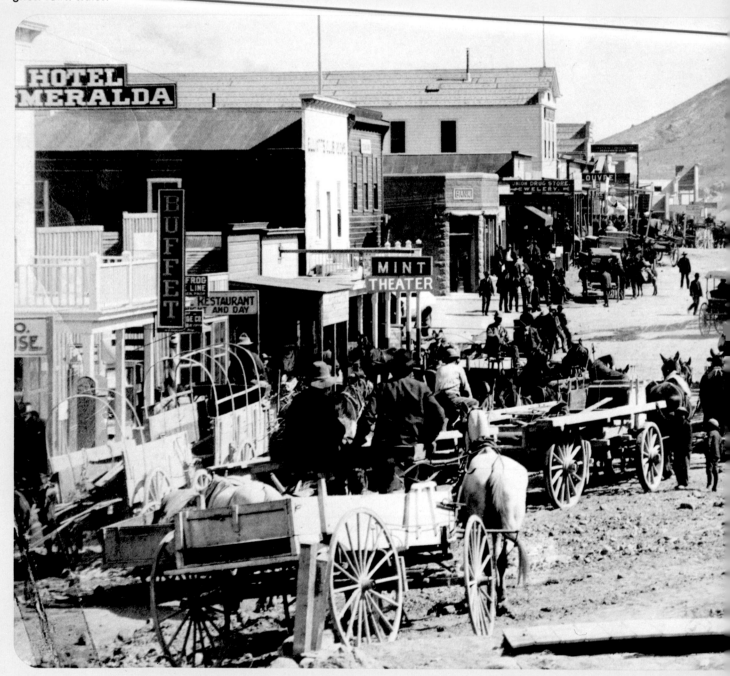

GREAT BASIN
HOORAH FOR WASHOE!
1859...

BY THE LATE FIFTIES, the California miners were restless—almost desperate. The easy pickings were gone. Footloose and disorderly, they constituted a veritable army of get-rich-quick types who wanted, not jobs, but a new bonanza. And suddenly there was one. Electrifying news came from across the Sierra: someone named Comstock had given his name to a fabulous silver strike!

As the prospectors raced for the new territory, famous Virginia City was born, yielding overnight fortunes that shortly outstripped even California's. And the curtain went up on one of the most astonishing scenarios in the history of the West: a whole series of lesser bonanzas and *borrascas* (busts) sweeping across the Great Basin—that vast, sagebrush wilderness rimmed by the Sierra Nevada range, on the west, and Utah's Wasatch Mountains, to the east. Wave after raucous wave of humanity invaded the arid fastnesses, extending the cycle of wealth and disappointment well into the twentieth century. When the fickle hordes gave up at last, the dust of their departure filtered down on some of the ghostliest ghost towns anywhere.

THE GREAT BASIN AND ITS GHOST TOWNS

More than one ghost was conceived in the strange events which preceded the discovery of the Comstock Lode. In a ravine leading down from the future Virginia City's Mt. Davidson, some California-bound miners had noticed traces of gold as early as 1849. The original finders did not tarry; but here, not long after, others founded the boomville of Silver City, Nevada. To the southwest, Mormon farmers had already established the Territory's first community of Genoa. When some of them abandoned an irrigation project to try gold mining, the little towns of Dayton and Johntown came into being.

But it remained for two Irishmen—Peter O'Riley and Patrick McLaughlin—to discover some black dirt and "blasted blue stuff" that proved the outcropping of a silver vein. In the twenty years following the first news of this bonanza, Virginia City and Gold Hill poured forth silver as well as gold to the tune of some three hundred million dollars.

The impact was felt far beyond "Washoe," as the territory was called. Much of the wealth found its way to San Francisco, where an important financial and banking system grew up around the frenzied trading of Comstock shares; Virginia silver virtually underwrote the diversified growth of this fancy new city by the Golden Gate. The Comstock's factory-like atmosphere marked the first true industrial expansion in the West; as technological precedent and prototype, its influence was pervasive. And Washoe's sudden growth caused ripples in Washington, where Lincoln's government, drained by the Civil War and anxious for support in passing the Emancipation Proclamation, hurried the territory into statehood in 1864, rechristening it "Nevada."

In seeking out these depopulated mining camps, it is helpful to bear in mind the overall topography of the Great Basin, which is an immense, arid sink, ribbed by north-south mountain chains. Generally, the old camps are found near the lower slopes of the mountains. Since eastern California, Nevada, and western Utah are still very thinly populated, it's well, before you go, to remember the comment of an exasperated prospector named Mark Twain: "No flowers grow here, and no green thing gladdens the eye. The birds that fly over the land carry their provisions with them."

✗ True Ghost Town: Population at or near zero; contents may range from many vacant buildings to rubble and a few roofless walls. Places where only traces remain are marked "site."

✸ Partial Ghost Town: Disused structures and mining remnants mingle with modern elements.

★ Tourist Ghost Town: Living town has significant elements from mining rush or other historic era; old structures may be spruced up or rebuilt to promote tourist atmosphere.

(40) Interstate Highways

(80) U.S. Highways

(95) State Highways & Secondary Roads

NOTE: Map is as accurate as present information permits. Refer to detailed maps for minor roads, and always inquire locally about road conditions.

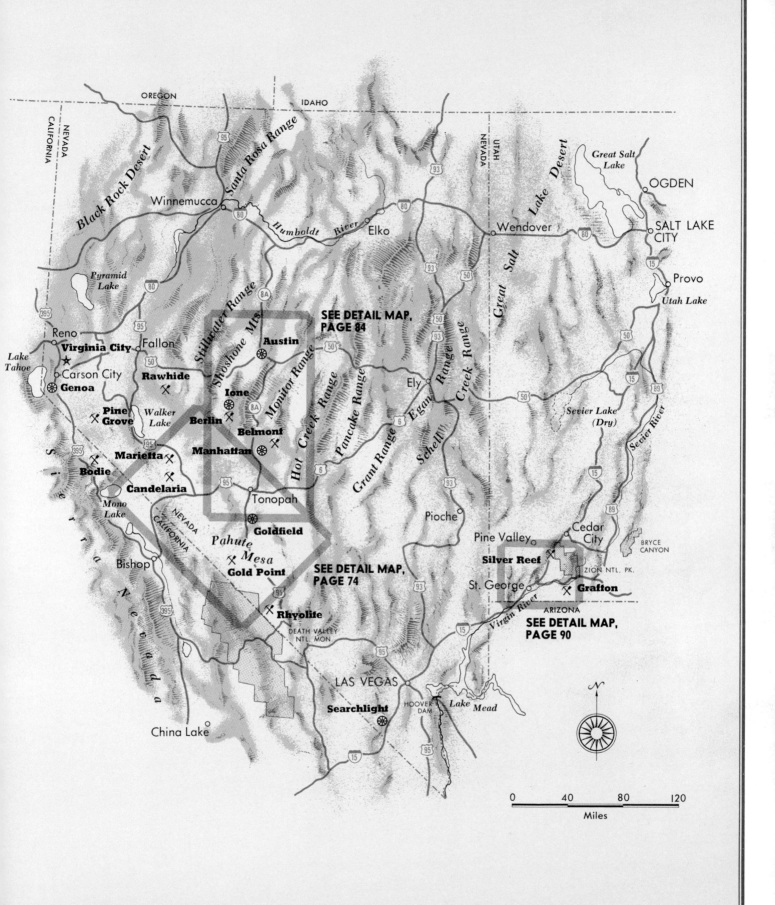

OREGON IDAHO

NEVADA
CALIFORNIA

UTAH
NEVADA

Black Rock Desert

Santa Rosa Range

Winnemucca

Great Salt Lake

OGDEN

SALT LAKE CITY

Elko

Wendover

Humboldt River

Great Salt Lake Desert

Pyramid Lake

Provo

Utah Lake

Reno

Virginia City

Fallon

Austin

SEE DETAIL MAP, PAGE 84

Ely

Lake Tahoe

Carson City

Genoa

Rawhide

Ione

Sevier Lake (Dry)

Stillwater Range

Shoshone Mts.

Monitor Range

Hot Creek Range

Pancake Range

Egan Range

Schell Creek Range

Pine Grove

Berlin

Belmont

Walker Lake

Marietta

Manhattan

Bodie

Candelaria

Tonopah

Grant Range

Pioche

Sevier River

Cedar City

BRYCE CANYON

Mono Lake

Goldfield

Pine Valley

Silver Reef

ZION NTL. PK.

Bishop

Pahute Mesa

Gold Point

SEE DETAIL MAP, PAGE 74

St. George

Grafton

NEVADA
CALIFORNIA

Rhyolite

DEATH VALLEY NTL. MON.

Virgin River

ARIZONA

SEE DETAIL MAP, PAGE 90

Sierra Nevada

LAS VEGAS

Searchlight

HOOVER DAM

Lake Mead

China Lake

N

| 0 | 40 | 80 | 120 |

Miles

VIRGINIA CITY, NEVADA
"ALL IS LIFE, EXCITEMENT, AVARICE, LUST, DEVILTRY..."

a GHOST TOWN worth seeing

From Reno, go nine miles south on U.S. 395 to State 17, which rises steeply into the barren mountains to the southeast, reaching Virginia City in fourteen miles.

Perhaps the key to Virginia City's attraction today is that, though bustling tourism has replaced mining as the principal enterprise, the town's essential spirit is not all that different from what it was over a hundred years ago, when J. Ross Browne wrote, "Perhaps there is not another spot upon the face of the globe that presents a scene so weird and desolate in its natural aspect, yet so replete with busy life, so animate with human interest . . . saloons are glittering with their gaudy bars and fancy glasses and many-colored liquors, and thirsty men are swilling the burning poison; bill stickers are sticking up bills of auctions, theatres and new saloons . . . A strange city truly, abounding in strange exhibitions and startling combinations of the human passions." Yesteryear's highwaymen have given way to today's one-armed bandits, the great old mansions have turned into museums, and you're invited to tour some of those same mines where "a wondrous battle raged, in which the combatants were man and earth."

Open-season in Virginia City is from spring to fall. The biggest crowds, of course, come on weekends. But since few visitors stay overnight, you can beat even the summer throng by arriving in the early morning. Then, in the crisp, bright silence, significant details can more easily catch one's eye, and the stolid buildings seem more willing to admit their age. Caught with its tinseled guard down, Virginia seems almost real.

MAVERICK atmosphere along Virginia City's main drag is a replay of the days when sweating miners rubbed elbows with silver barons, card sharks, and parlor ladies.

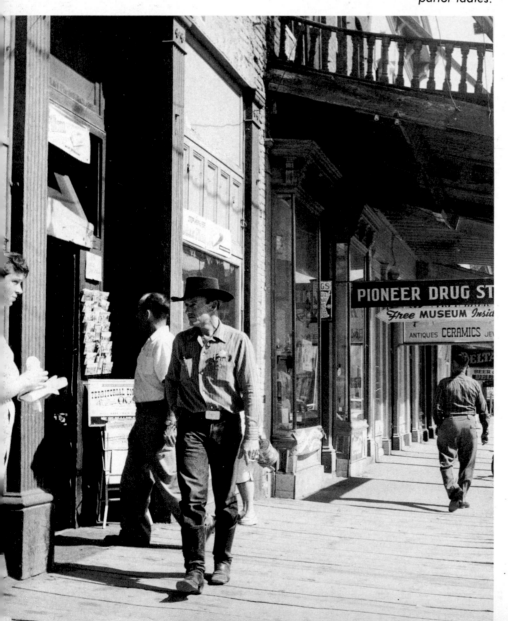

CENTURY-OLD SURVIVORS of Virginia's youth invite perusal before the midday crowds arrive. Evolution of an industrial mining system new to the West is symbolized by the stoutly assertive Miner's Union Hall.

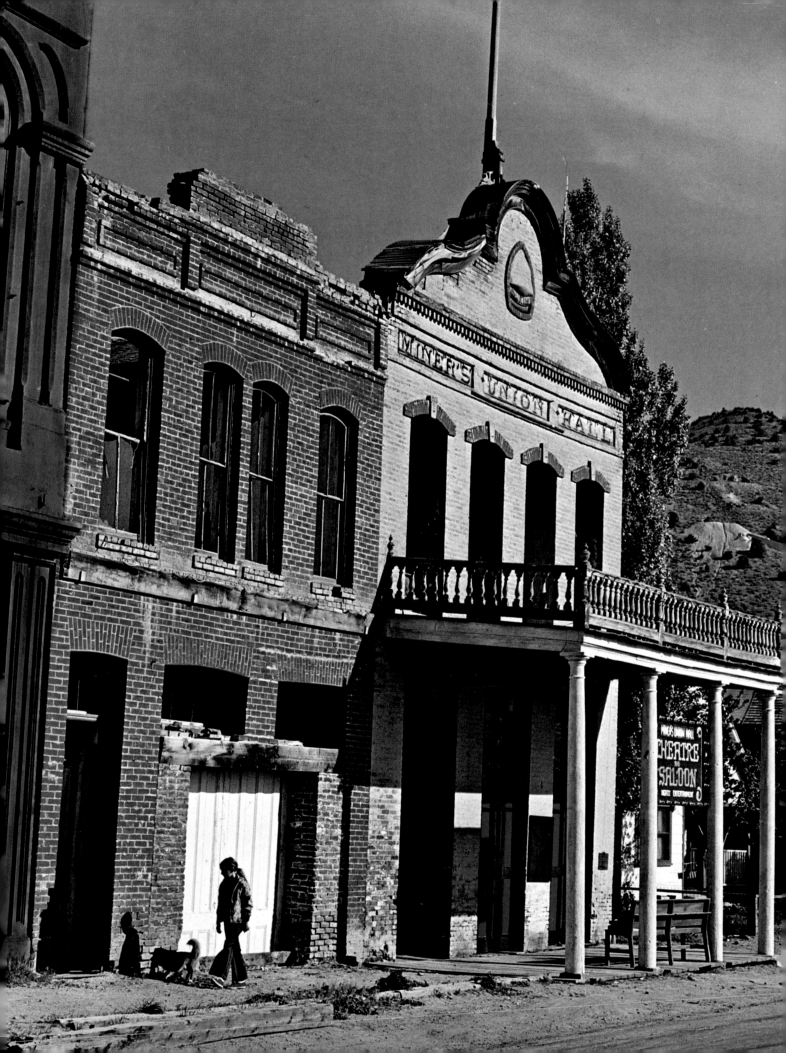

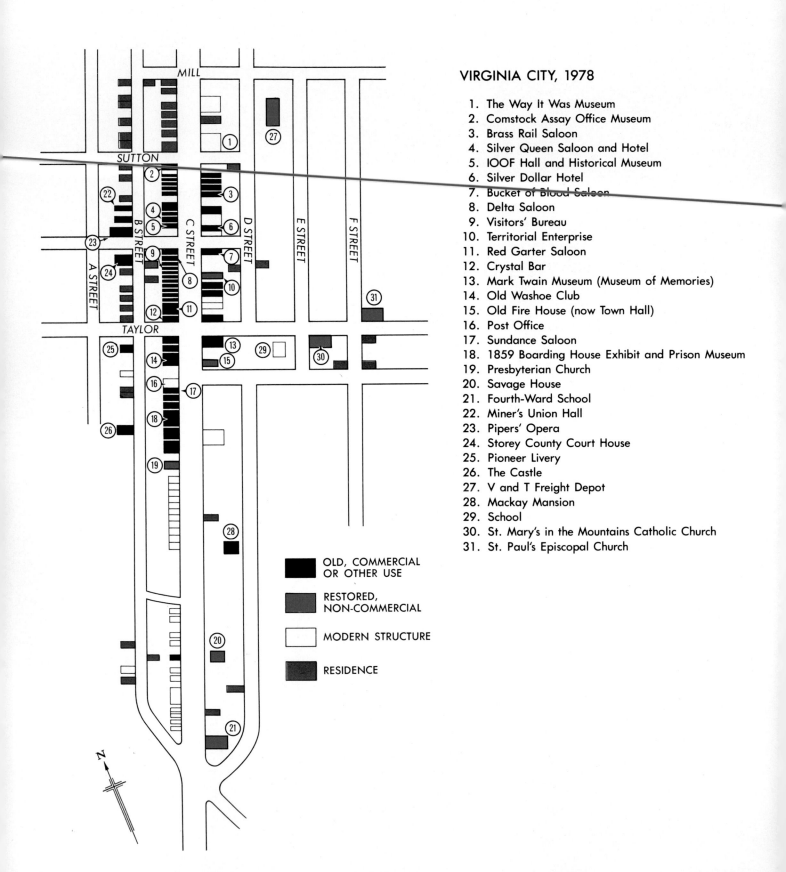

VIRGINIA CITY, 1978

1. The Way It Was Museum
2. Comstock Assay Office Museum
3. Brass Rail Saloon
4. Silver Queen Saloon and Hotel
5. IOOF Hall and Historical Museum
6. Silver Dollar Hotel
7. Bucket of Blood Saloon
8. Delta Saloon
9. Visitors' Bureau
10. Territorial Enterprise
11. Red Garter Saloon
12. Crystal Bar
13. Mark Twain Museum (Museum of Memories)
14. Old Washoe Club
15. Old Fire House (now Town Hall)
16. Post Office
17. Sundance Saloon
18. 1859 Boarding House Exhibit and Prison Museum
19. Presbyterian Church
20. Savage House
21. Fourth-Ward School
22. Miner's Union Hall
23. Pipers' Opera
24. Storey County Court House
25. Pioneer Livery
26. The Castle
27. V and T Freight Depot
28. Mackay Mansion
29. School
30. St. Mary's in the Mountains Catholic Church
31. St. Paul's Episcopal Church

■ OLD, COMMERCIAL
 OR OTHER USE

■ RESTORED,
 NON-COMMERCIAL

□ MODERN STRUCTURE

■ RESIDENCE

MOST AUTHENTICALLY furnished of the town's several mansions, "The Castle" remains as it was in boom times. Its three successive owners have carefully kept such features as 150-year-old Czechoslovakian crystal chandeliers, hand-blocked wallpaper from France, and Comstock silver doorknobs.

SQUARE-SET TIMBERING: THE CRUCIAL LINK

MAJOR ADVANCE in mining technology made on the Comstock was a basically simple method called "square-set timbering." Mortise-and-tenon joints (above) locked timber ends together, and timbers formed an endless series of hollow cribs four by six feet square, as in mine at right. Such a honeycomb could reinforce larger underground cavities than could single timbers, and the structure could be made stronger yet by filling vertical columns with waste rock.

EXTERIOR OF THE HOISTING WORKS

WORKING THE LEDGE

BIGGEST PRODUCER of all on Nevada's Comstock was the famous
Belcher Mine, which churned out over $26 million worth of silver and
gold between 1863 and 1916. Belcher stock bolstered the Comstock
financial craze by zooming from $1.50 a share in 1870 to $1,525 a
share nineteen months later. Square set timbering enabled the mine to
reach great depths, where the rock was so hot that despite "the only
air-shaft on the Comstock lode worthy of the name," the men were able
to work only in very brief shifts before returning to higher levels
to cool off.

Grandiose Residue: COMSTOCK SCHEMES

In an era when the fantastic became commonplace, nobody seemed surprised by sundry immodest proposals put forward by men of purportedly logical mind for taming the rich but recalcitrant earth. Workable or not, some of the more colossal results are still with us.

TO SOLVE simultaneously the problems of flooding, intense heat, and ore transport encountered by the deep Comstock mines, Adolph Sutro (left) in 1865 proposed digging a horizontal ventilating tunnel from the Carson Valley, four miles away. At great expense, and after many complications, the tunnel (below) was completed in 1879. But by then the ore had almost given out, and the scheme never paid for itself—though it paid Sutro, who sold his stock early. Near the tunnel mouth is the little ghost town of Sutro.

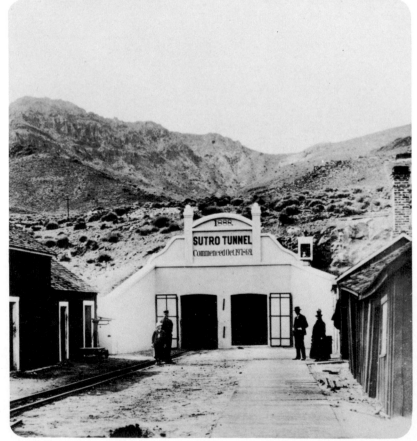

MAMMOTH remains of a richly financed but ill-fated plan to reprocess Comstock tailings are sprawled across American Flat, which can be reached via a short dirt road heading west from Gold Hill, just south of Virginia City, Nevada.

MARIETTA, NEVADA
A NAUGHTY LADY WITH THREE LIVES

a GHOST TOWN worth seeing

From Tonopah go west/northwest on U.S. 95 sixty-one miles to Tonopah Junction. Turn southwest on State 10 for nearly five miles. At a sign marked "Marietta" turn right (west) on a graded road. In about ten miles the route drops from a mountain pass into a wide desert saucer and reaches the townsite.

Wild burros meander past a couple of funny wooden edifices and widely strewn rock walls and foundations. There's a collapsing stage station with a stone-fenced corral out back. On a private spread, some folks who love these silent spaces pursue various creaky enterprises: hunting up old milling equipment, maintaining tottering trestles and outbuildings, guarding an astonishing collection of ancient autos dragged in from the desert.

It's a far cry from the three-lived Marietta of old. The town got its start on silver-lead in the early 1860's. It shifted into second on pure salt from nearby Teels Marsh, loading the stuff onto camels and mules for a hard trek to hungry ore mills near Virginia City and Aurora. Finally, in 1872, "Borax" Smith found valuable borate in the marsh. After bringing in hundreds of Chinese laborers, he expanded into California.

Lawlessness boomed with the town: the stage was robbed thirty times in 1877. But in the 90's the borax gave out. By the 1920's, Marietta was a ghost. Today, beside the marsh, her shifting sands still reveal old square nails, sun-colored bottle shards, and even an occasional Chinese opium can.

TUMBLEDOWN STAGE STATION is among the few remaining commercial structures. Sagebrush, sand, and wildflowers are slowly reclaiming the ruptured ground.

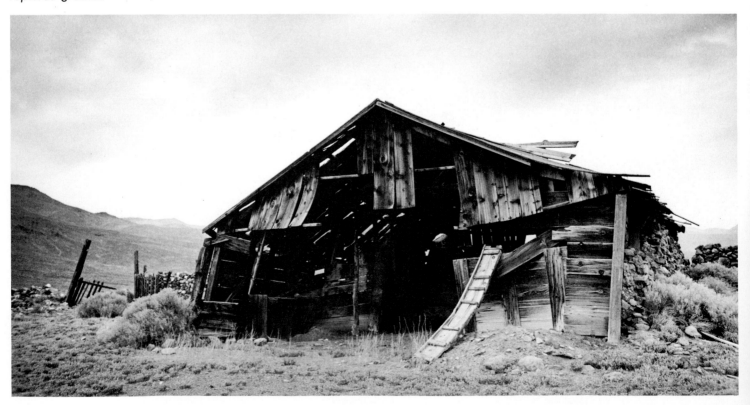

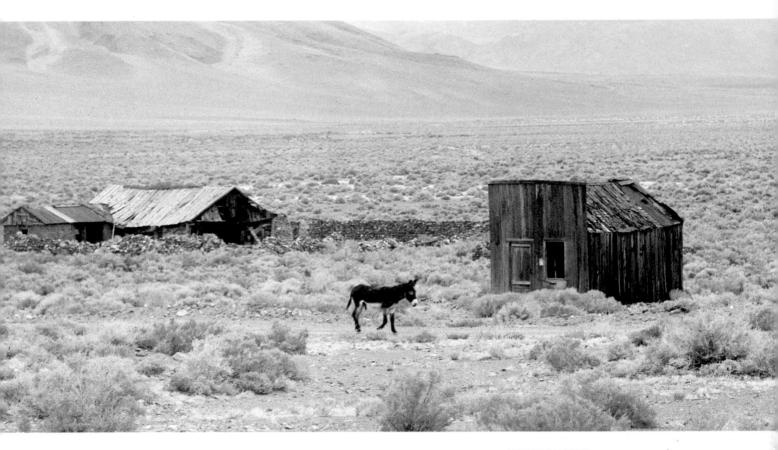

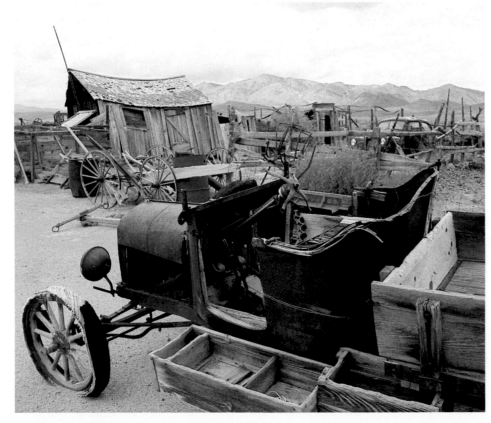

WRY TOUCHES at once-naughty Marietta include an occasional wild burro and his friends wandering down the former main drag, and a private hoard of old cars, trucks, and other oddments dragged in from the deserts over the years. In this onetime boom camp all is now silent—except, of course, for the burros.

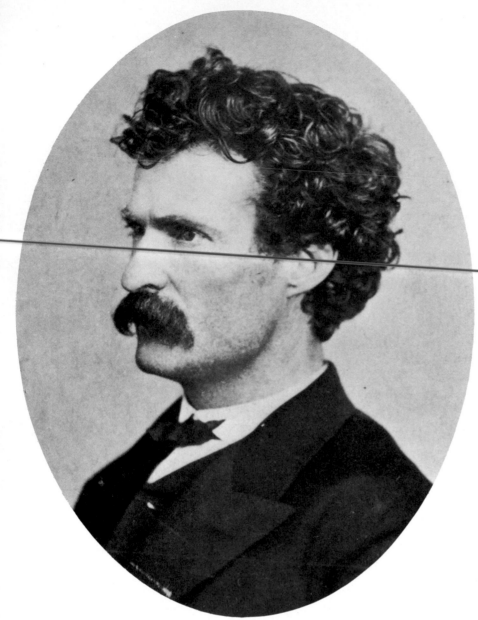

SAMUEL CLEMENS came West with his brother in 1861 and later wrote
Roughing It, a marvelously funny book about his journey and his
impressions of Virginia City. As an unlucky prospector in the Esmeralda
District of Nevada, he sent Virginia City's Territorial Enterprise humorous
sketches which he signed "Josh." Hired by the paper for $25 a week,
he stayed with it for two years, signing his columns "Mark Twain"
(see column at right) and perfecting the style that would soon
earn him worldwide acclaim.

Much of the verve and color of the exploding West was captured by its newspapers, which not only described events but became, in themselves, part of the wonderfully wild scene.

In the Great Basin, as elsewhere, upstart papers shared many problems. The hand-operated presses were primitive at best. Oftener than not, the editor was also the printer and business manager—a combination of talents not always happily wedded in one personality. Again and again the early sheets cried out for financial help, in cash or in kind. "We can't publish without paper; please send us your rags!" wailed Utah's *Deseret News*, which went on to request wheat, corn, butter, calves, pigs, and the furs of beaver, otter, mink, wolf, or fox. One editor simply gave up and committed suicide; another stole a grave marker and made a printer's stone out of it. Every paper had a vital stake in the longevity and prosperity of its community, and plumped it hard while ridiculing rival papers and towns.

The miners, in their isolated settlements, were hungry for news from "back East"— and vitally interested in fast-breaking developments in gold and silver prospecting. Highly prone to rumor themselves, they were fussy neither about factual accuracy nor about grammar or spelling: what they wanted was excitement.

Thriving on controversy, the editor delivered himself of freewheeling personal opinions. He had no libel laws to worry about, but he often suffered some concern for his personal safety at the hands of citizens who objected to his opinions. One offending editor was tarred and feathered; others were pummelled, bullwhipped, knifed, and challenged to duels. More usual were shouting matches along the boardwalk or in the saloon—two of a reporter's main working arenas. Thus, a leather-lunged editor could become as much participant as observer in the madcap events he covered.

The raw individualism of the frontier was mirrored in the very titles of its newspapers. Nevada's two earliest were the *Gold Canyon Switch* and the *Genoa Scorpion*. Later appeared Virginia City's *Daily Trespass*, Battle Mountain's *Measure for Measure,* and the *Waubuska Mangler,* though this one later turned out to be a hoax. The town of Potosi, Nevada, had two rival sheets: *East of the Nevada; or the Miner's Voice from the Colorado,* and the eccentric *Potosi Nix Cum Rouscht.* Eastern California's best-known mining camp paper was the *Death Valley Chuck Walla.* From Utah came such journals as the *Censor,* the *Rustler,* the *Women's Exponent,* and *Kirk Anderson's Valley Tan.*

But it was Virginia City's *Territorial Enterprise* that stood head and shoulders above the rest. Here gathered a whole array of unusual talent—including a down-at-the-heels prospector who signed his columns "Mark Twain."

Small or large, defunct or successful, these early journals handed down to us the facts, feelings, and spirit of a unique era.

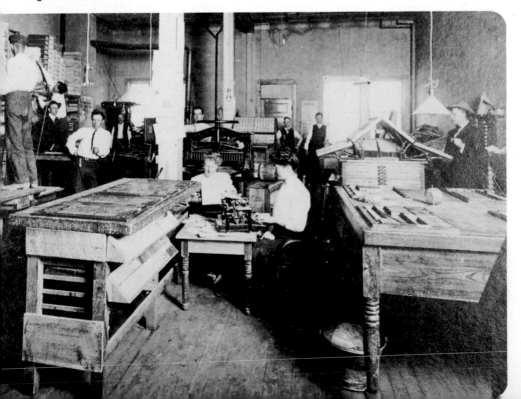

METEORIC rise and fall of mining camps was set down in many of their one-room newspaper offices. This one was located in eastern Nevada's White Pine County, now the locale of a number of ghost towns.

Loneliest Haunts:
GHOSTS OF THE CALIFORNIA-NEVADA BORDER

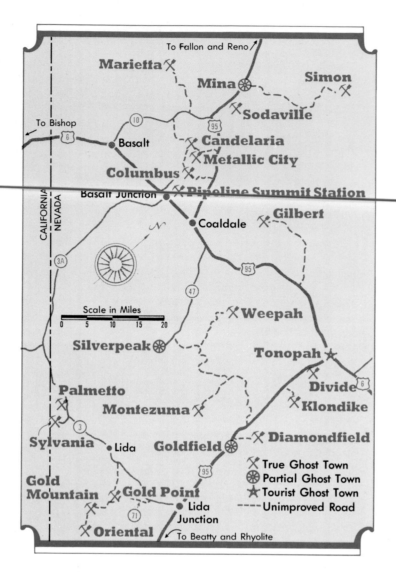

Map labels:
To Fallon and Reno
Marietta
Mina
Simon
Sodaville
To Bishop
Basalt
Candelaria
Metallic City
Columbus
Basalt Junction
Pipeline Summit Station
Coaldale
Gilbert
Weepah
Silverpeak
Tonopah
Palmetto
Divide
Montezuma
Klondike
Sylvania
Lida
Goldfield
Diamondfield
Gold Mountain
Gold Point
Lida Junction
Oriental
To Beatty and Rhyolite

CALIFORNIA / NEVADA

Scale in Miles
0 5 10 15 20

Legend:
✗ True Ghost Town
⊕ Partial Ghost Town
★ Tourist Ghost Town
---- Unimproved Road

The dense concentration of ghost towns shown on the map at left is typical of Nevada. Based on wild prospects that were often real but oftener unreal, the Great Basin mining rushes spawned a fantastic number of settlements that withered as quickly as they bloomed.

A generation after the Virginia City bonanzas, the Goldfield area played host to a series of exceedingly valuable ore discoveries—and to some of the most outrageous stock promotion schemes in American history. Thousands flocked to this barren, volcanic landscape in the early years of the twentieth century. But the rich claims were all made so early that one exasperated latecomer scrawled on a survey board: "I lay claim from this point one thousand feet up in the air. Now beat that you damn land sharks." By 1920 Goldfield's mines were denuded, most of the population gone. Ever since then, the sizable town has continued to wither, its few remaining residents huddled among reminders of past glories.

With the exception of Tonopah, the riches-to-rags story was repeated in the many other, smaller communities that sprang into existence amid these lonely desert expanses. In many instances only traces survive, and today's traveler needs a fertile imagination, along with a four-wheel drive and current county road maps, to reexperience the old boom days. But the defunct places pictured on these and the following pages are still worth seeing.

SUN-BRONZED remains of lonely Klondike gaze out from the brow of a mine-scarred hill ten miles south of Tonopah. The camp had its heyday around the turn of the century, shipped small amounts of gold and silver ore for years thereafter, and in the end was completely abandoned. Klondike is typical of the kind of minor true ghost town for which Nevada is well known.

CLASSIC RUIN, the hollow face of one of Rhyolite's four great bank buildings stares out at the Amargosa desert. Born in 1905, the town blossomed to a population of 6,000 two years later. Yet it dropped to 700 by 1910 and was soon a complete ghost. Among the scattered stone and masonry hulks, only Rhyolite's fancy depot and a famous house made of bottles are still occupied.

AGLOW in the desert dawn, this little grouping of false-front stores stands some distance from the smattering of quaint structures, occupied trailers, and deserted mining artifacts that comprises Gold Point.

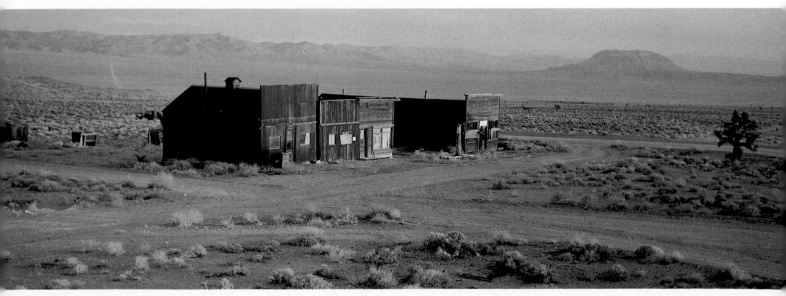

PILLARED PORCH stands among many
victims of a half century of neglect
in Goldfield's residential section (left).
Though only partially a ghost town, Mina
presents travelers on Highway 95 with
blocks of eerily decayed storefronts
and this former hotel building (above).

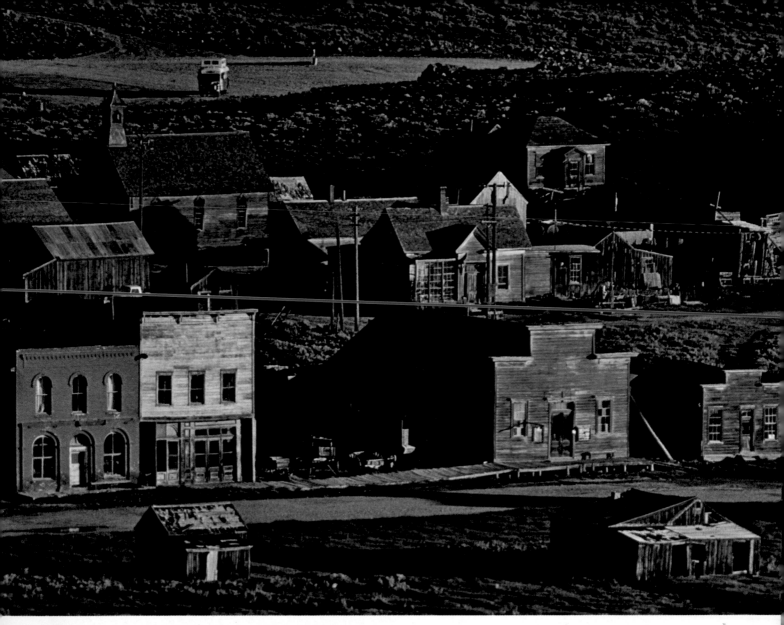

DAWN SHEDS a warm glow on Bodie's weathered storefronts, as it
has for more than a hundred summers. But in winter the snow often piles
as high as twenty feet, leaving only the tops of the buildings exposed
and bearing out the complaint of the early prospectors that Bodie had
"the worst climate out of doors." Since there are no tourist facilities,
visitors must rise very early to reach Bodie at dawn.

BODIE, CALIFORNIA
"GOODBYE, GOD, I'M GOING TO BODIE."

Here is possibly the best all-round ghost town in the West. Far enough off the main road to discourage cursory vandals, it is protected as a State Park, though it doesn't have the orderly feel of one. Its dozens of deep-grained, russet-and-gold wooden buildings are discreetly maintained in a condition of "arrested decay" while the weeds grow freely around the many scattered artifacts.

Things were not so delicate in the old days. Bodie's sixty-five saloons were notorious. One preacher summed up the town as a "sea of sin, lashed by the tempests of lust and passion." In the poor cribs and elegant bagnios of Maiden Lane and Virgin Alley, such girls as Beautiful Doll, Madame Moustache, and Rosa May were sometimes rewarded with golden nuggets as tips. Violence was commonplace. "There is some irresistible power," commented the *Bodie Standard*, "that impels us to cut and shoot each other to pieces." Whether the notorious "bad man from Bodie" was actually a single person or a composite of Washoe Pete, Tom Adams, and Rough-and-Tumble Jack is still debated; the character became, in any case, a legend throughout the West. And the little girl whose family was moving from Aurora to Bodie, and who concluded her evening prayers with "Goodbye, God,

a GHOST TOWN worth seeing

From Carson City, Nevada, head south for eighty-two miles on U.S. 395 to Bridgeport, California; continue seven miles farther, turn east on unpaved road which winds through barren hills for thirteen miles to reach Bodie.

I'm going to Bodie," was so widely quoted that one civic-minded newspaperman tried to claim she had really said, "Good, by God, I'm going to Bodie!"

Despite such legends, which have been embroidered by time, Bodie was populated mainly by hard-working miners who, after a long day in the tunnels, usually went home to bed, saving their partying for Saturday night. When they died, it was more often from disease or accident than from gunfire.

Don't try to visit Bodie in the winter: the temperature drops to twenty or thirty below, with ten to twenty feet of snow. The venerable town is delightful, however, in spring and summer—as long as you remember to bring your lunch and don't mind the thirteen miles of washboard road going in.

CLOSE LOOKING brings glimpses of early-day life in Bodie. Above left: Utilizing whatever materials were available, builders formed metal sidings from patterned Victorian sheet iron, flattened tin cans, and other oddments. Far left: A bedstead in one of the frame houses on Bodie Bluff. Above right: Stout rigging of one of Bodie's all-important freight wagons.

GHOSTLY SPIRITS float undisturbed in the still air of Bodie's little Methodist Church, now that the classic structure has been closed to visitors. Vandals stole many of the interior ornaments, including an oilcloth imprinted with the Ten Commandments, one of which, of course, is "Thou Shalt Not Steal."

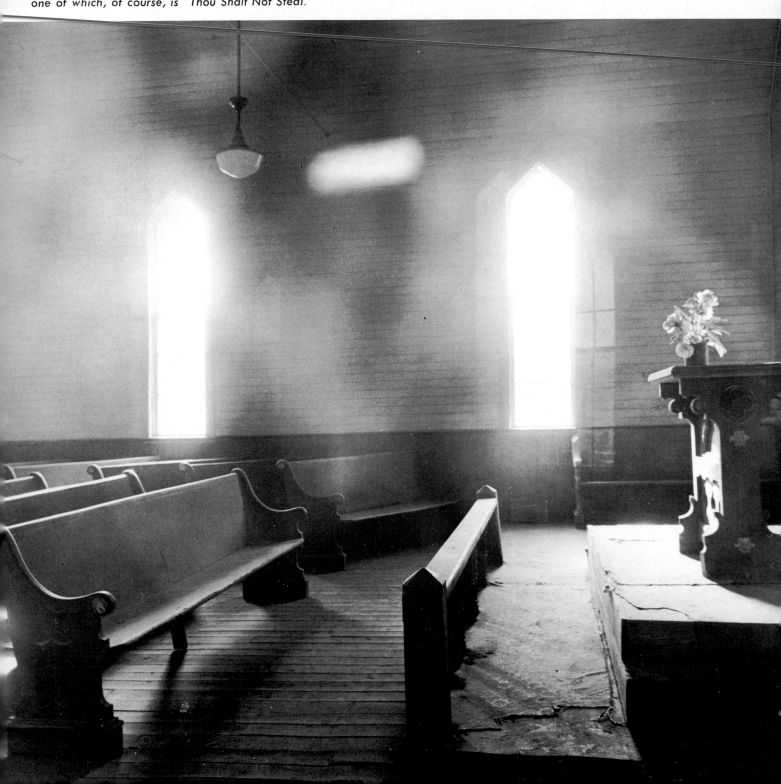

"BAD, BAD BODIE" provided this
little jail with plenty of customers.
Murders allegedly occurred about
once a day—at least until June of
1881, when the Bodie Daily Free
Press reported that "Bodie is becoming
a quiet summer resort—no one
killed here last week."

ITS EDGES CURLED by time, this old board-
walk rises and falls along Main Street in front
of the Miners' Union Hall, the Odd Fellows
Hall, and the brick post office.

VENERABLE FACADE once welcomed Bodie's
roistering Odd Fellows to their lodge. Built in
1878, the two-story hall also served as
a meeting place for members of the Bodie
Athletic Club.

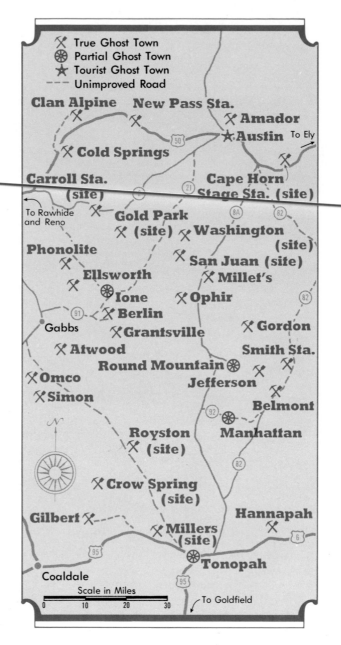

Map legend:
- ✗ True Ghost Town
- ⊛ Partial Ghost Town
- ★ Tourist Ghost Town
- --- Unimproved Road

Clan Alpine · New Pass Sta. · ✗ Amador · ★ Austin · To Ely · ✗ Cold Springs · 50 · Carroll Sta. (site) · Cape Horn · 21 · Stage Sta. (site) · To Rawhide and Reno · ✗ Gold Park (site) · 8A · 82 · ✗ Washington (site) · Phonolite · ✗ San Juan (site) · ✗ Millet's · Ellsworth · ⊛ Ione · ✗ Ophir · 82 · 91 · ✗ Berlin · Gabbs · ✗ Grantsville · ✗ Gordon · ✗ Atwood · Smith Sta. · ✗ Omco · Round Mountain ⊛ · ✗ Simon · Jefferson · 92 · Belmont · Royston (site) · Manhattan · 82 · ✗ Crow Spring (site) · Hannapah · Gilbert ✗ · ✗ Millers (site) · 95 · ⊛ Tonopah · Coaldale · Scale in Miles · 0 10 20 30 · 95 · To Goldfield

Ribbed by treeless mountain chains and bleak valleys, central Nevada became the destination for restless prospectors seeking another Comstock Lode. Though they never found one, they did spark a series of lesser booms, leaving some tragicomic treasures for today's assayers of the unusual.

Many of the ghost towns shown on the map at left will be found to contain only a few walls or rubble. Some of the best of them are, however, pictured on these and the following pages. Helpful sources include the Toiyabe National Forest maps and the *Nevada Map Atlas*, published by the Nevada State Highway Department at Carson City. Take along plenty of water and film, and fill up with gasoline wherever you can in this region, where signs of civilization can be few and far between.

It was in the 1860's that Austin became the nerve center for the mining excitements of central Nevada, and though its population is now down to around 300, it remains the county seat. Among historic buildings are the Austin City Railway engine house, the Gridley store, the courthouse, several churches, and a row of quaint, empty store-fronts. Busy Tonopah has a more modern atmosphere, but the hills above town are ringed with headframes and other residue of the early mining period. On the main street the U.S. Forest Service maintains an office where you can get the Toiyabe maps and other useful information. Among the better ghosts not pictured on these pages are Hannapah, which is easily accessible, and Gilbert, which is harder to find.

FIVE WAGONS OF THE FRONTIER

CONESTOGA WAGONS, pulled by a team of six horses, carried enormous freight cargos. By the 1860's, the Conestoga had evolved into the covered wagon, which had to be both strong and light because the westering pioneers often lowered them down ravines on ropes. Top buggies, the sportscars of the frontier, were invaluable if you were a-courtin'. Concord coaches became the stage coaches which carried up to 800 pounds of cargo, plus passengers and precious bullion. Buckboards had a variety of uses; some individual pioneers who wished to travel light and fast came West in them.

CONESTOGA

COVERED WAGON

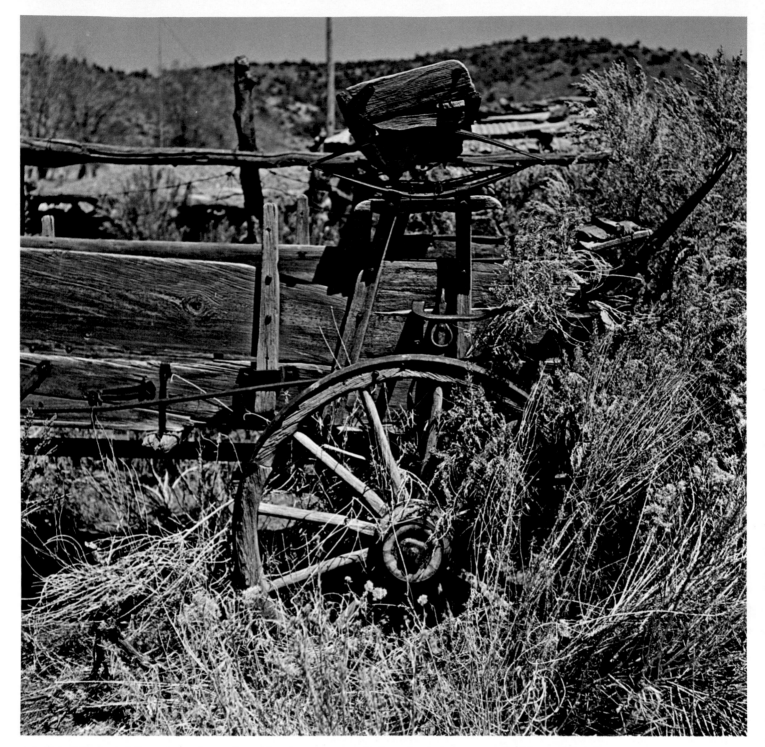

SENIOR CITIZEN of Ione, Nevada, is this old utility wagon, which is slowly being engulfed by sagebrush.

TOP BUGGY

CONCORD COACH

BUCKBOARD

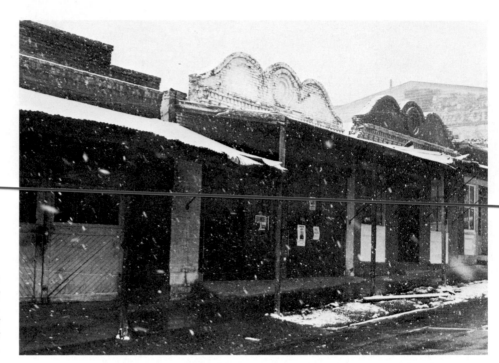

SNOWFLAKES have floated down on Austin for over a century without disturbing its interesting deserted buildings (right). Huge ore mill at Berlin (below) dominates what's left of the little town and overlooks the broad Ione Valley and Paradise Range.

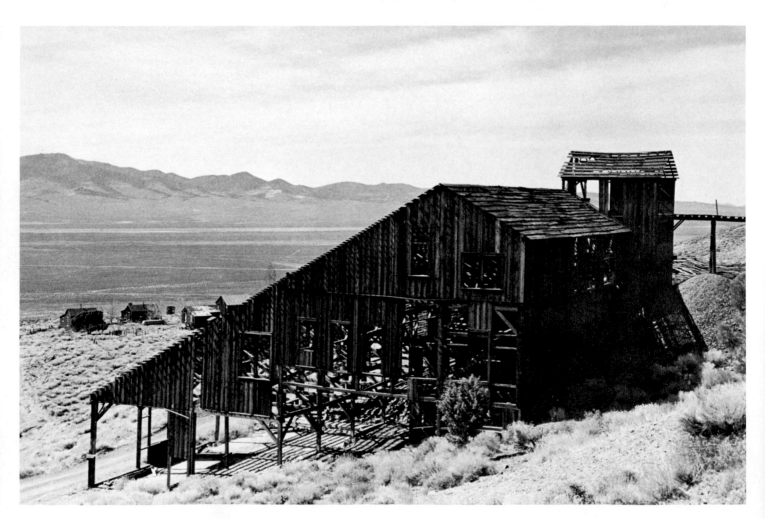

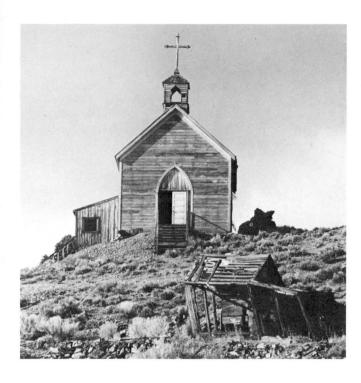

PERKY but empty little Catholic church presides over Manhattan. Oddly enough, it was moved here from another ghost town—Belmont (see following pages).

FOUNDER of Rawhide's Wonder Lumber Co. may have wandered over from Wonder, another defunct place— or simply wondered at the 8,000 souls who suddenly descended on this godforsaken spot in 1908, only to depart within a year. Rawhide lies about 20 miles south of U.S. 50 at a point about 35 miles southeast of Fallon.

BELMONT, NEVADA
WIDE OPEN FOR NO BUSINESS

a GHOST TOWN worth seeing

From Tonopah, go east six miles on U.S. 6. Turn north for thirteen miles on State 8A. Turn right on State 82 for twenty-seven miles to the town. Half of the latter was paved by 1977; eventually it will all be paved.

Approaching Belmont from the south or east, you gaze across miles of desolate valley floor toward one of two tall chimneys which, like sentinels, guard the approaches to town. Built of brick molded and fired on the site, they reflect Belmont's rare fortune in having had a good natural supply of building materials—clay, rock, and wood.

Pleasantly tucked amid gentle hills, this is one of Nevada's best ghost towns, with many long-deserted stone, brick, and frame buildings. Grandest relic is the former Nye County Courthouse, a two-story brick edifice surmounted by a square cupola. Venturing inside, you pick your way across broken strips of lath and dusty shards of plaster, and, at your own risk, try the creaky staircase and even creakier steps leading up into the cupola. Belmont's twenty-year heyday came after the Comstock's, and was followed by the turn-of-the-century Tonopah boom which largely drained Belmont of its residents.

GAUNT skeleton of the old Highbridge ore mill is located off the main road, several hundred yards south of a tall, round chimney.

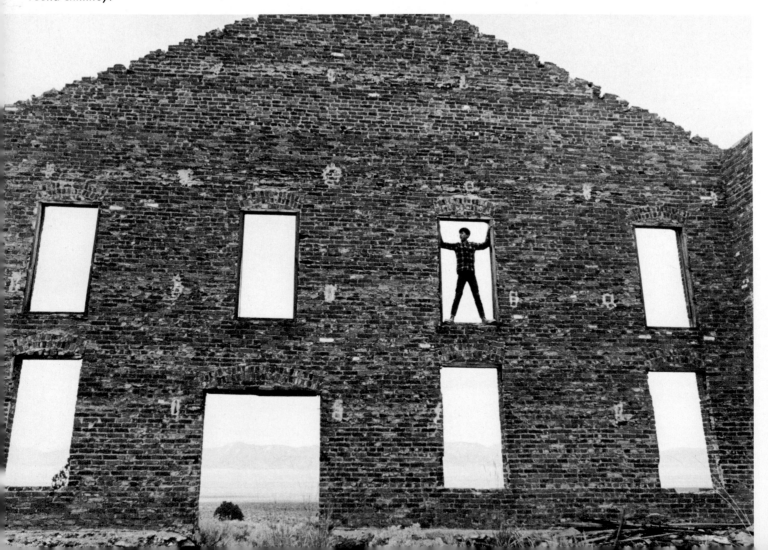

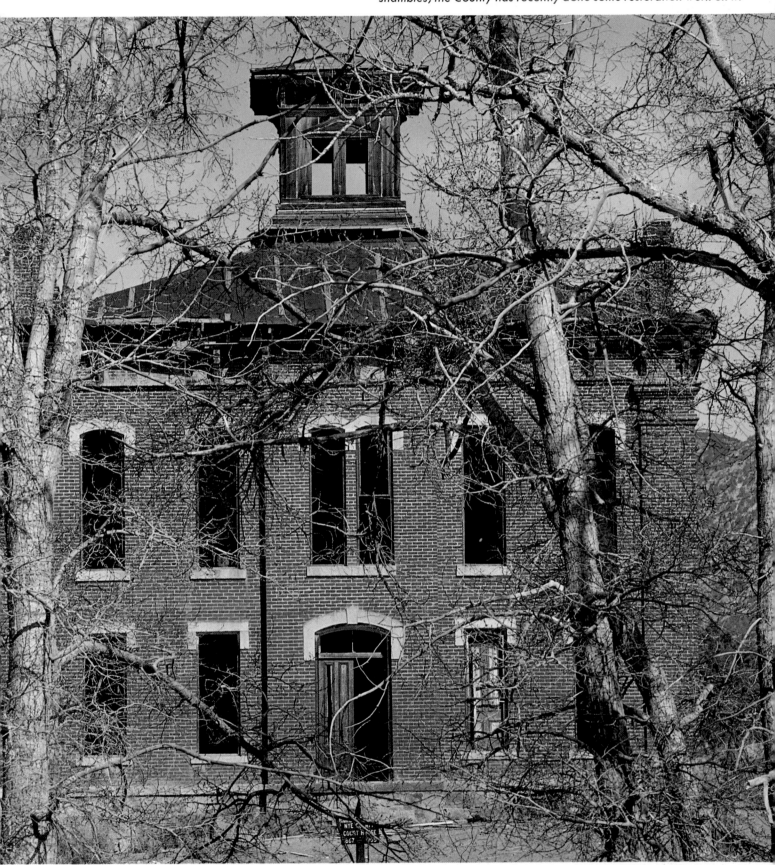

RED BRICK COURTHOUSE *is Belmont's grandest relic. Though the building was long in shambles, the County has recently done some restoration work on it.*

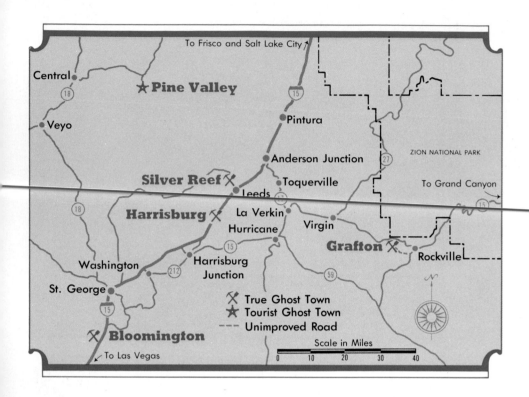

STOUT ROCK dwellings at Harrisburg are fashioned from native fieldstone, as are the fences. Handsome buildings are dotted throughout the one-time agricultural valley watered by Quail and Cottonwood creeks.

Partly because of Mormon migrations, the agricultural frontier came early to southern Utah, with the result that four of the five ghosts shown on our map at left derive not from mining but from farming or lumbering.

Lovely Pine Valley reposes among densely forested mountains at 6,500 feet. Begun as a sawmill center in the late 1850's, it prospered for forty years, but withered toward the turn of the century. Today a dozen or so year-round residents and many summer homes prevent it from being a true ghost town. But its imposing, two-story Mormon church is a justly famous edifice.

Harrisburg grew in the 1860's from the labors of some sixteen families who planted corn, cotton, sorghum, vineyards, and orchards, and who fashioned its long walls and stout buildings from the big stones that peppered the fields. But grasshopper plagues, Indian raids, and water problems denuded the town by the mid-90's. The fate of another tiny agricultural ghost, Bloomington, is uncertain: it has been nearly engulfed by a housing development.

Silver Reef, a major silver camp by the mid-1870's, hit its zenith around 1880. Boardwalks stretched a full mile along Main Street, and the mills spewed forth $8 million yearly. But supply and demand problems left the town a ghost by the 1890's. Only the vacant Wells Fargo building and the occupied John Rice house stand intact today.

Frisco, like Silver Reef, sprang to life as a silver producer in the 1870's but was in full decline twenty years later. Several buildings remain, along with jagged walls and five charcoal kilns. To reach Frisco, take State 21 west from Milford for 15 miles, then turn northwest on a dirt road. The intersecting, sometimes confusing desert tracks appear as of 1969 on the Beaver and Millar county maps.

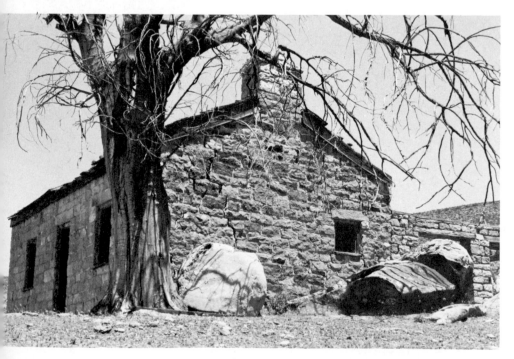

WELL-CONSTRUCTED office o† Wells Fargo (right) is the main landmark at Silver Reef. It has the distinction of being listed on the National Historical Register. In the foreground is an early milling wheel

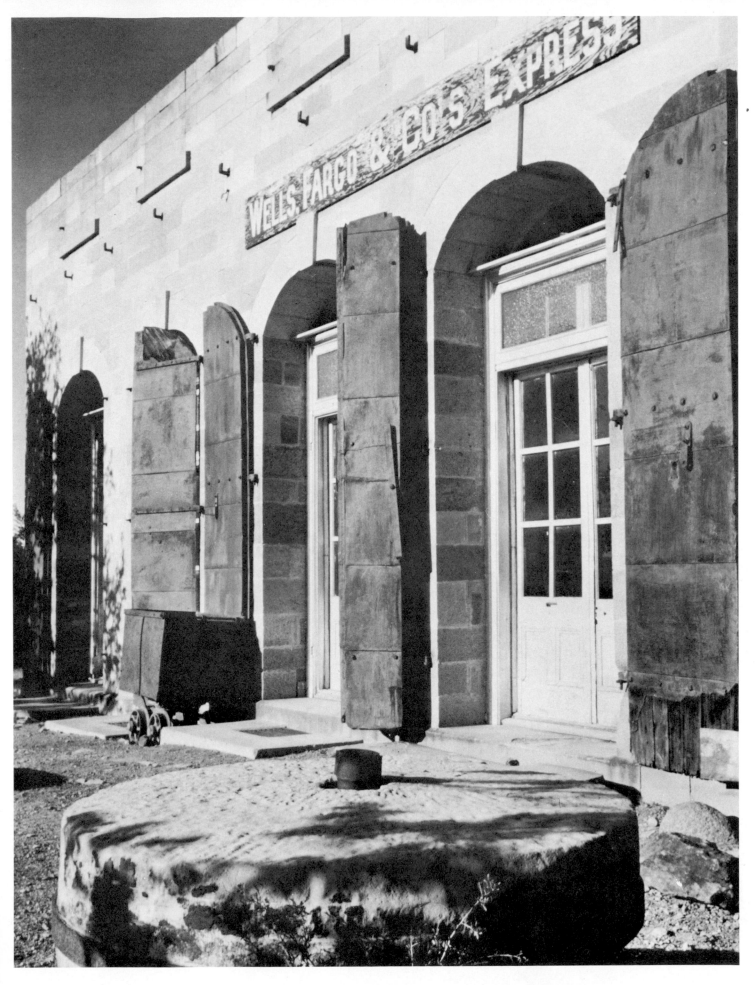

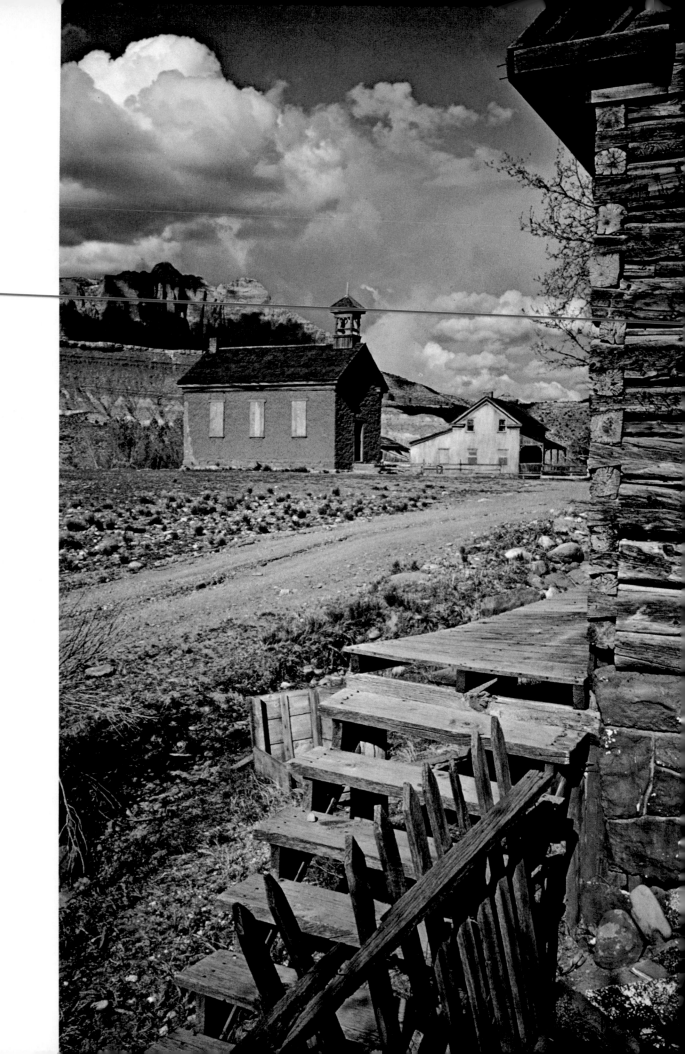

GRAFTON, UTAH
DIXIE COTTON, ZION SILK

While most Great Basin ghost towns lie in bleak desert settings, Grafton is an exception. Amid orchards, mulberry trees, and lowing cows, the abandoned settlement slumbers beside the Virgin River, under the shadow of the dramatic cliffs of Zion National Park.

Grafton was founded about 1859 by five Mormon families. They had come with others to settle southern Utah, which they called "Dixie" because Brigham Young had decreed that the staple crop was to be cotton. Assisted by the friendly Paiute Indians, the families dammed the river for irrigation.

In 1862, disaster struck: A flood inundated the entire valley. As reported in Salt Lake City's *Deseret News*, "the houses in old Grafton came floating down with the furniture, clothing, and other property of the inhabitants . . . including three barrels of molasses." Realizing that floods were a special hazard in the area, the survivors moved their settlement to safer ground and dug a system of canals and ditches. Along with cotton, they planted corn, wheat, and tobacco. By 1865 they had two hundred acres under cultivation. In time, the raising of livestock also became important.

Tragedy struck again when the Indians went on the warpath. One settler after another was killed by marauding Paiutes—as Grafton's gravestones still testify. The men were forced to work their fields in armed groups; periodically, the whole town had to be evacuated. When, in the 1870's, the Indian threat abated, the settlers obtained Brigham Young's permission to plant mulberry trees and grow silkworms. Now the wives had comfortable, pretty silk dresses!

Although Grafton wilted toward ghost town status after 1907, its charm and spectacular setting were not lost on Hollywood: since 1950, portions of several films, including *Butch Cassidy*, have been shot here.

a GHOST TOWN worth seeing

From St. George, west of Zion National Park go nine miles northeast on Interstate 15; then take State 15 twenty-seven miles east to Rockville. Here, get local directions for unpaved road which leads southwest about two miles to Grafton.

VICTIMS OF INDIAN ATTACKS, and other Grafton settlers, are buried in this well-kept Mormon cemetery which lies on the road southeast of town.

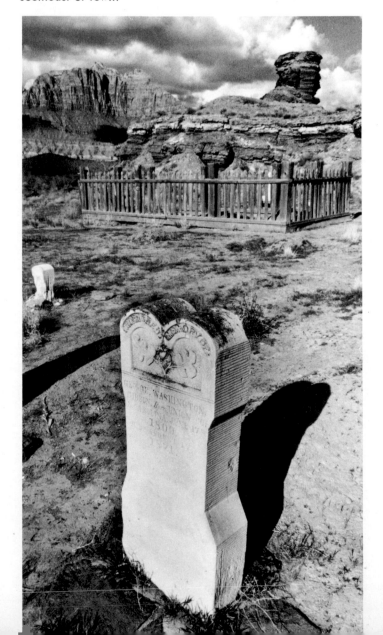

SPECTACULAR SETTING, under the cliffs of Zion National Park, makes Grafton one of the West's most photogenic ghost towns. The reddish earthen building was a Mormon meeting center and school.

NORTHERN NEVADA

While Nevada's most accessible tourist ghosts are found in the Virginia City area near Reno, and her more extensive true ghost towns lie farther south around Tonopah, the northern fourth of the state holds tempting destinations for the adventurous. Plenty of time, patience, fuel, and water are necessary. For a few of the towns a four-wheel-drive vehicle may be required. Apart from local advice, the best direction-finder is the *Nevada Map Atlas*, published by the Nevada State Highway Department.

The best-known ghosts in the western sector are **Unionville** and **Rochester**, originally silver boomtowns. Unionville now mingles stone ruins with quiet pastoral dwellings, and Rochester has wooden remains dotted among evidence of more recent mining activity. **Flanigan** and **Jungo** are old railway settlements, Flanigan completely deserted and Jungo nearly so. As its name implies, **Leadville** was a lead and silver camp, of which a few buildings and the remains of some mine track and tunnel survive. The **Nightingale** mining district shows signs of recent activity as well as old remnants. Several structures are left at **Seven Troughs, Scossa,** and **Placeritas,** and one at **Vernon.**

Paradise Valley, a sleepy ranching town, has picturesque accents like hitching posts and false-front stores to remind you of a history that goes back to 1863. To the north are the water-powered Silver State Flour Mill and the old buildings of Camp Winfield Scott. **Galena** and **Copper**

Canyon, officially listed as historical sites, mingle mill ruins and old graves with evidence of more recent mining interest. **Gold Acres** has been resuscitated with new mines, a school, and a score of occupied buildings. Also reactivated are the nearby gold camps of **Tenabo** and **Cortez.** The sites of **Mineral Hill, Bullion, Cornucopia, Edgemont, White Rock, Rio Tinto,** and **Gold Creek** are for history buffs only. Rounding out northern Nevada's central sector are **Midas,** its occupied farm units surrounded by abandoned mines, and **Tuscarora,** a living village with a mining patrimony evident in its elaborate cemetery, open shafts in surrounding hills, and a museum of relics.

For the ghost towns of the northeastern sector, historic **Elko** is a good starting point. Site of a Basque festival held each July, this cow-and-truck town also contains the Northeastern Nevada Museum dealing with manmade and natural history. Mountain-girt **Jarbidge,** far to the north, was once Nevada's biggest gold producer but is now a tiny, seasonal sportsmen's center with some false fronts and mining remains. The farm towns of **Tobar** and **Metropolis,** which hit the skids in the 20's and 30's, are today total ghosts; only cellars remain at Tobar, and a cemetery at Metropolis. The ruins of a smelter are all that's left at the site of **Sprucemont,** concealed on a forested mountainside; four miles to the northeast are the reoccupied buildings around the Black Forest Mine, which produced lead and silver until 1942.

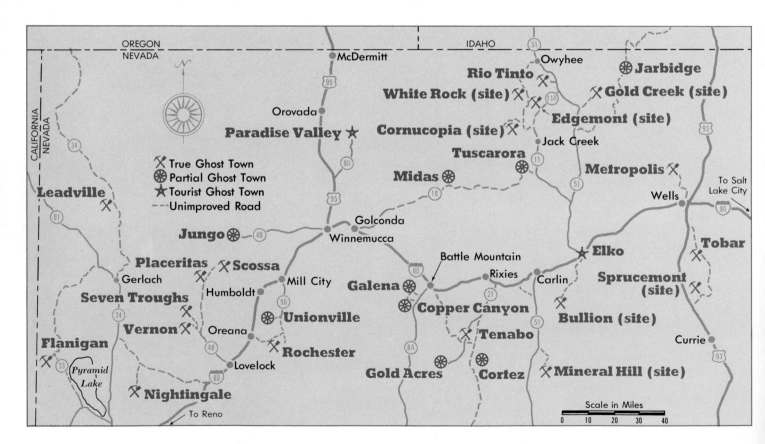

The Great Basin

EASTERN NEVADA

Late to boom, early to bust, the mining excitements of eastern Nevada left a sizable residue of relics which it may or may not take a four-wheel-drive vehicle to reach. An invaluable aid is the *Nevada Map Atlas*.

After shedding the skin of their uproarious youth, **Eureka** and **Pioche** left much of it lying around in plain view. Quite a few of the buildings along Eureka's main drag date from the 1870's and 80's, and five old graveyards nestle in the hills west of town. Pioche features a chock-full historical museum, downtown buildings from the 70's and 80's, and a dramatic ore tramway overlooking the southern outskirts.

One of the state's better-known ghosts, **Hamilton** continues to crumble. Less often visited are the old mines around Mt. Hamilton to the west, including the site of **Babylon**.

Preserved as a tourist highlight are the **Ward Charcoal Ovens**. Less often visited are the three beehive coke ovens at **Bristol Well**. Enthusiasts of mining camp history may also savor these very slim sites: **Ward** itself, marked by a cemetery and mining remnants; the rock walls of **Hiko**; what's left of a smelter at **Crescent**; the cemetery and stone structures of **Delamar**; the disintegrating cabins and part of a mill of **Minerva**; a few old cabins amid newer operations at **Atlanta**; **Osceola**, comprising a variety of ruins and an old mine; and once-prosperous **Jackrabbit's** deteriorated tram terminal.

Close perusal of the *Nevada Map Atlas* will reveal the sites of other vanished towns, and that detailed guide is a necessity in searching for such spots as **Silver Bow** and **Golden Arrow**, with their gaunt skeletons; the **Reveilles**; and the scant remains of **Troy**, **Hicks Station**, and **Keystone**. Such adventures are for out-and-out desert explorers only. More is left at **Tybo**, and it's easier to reach.

WESTERN UTAH

The fringes of desolate Great Salt Lake Desert harbor some of the least-known ghosts in the West. Passenger cars can make it to nearly all of them.

One of the state's prime ghost towns is **Gold Hill**. Though its mines churned out a variety of minerals until World War II, the population is now down to about a dozen. Twice as many live in nearby **Callao**, which also features a picturesque assortment of abandoned structures.

Lots of empty false-front stores, mine structures, and houses remain at **Eureka**. Yet because the town is within commuting range of Provo and Salt Lake, its population is creeping toward a thousand. Nearby **Mammoth** is much smaller and funkier.

Only gaunt concrete foundations remain at **Mercur**. But **Ophir** is a well-preserved, living village sprinkled with historic, abandoned buildings such as the old city hall. **Iosepa** was settled by a group of Hawaiian Mormons but was dogged by the inhospitable environment and by leprosy. Remaining are a cemetery to the northeast and a strange row of fire hydrants in the desert. **Richville** (Mills Junction) is a very old, defunct milling center whose outstanding relic is the three-story E. T. Benson knitting mill, listed on the National Historic Register.

Whereas **Cedar Creek** is totally abandoned and collapsing, **Park Valley** lives on among numerous reminders of better days. **Terrace**, an old rail settlement, requires special guidance and some shoe leather to find. (Off the map to the east are the interesting ghosts of Argyle, Round Valley, and Sage Creek—see page 115.)

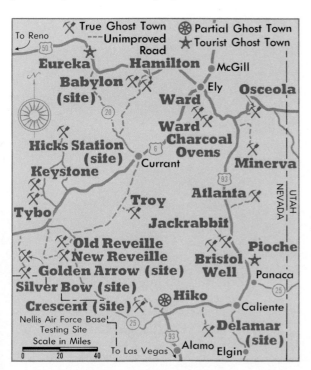

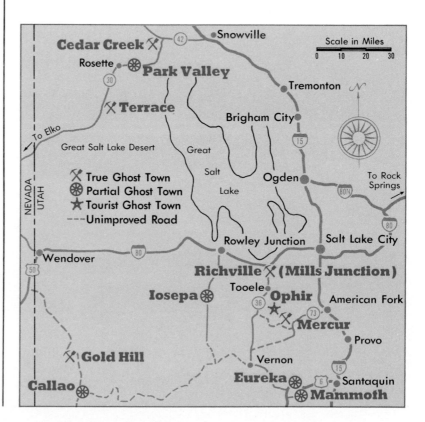

HUSTLE AND BUSTLE of the mining frontier was nowhere more evident than in Cripple Creek, Colorado, during the 1890's. After producing nearly half a billion dollars worth of gold, Cripple Creek collapsed and became a near ghost. The old-time town has recently reawakened as a tourist center.

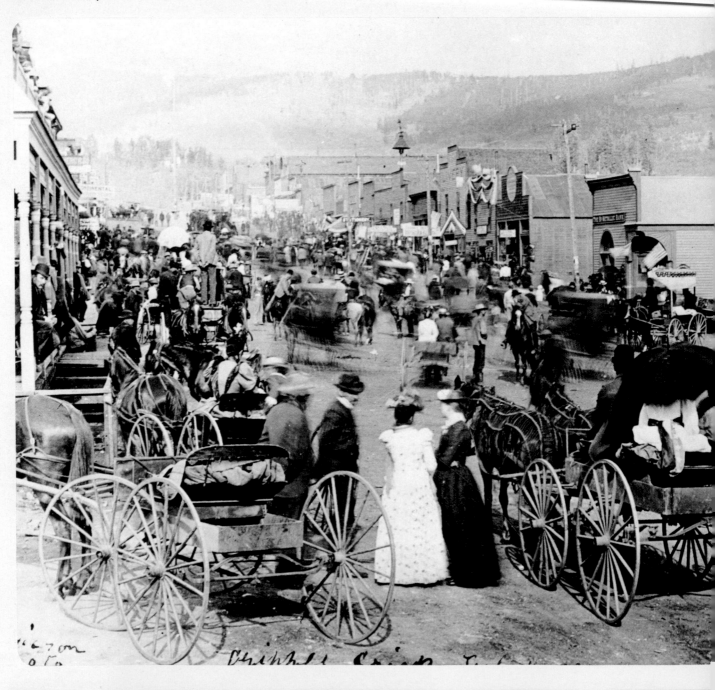

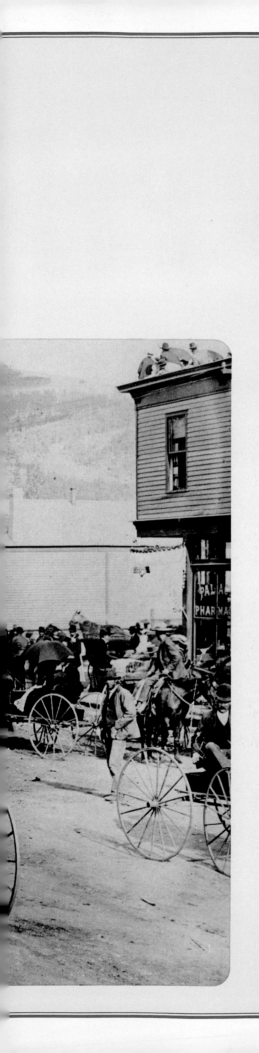

ROCKY MOUNTAIN SPREADING FEVER

1859...

NOW IT WAS COLORADO'S TURN. The tale first told in California's Sierra foothills and already unfolding in Nevada's Comstock was about to be told again—with exaggerations. GOLD IN KANSAS TERRITORY!! were the words flashed across the nation in the first newspaper dispatches of a bonanza in the Colorado mountains. Fleeing the after-effects of the depression of 1857, a new generation of gold-seekers adopted the motto *Pike's Peak or Bust!* and became known as "59'ers."

But the ups and downs of gold rush life soon proved even more frustrating in the Rockies than in the Far West. Instant towns went up—and became instant ghost towns. Of the hundred thousand hopefuls who, according to one authority, started across the plains in 1859, only half even reached the rallying point called Denver; and half of these promptly turned around and went home. "Humbug of humbugs," they called Colorado.

Yet those who stayed helped to roll back an important new frontier. Hope returned as experienced, professional miners began arriving from California and elsewhere. New

discoveries laid the basis for substantial towns all the way from southern Colorado to northern Idaho, and from western Montana down to eastern Utah—a vast territory which had hitherto been only a wilderness. But even the larger communities were not immune from the gyrations of fortune. Life on the mountainous frontier was still hard and uncertain—as late as the 1870's only one child out of two lived to its third birthday—and there were many ghost towns still in the making.

The camps' life cycles were remarkably similar. The early, flush days were exciting and full of optimism. Suddenly the easily-worked surface gold gave out; gloom settled over the camp, and its population dwindled. Then the late 1860's and early 1870's brought dramatic breakthroughs in transportation and technology. The town woke up as the railroad came whistling in, bringing along vital supplies and hauling away heavy ores. Big new machines hammered away at the tough rocks, and, following on the Comstock example, the treasure seekers focused not only on gold but on glittering silver. While the saloons again ran at full tilt, refinement also came to the frontier. A Montana debating society even posed the question: "Resolved, that the Love of Woman has had more influence upon the Mind of Man than the Love of Gold." Yet in time the hard-rock deposits, too, began to give out. A final blow was the collapse of the silver market in 1893, brought on by demonitization.

Strewn in the wake of this wide arc of boom and bust, the Rocky Mountain ghost towns are today among the richest and wryest of their kind. The old wooden structures lean more precariously each year, under the twin pressures of winter snows and vandalism. Occasional brick and stone buildings, more resistant to fire and the elements, remind us of the Victorian era's sense of civic pride. And some larger towns—like Central City, Colorado—have lately been rescued from ghostly limbo to become tourist centers, with good displays of treasured artifacts and old photographs.

The adventurous will welcome Colorado's justly famous high-altitude jeep trails, rugged routes which twist through some of America's most spectacular scenery on the way to the more isolated ghost towns. The jolting ride's the thing in most cases, though, because few of the remote towns can match the more accessible ones in style and number of surviving structures. Eastern Utah and northern Idaho are slimmer pickings (southern Idaho is covered in Chapter Four). But western Montana holds some special treats for ghost towners.

Most of the best Rocky Mountain ghosts and semi-ghosts can be reached easily by passenger car in summer. Winter trips may take more nerve, but often reward the visitor with an incomparable mood of snowy stillness.

THE ROCKIES AND THEIR GHOST TOWNS

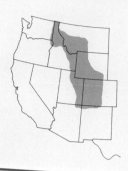

✗ True Ghost Town: Population at or near zero; contents may range from many vacant buildings to rubble and a few roofless walls. Places where only traces remain are marked "site."

✸ Partial Ghost Town: Disused structures and mining remnants mingle with modern elements.

★ Tourist Ghost Town: Living town has significant elements from mining rush or other historic era; old structures may be spruced up or rebuilt to promote tourist atmosphere.

(40) Interstate Highways

(80) U.S. Highways

(95) State Highways & Secondary Roads

NOTE: Map is as accurate as present information permits. Refer to detailed maps for minor roads, and always inquire locally about road conditions.

CANADA

MONTANA

IDAHO

d Oreille Lake

○ Kalispell

Flathead Lake

Garnet ✕

MISSOULA ○

Bitterroot

Granite ✕ **Elkhorn**

Anaconda ○

○ BUTTE

Marysville ⊛

HELENA ○

✕ **Castle**

SEE DETAIL MAPS, PAGES 117, 126

Yellowstone River

Virginia City ★

✕ **Bannack**

Range

MONTANA
WYOMING

YELLOWSTONE NTL. PK.

IDAHO

CRATERS OF THE MOON NTL. PK.

GRAND TETON NTL. PK.

Pocatello ○

Snake River

SEE DETAIL MAP, PAGE 115

○ Riverton

Lander ○

✕ **South Pass City**

IDAHO
UTAH

Great Salt Lake

Rock Springs ○

FLAMING GORGE NTL. REC. AREA

WYOMING

COLORADO

SALT LAKE CITY ▢

★ **Park City**

DINOSAUR NTL. MON.

ROCKY MOUNTAINS NTL. PK.

SEE DETAIL MAP, PAGE 125

★ **Central City**

DENVER

⊛ ✕
Scofield Spring Canyon

Green R.

SEE DETAIL MAP, PAGE 130

River

COLORADO SPRINGS

✕ **Sego**

SEE DETAIL MAP, PAGE 120

ARCHES NTL. MON

Moab ○

Colorado

Grand Junction ○

St. Elmo ⊛

Gunnison ○

CANYONLANDS NTL. PK.

Ouray ○

Alta ✕

MESA VERDE NTL. PK.

Durango ○

COLORADO
NEW MEXICO

UTAH
ARIZONA

N

0 40 80 120
Miles

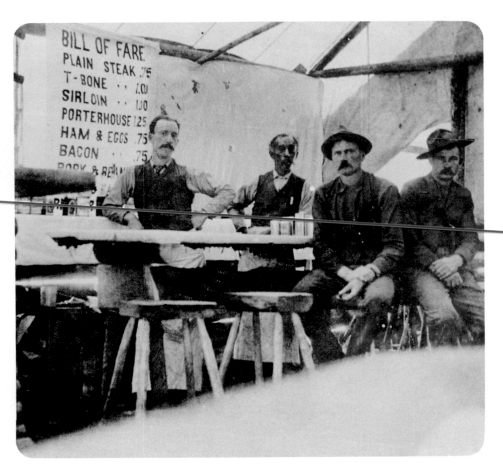

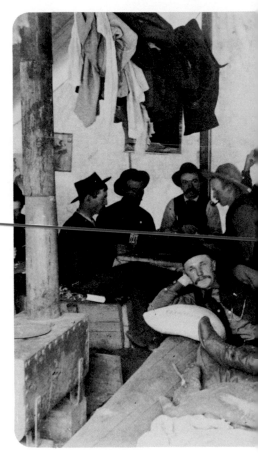

FIRST COMMERCIAL
establishment in a mining camp
was often a combination
restaurant, store, and saloon,
roofed with canvas stretched
over a log frame.

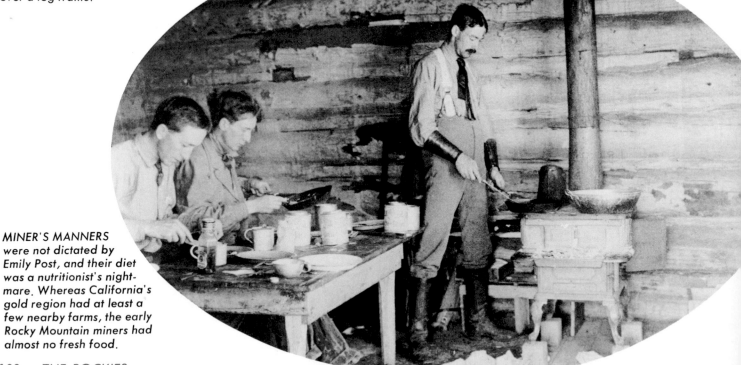

MINER'S MANNERS
were not dictated by
Emily Post, and their diet
was a nutritionist's night-
mare. Whereas California's
gold region had at least a
few nearby farms, the early
Rocky Mountain miners had
almost no fresh food.

Raw Beginnings: THE TENT TOWNS AND BOARDING HOUSES

In the Rockies, as in California and Nevada, the early mining camps sprang up almost overnight, as people flocked in at the news of the earliest discoveries. Where the trapper and pioneer farmer had sought isolation and self-sufficiency, the miner obtained cash and wanted to spend it fast. Irreligious and footloose, he seldom arrived with a family, but craved the noise and ready companionship that only a town could provide. Very quickly, newly arrived merchants would be ready to accommodate him with goods and services previously unknown on the frontier.

The early miner lived in a tent or rude shack near his "diggins," and he often continued to live apart from the town. One diarist reported that "The people were camped all around . . . in wagons, tents and temporary brush houses or wickiups. The principal business houses were saloons, gambling houses, and dance halls, two or three so-called stores with very small stocks of general merchandise and little provisions." Besides saloonkeepers, merchants, and prostitutes, early arrivals included speculators, lawyers, salesmen, and the all-important freighters.

Speed was everything. No one knew how long the gravels would pay. But while they did, the merchant whose stock arrived first stood to profit as handsomely as the man who first found the gold, or the promoter who made the first subdivisions. In such an atmosphere, prices skyrocketed.

As the town developed, the boarding house became one of its key institutions, offering respectable women jobs long before schools or laundries did. Accommodations were often quite rough, with floor space itself sometimes going for premium prices. Travelers commented on the widespread sport of eavesdropping through the thin partitions.

Eventually some mining companies began building bunkhouses and boarding houses for their men—prelude to the full-fledged "company towns" which were to emerge after the turn of the century. Stoutly built, certain boarding houses have weathered the severe winters better than neighboring structures. The one at Alta, Colorado, is an example. Exploring these hulking ruins today, one can only speculate on the identity of those who lived—and sometimes died—in their long-vacant rooms.

VICTORIAN PIN-UPS, cards, and months-old magazines were among a mining camp's few amusements—until the hurdy-gurdy girls made their appearance.

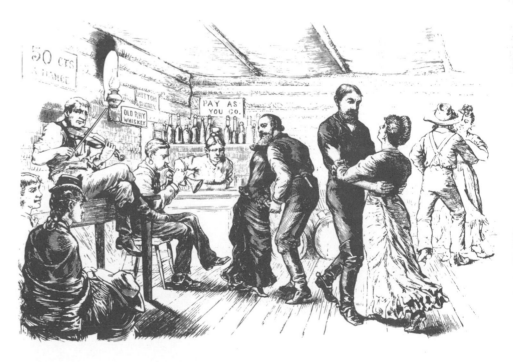

"MEN ARE FOOLS and women devils in disguise," observed Leadville's newspaper. "That's the reason the dance halls clear from one to two hundred dollars per night."

GARNET, MONTANA
STARTED LIFE EARLY—AND LOOKS IT

a GHOST TOWN worth seeing

From Missoula, go approximately thirty-two miles southeast on Interstate 90 to Bearmouth. Take extremely steep, unpaved mountain road for approximately ten miles north to Garnet.

Anyone taking the incredibly steep, unpaved road up to Garnet today cannot fail to wonder at the stamina of the men who overcame such imposing barriers in order to mine the Rockies.

The Garnet winters were fierce. Many miners left for the season, but a few stayed behind to repair their equipment and pile up paydirt that couldn't be washed until spring. The story goes that once, when Garnet was snowed in and supplies ran out, a man made it all the way through the maze of underground tunnels to the neighboring town of Bearmouth.

Gold was found here in the early 1860's. Unlike many of Montana's long-vanished early boomtowns, Garnet enjoyed a moderate, if fluctuating, prosperity well into the twentieth century. Very old and tottering, some of its buildings have no foundations or floors at all, but are simply boards stuck in the ground. Although severely vandalized in the 1960's, Garnet attracted the attention of the Bureau of Land Management in the 1970's as a representative mining town worthy of restoring on a non-commercial basis. Reversing its usual policy of burning abandoned buildings, the B.L.M., in cooperation with volunteers, has funneled considerable money and expertise into rebuilding roofs and constructing foundations for some buildings, preserving others just as they are, and providing guard protection and visitor access.

RICHLY FORESTED hillsides rising all around Garnet are worth exploring for isolated structures, the ore mill itself, and pieces of old mining machinery such as this.

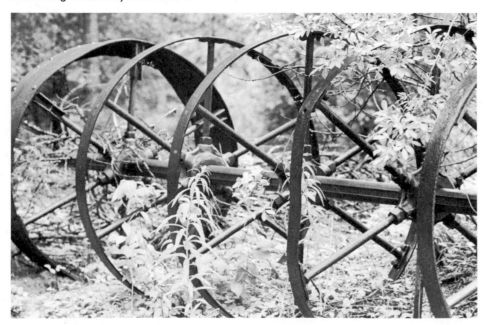

PRECARIOUS TILT of some Garnet's buildings makes y wonder how they ever lasted many winters as they hav

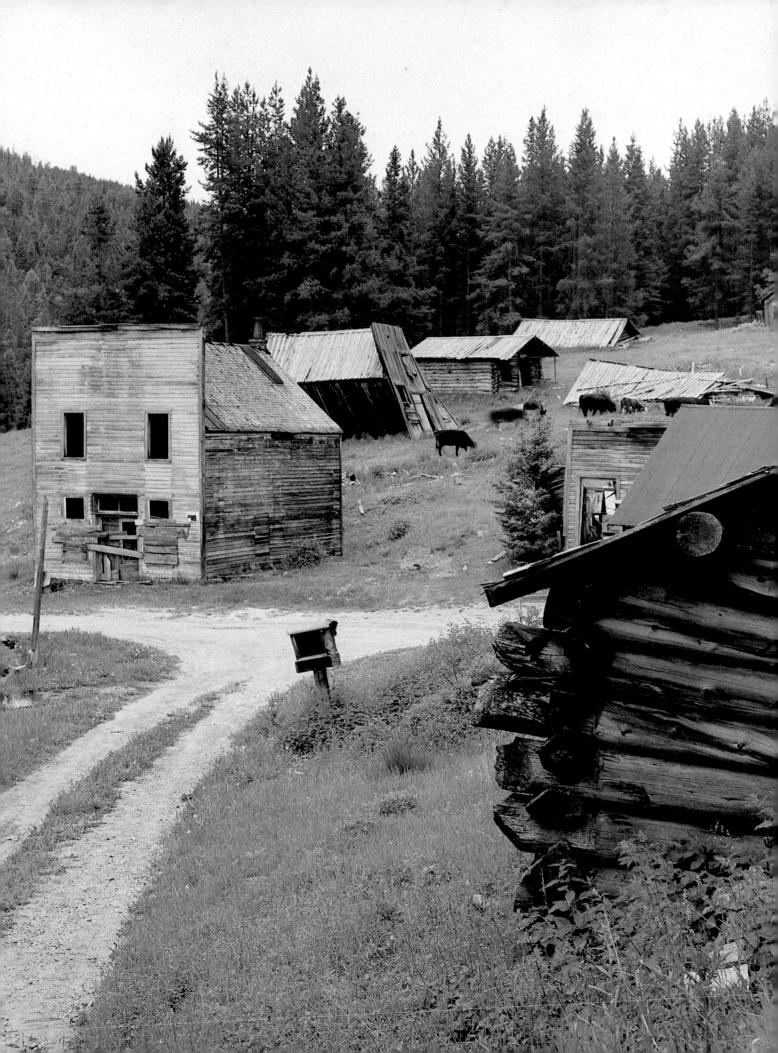

VARIED STYLES suggest varied eras in these ghost town details.
Above: deeply grained, square-hewn log joints typical of the earliest
period of Montana mining camps. Far right, above: one of the ornaments
of the cast-iron frontal pillars of the Miner's Union Hall, Granite,
Montana. Ordered from hundreds of miles away at great expense,
these pillars expressed the civic pride and pooling of capital which
came with the hard-rock mining booms later in the century. But in the
winter of 1974-75 an exceptionally heavy snow load collapsed the entire
front of the building, along with the roof. Far right: wallpaper from the
same building, ordered out of a mail order catalogue from the East.
Right: the precisely sawn lumber and standardized hardware of a
company boarding house at Ohio City, Colorado, probably dating from
the turn of the century or later.

Telltale Details: INTIMATE PRESENCE OF THE PAST

The closer you get, the more you see. Grains of time and wood. Scrap of curtain: how glad she was to get it! Battered nail, shoe-worn steps. News of the day stuck up against a Rocky Mountain winter: you can still read the fine print. Bring a close-up camera and take home your own impression.

BANNACK, MONTANA
"TU GRASS HOP PER DIGGINS 3O MYLE"

a GHOST TOWN worth seeing

From Salmon, Idaho (on U.S. 93 about one hundred twenty miles south of Missoula) go southeast twenty-two miles on State 28 to Tendoy. Turn east on an unsurfaced road which becomes Montana State 324. Just beyond Grant, approximately fifteen miles from Bannack, turn north.

Lewis and Clark journeyed by canoe through the upper Missouri and Beaverhead Valleys in 1805, and in their wake came a few trappers. But it remained for a little band of miners on their way from Colorado to Idaho in 1862 to make the first significant gold strike at the western edge of the territory later to be called Montana. Dubbing their site "Grasshopper Diggins," they decided to build log cabins and stay through the winter. When others joined them, the mining camp of Bannack was born. A year later, its deposits of both placer and quartz gold proved so valuable that Bannack soon boasted more than three thousand residents. Yet the town was still so hard to find that one resident scrawled the above directions on a sign, adding, "kepe the trale next the bluffe."

Today, Bannack's remarkable structures contain more than a century of colorful history. The little jail, stoutly mortised together out of square-hewn logs, was built by that notorious scalawag, Sheriff Henry Plummer. Pretending to pursue holdup men while actually leading them, Plummer was eventually found out and hanged on his own gallows. The largest building in town, a two-story brick affair, served as the county seat from 1875 until 1881, then became a hotel. Other historic buildings include the Masonic hall, built in 1874; the schoolhouse, in 1871; and the lovely little frame church, dating from 1870. There are a number of old log cabins, tightly chinked with lime. And don't miss the two graveyards. All in all, Bannack is a classic among western ghost towns.

PRETTY FRAME CHURCH, its siding curled and deeply weathered, was built in 1870. Visitors are free to wander and muse, and perhaps to pray, in its dusky interior, where the seats and lectern are still in place.

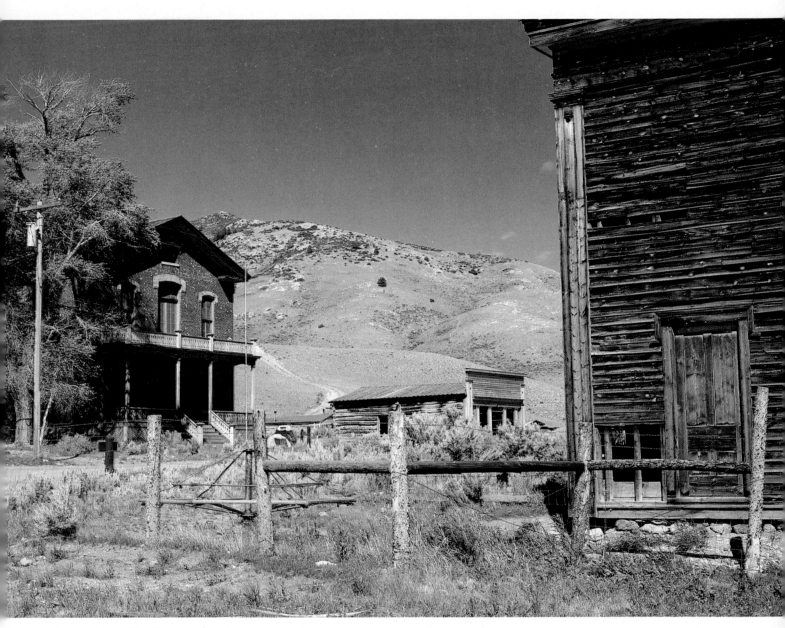

VENERABLE STRUCTURES, many of them false-fronted, stand at intervals along Bannack's main street. Brick building at left was the original Beaverhead County Courthouse and later the Hotel Meade. Wall at right belongs to the two-story Masonic Hall, which was erected in 1874.

Commerce: GAUGE OF TOWN GROWTH

In the precipitous Rockies, commerce depended to a crucial degree on the fluctuating conditions of mineral yield and transport. At first, the prices of every commodity gyrated wildly with every local rumor of boom or bust. Then, as the mining era matured and the distribution of ores became better known, merchants could make more permanent plans.

The dreadful state of the early freight routes was gradually alleviated by the appearance of toll roads and toll crossings, whose operators had to maintain them with at least occasional reliability. The opening of the direct Missouri River line from the Midwest was an unquestionable benefit to Montana. But it was the railroad, developing rapidly after the Union Pacific reached Cheyenne, Wyoming, in 1867, that made the big difference. Denver, in particular, profited by a series of new rail links; and all through the Rockies the cost of goods, as well as of smelting and labor, dropped sharply.

At last, with inventories deepening and diversifying, and with more and more specialized tradesmen on hand, the Rockies could urbanize at an accelerated pace.

1882.
Coulson Line!

Will run several of the Fastes and Best Boats on the Missouri this season.

Leaving Bismarck and Benton twice a week. Rates for the East or West furnished on application.

STEAMBOATS *vied for passengers and cargo between the Midwest and the gold fields of Montana and northern Idaho.*

RATES OF FERRIAGE
FOR EACH WAGON & PAIR HORSES

MULES OR OXEN	3.00	
WAGON LOADED WITH 4,000 LBS & OVER	4.00	
ADDITIONAL PR. OF ANIMALS	1.00	
PACK ANIMALS	.50	
MAN & HORSE	1.00	
LOOSE HORSE & STOCK	.25	
DO SHEEP & HOGS	.10	
FOOTMAN	.50	
ONE HORSE VEHICLE	2.50	

DOUBLE RATES AT NIGHT

TOLL ROADS *and toll crossings offered at least some incentive for keeping the vital freighting routes in good repair.*

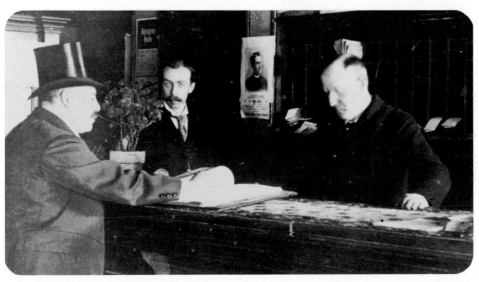

"LAVENDER AGE" niceties of a shave and a haircut were readily available in the heyday of Park City, Utah, but are harder to come by in the half-deserted community which has survived.

EXPANDING COMMERCE meant a well-heeled gentleman could get a luxury hotel room at Cripple Creek, Colorado. But when the gold gave out, Cripple Creek withered.

a GHOST TOWN worth seeing

From Helena, take Interstate 15 (U.S. 91) twenty-eight miles south to Boulder; there turn southeast on State 281 for four miles, then northeast on a good but unpaved road approximately twelve miles to Elkhorn.

Dating from the second wave of Montana's gold and silver rushes, Elkhorn has survived as one of the most extensive ghost towns in the West. Its principal mine, the Elkhorn, opened around 1872 and has changed hands repeatedly. Booming in the 1880's and '90's before tapering off in this century, the Elkhorn reputedly produced some $14 million in silver during its long life.

Although a few cabins have been re-occupied, the town retains the air of an abandoned period-piece. Scores of empty log and frame structures, brown and weathered, nestle in a small valley ringed with evergreen hills. Most were family dwellings: Elkhorn's miners worked for wages and brought their families with them. Many were foreigners — Dutch, Germans, Scandinavians, Irish, French, and Cornish. A colony of 500 woodchoppers occupied one end of town; their labors were essential for fueling the mills and warming the homes throughout Montana's bitter-cold winters.

Two hotels still stand, but the most striking building is the Fraternity Hall, with its castellated cornices and its unique second-story outcropping. A grand variety of lodges and other groups celebrated here, sometimes even staging prizefights in the spacious interior. Once, during a dance, two men got into a fight over what kind of music the band should play. The square-dancer shot the waltzer dead—and was later hanged for it.

TIGHTLY CHINKED with lime to insulate residents against the fierce Montana winters, the square-hewn logs of this rustic Elkhorn cabin typify the building style of the "Treasure State's" nineteenth century mining camps.

SAVED! When a California berry farm offered over $10,000 for Fraternity Hall, at center, and Gilliam Hall, next door, the owner—reluctant to see these famous buildings moved out of Montana—contacted the Western Montana Ghost Town Preservation Society. The Society raised enough loans and gifts to buy the properties for a much lower figure and to start stabilization work on them.

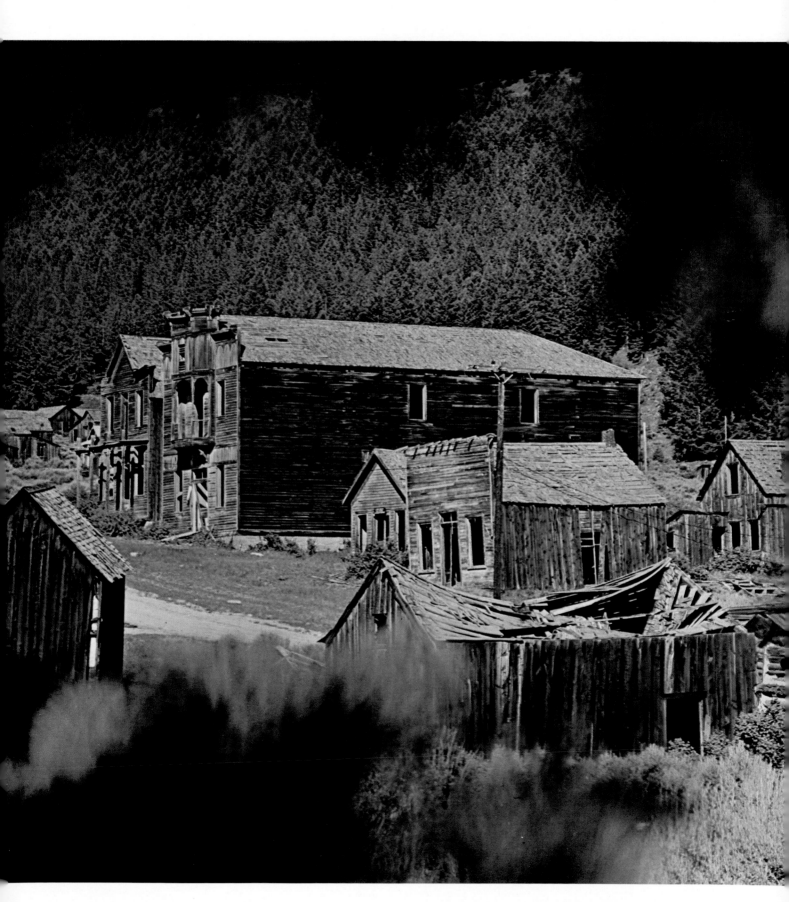

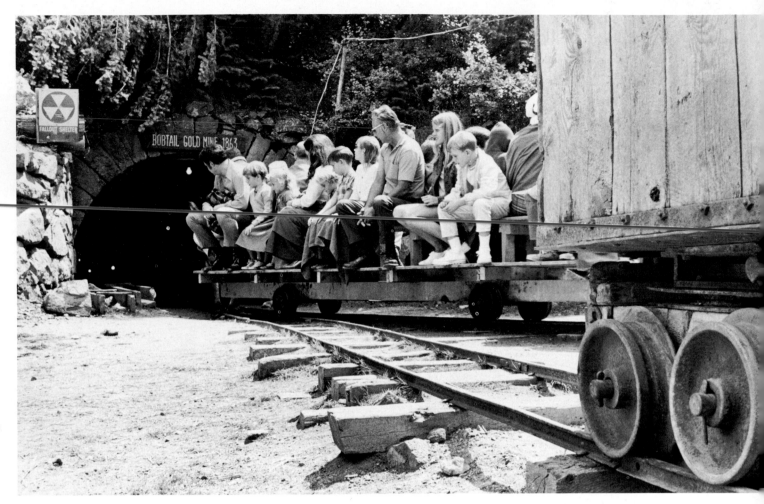

TUGGED ALONG by a tiny donkey, visitors are conducted far back into the Bobtail Gold Mine, one of Colorado's deepest. It's located at the picturesque former mining camp of Black Hawk, a neighbor of Central City.

GETTING THE RICHES: THE STAMP MILL

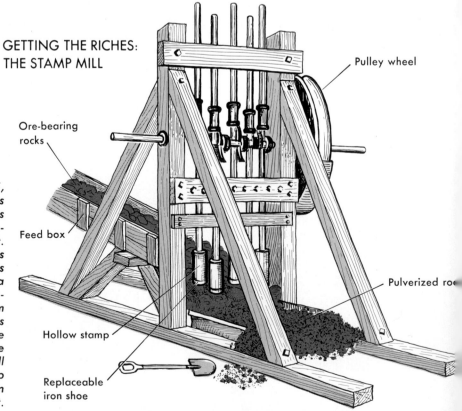

SIMPLE BUT EFFECTIVE, stamp mills crushed the rocks under heavy iron pestles whose movement was controlled by a cam shaft. Though the noisy machines had been used for centuries in Europe, in 1851 California miners added the replaceable shoes, mounting them to rotate freely and thus wear out evenly—a feature which gained worldwide acceptance. Employed all through the West, stamp mills are today a common ghost town artifact.

Pulley wheel

Ore-bearing rocks

Feed box

Pulverized roc

Hollow stamp

Replaceable iron shoe

Underground Era: RELIVING THE HARD-ROCK BOOM

Through most of the Rockies, the real treasure lay deep in the mountain rather than on the surface or in streams. Revisiting the old mines and machinery, one marvels at the pluck and ingenuity of the men who dug the tunnels, chipped away the tough rocks, and loaded them onto donkey-drawn carts to be hauled to the stamp mills.

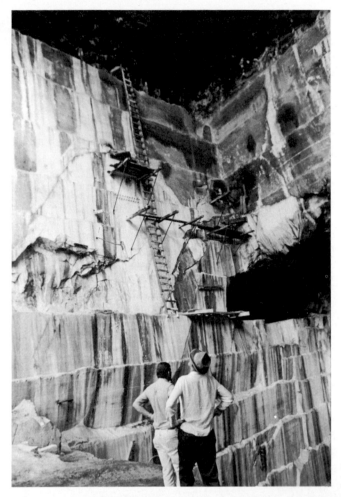

IMMENSE, abandoned quarry above the ghost town of Marble, Colorado, shipped fine marble for public architecture all over the U.S., including a single piece worth over a million dollars for the Lincoln Memorial, and a fifty-five ton block for the Tomb of the Unknown Soldier.

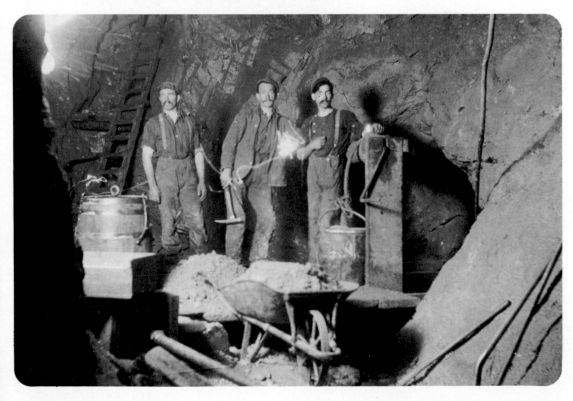

REMARKABLE early photo, apparently made by magnesium flare, shows miners in underground workings at Elkhorn, Montana, which is now a ghost town (see pages 110-111).

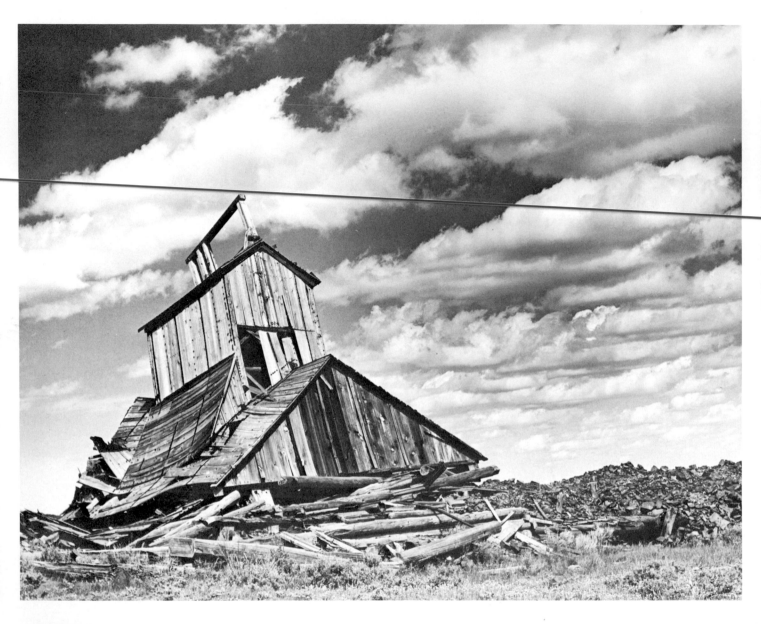

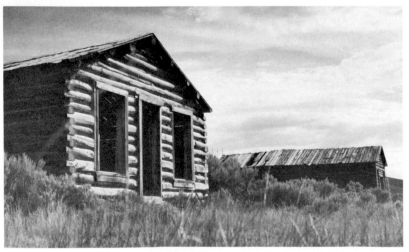

SKYWARD STARE of the ruined shafthouse of Lewiston's Good Hope Mine (above) seems to accentuate the immensity of the sky in this high plains country. Log stores at Pacific Springs (left) are among the handful of surviving structures in this muddy, deserted spot that was once an important way station on the emigrant trail. (Upper photo is from Ghost Towns of the Northwest by Norman D. Weis, Caxton Printers, Ltd.)

Wyoming's Wild Ones:
LOW GEAR ON THE HIGH PLAINS

Though laced with historic trails, Wyoming's high, wide-open plains are seldom recommended for their ghost towns. But while the state never saw a major mining rush, its southern sector contains at least two pockets of defunct mines and ghostly settlements that some visitors find the more interesting because of their obscurity.

The prime area is shown on the upper map at right. Miners, tradesmen, and ladies the likes of tough Calamity Jane and suffragette Esther Morris, drawn by discoveries of high-grade gold, swelled Atlantic City and South Pass City into Wyoming's largest towns by the late 1860's. But after 1875 the gold trickled out, and the places stagnated. Today, Atlantic remains a sleepy hamlet, dotted with early structures that include a classic log church. South Pass, a tourist "must," is a true historic ghost rescued by careful preservation efforts. Rarely visited, the other nearby ghost towns require a well-sprung vehicle and, preferably, detailed Fremont County maps.

Near the turn of the century came the copper and gold discoveries around Encampment. This longtime log and false-front skeleton has recently been fleshed out again as a summer haven. Forts Laramie, Fetterman, Bridger, and Fred Steele are famous old military posts. And just over the Utah border lie the agricultural ghosts of Argyle, Sage Creek, Round Valley, and Castle Rock.

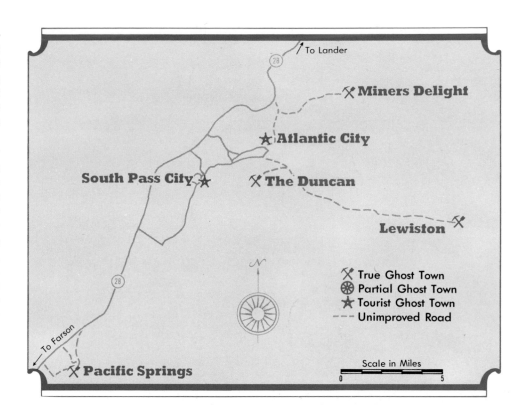

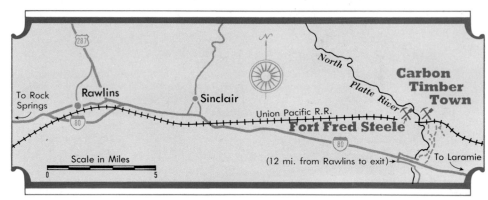

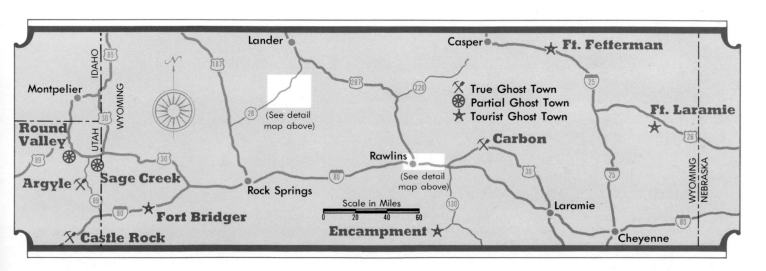

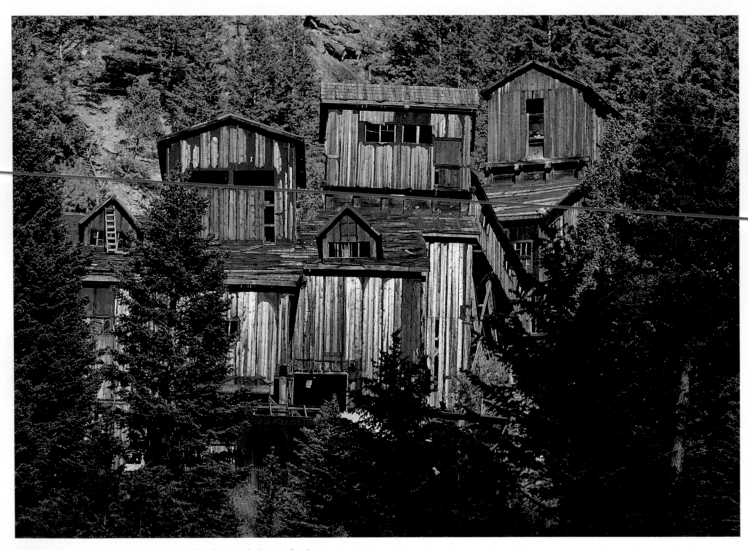

JUMBLED MILL COMPLEX perches high on a hill overlooking
the little community of Mammoth. Once a true ghost town,
Mammoth has returned to life as a summer haven.

Old Mills of Montana
A MIGHTY SPECIES — BUT ENDANGERED

A special treat for any ghost towner touring Montana was always the Drumlummon Mill in Marysville. The town itself has lots of historic buildings, roughly half of them occupied. But it was the famed Drumlummon Mine, the state's largest producer of gold in its day, that in effect built the town. In the first edition of this book we recommended it to visitors. As one authority later wrote, the mill itself was "a magnificent building with vast spaces, big conveyor belts and line shafts, many stairways and other interesting things. There is a ski area nearby and the mill could have made a terrific ski lodge. However, some kids set fire to it and had a great time watching it burn one night. It was completely destroyed."

Such tragedies underscore the sad fact that our historic places are now in constant need of being guarded if they are to be saved. For example, large chunks of siding and some of the huge timbers have been stolen from the Coolidge mill (see photo on page 118).

Some of Montana's mill sites are shown on the map at right. Hopefully, many of the structures will remain to be enjoyed by future generations. For the mills are visible history: it was the big-production mining camps that first blasted open the rugged Rockies for settlement, and the heart of every camp was its thundering ore mill.

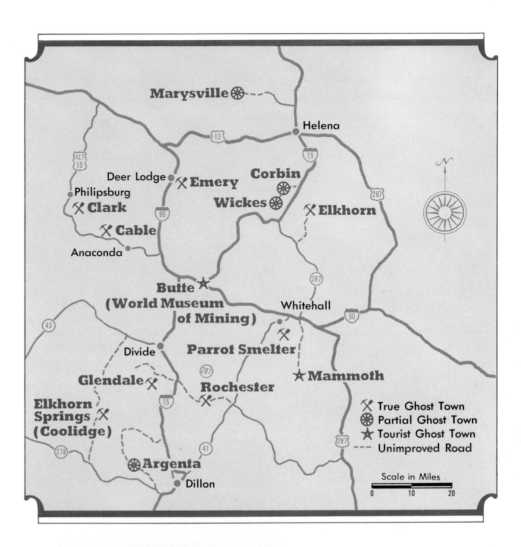

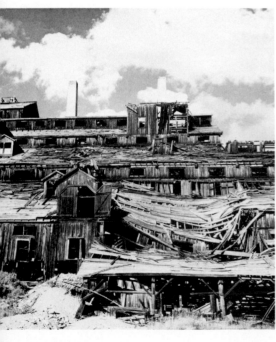

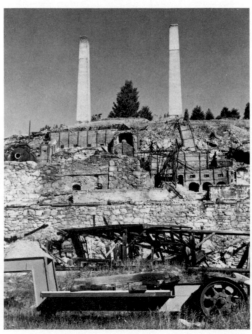

BEFORE AND AFTER photos depict the loss to our own and future generations when the Bi-Metallic Mill at Clark was razed by its owner, with the assistance of the U.S. Forest Service. Before it closed in 1905, the gigantic mill had 100 stamps that crushed 200 tons of ore per day.

CRAZY QUILT of light bars floods a silver mill at Elkhorn, Montana. Cows and horses have now adopted the structure as a kind of barn-away-from-home.

MASSIVE construction of the abandoned mill at Coolidge suggests the sizable know-how and investment that were needed to mine the Rockies.

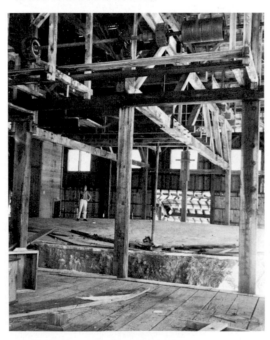

Utah's Mountain Ghosts:
BLEAK AND UNIQUE

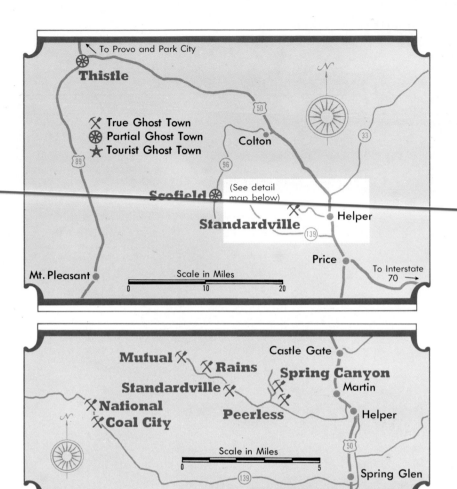

To Provo and Park City

Thistle

X True Ghost Town
⊕ Partial Ghost Town
★ Tourist Ghost Town

Colton

Scofield

(See detail map below)

Standardville
Helper

Price

Mt. Pleasant

Scale in Miles
0 10 20

To Interstate 70 →

Mutual X X **Rains** Castle Gate

Standardville X **Spring Canyon**
Martin

X **National**
X **Coal City** **Peerless**

Helper

Scale in Miles
0 5

Spring Glen

Centered around Utah's appropriately named Carbon County, company-built coal mining towns sprang up at intervals during the first two decades of this century.

Among the earliest was Scofield. A semi-ghost today, it has a somber distinction: here, in 1900, occurred one of the worst disasters in the history of American mining.

But the greatest concentration of coal town ghosts are those that were built successively westward along Spring Canyon: Peerless, Spring Canyon, Standardville, Rains, and Mutual. As you work your way up the narrow, right-hand fork of the canyon, the signs of industrial and domestic life gradually reveal themselves. There are countless rock walls without roofs, a large school building and meeting house, sheds, tramway cars, an immense coal tipple, stores, mounds of coal, more houses, and numerous other signs of industrial activity.

Established as early as the 1880's, the railroad town of Thistle eventually lost out to diesel power. Hard searching through a dense stand of trees is needed to find Thistle's long-defunct business section.

Not shown on the maps at left, Park City, born in 1869, became one of the richest gold and silver towns in the West. Though Park City has since come back to life as a ski resort, its wobbly stairways, fences, and buildings retain their antique flavor.

SPOOKY SCENE at Mutual's defunct store building seems accentuated by the appearance of a lone figure, one of the town's last remaining residents.

SILENT AND ALONE in winter the Silver King mining complex at Park City has seen far livelier days. It paid its owners over $5 million in profits

THE RAILROAD was a vital factor in the
development of coal mining towns.
At the ''tipple,'' or coal sorting plant in
Standardville (below), the coal was first
graded, then lowered into gondola
cars waiting on the spur at right. At
Scofield, the hazards of coal mining
were grimly exposed when 200 men died
in an underground explosion in 1900.
Today, the snows of winter still cloak
their graves (right).

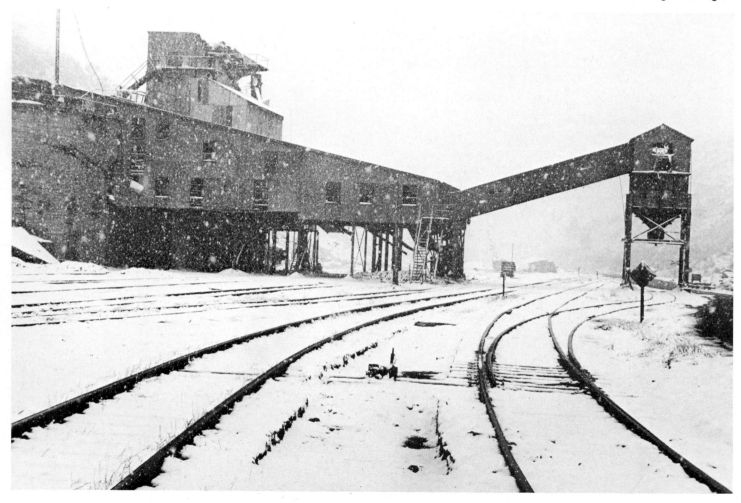

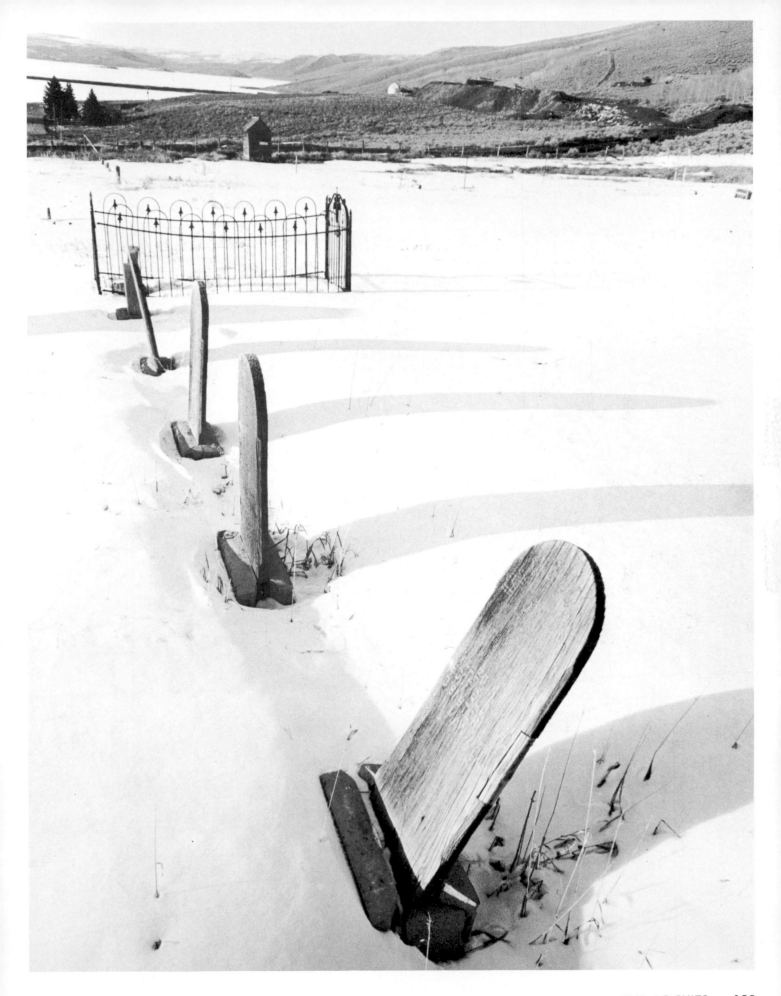

TOOTING ALONG through the hills for a short distance above Central City, Colorado, this narrow-gauge train gives tourists a chance to experience something of what early-day mining camp settlers knew as a vital form of transportation. The mountains above this tourist center are dotted with true ghost towns, such as Nevadaville, Apex, American City, and Kingston.

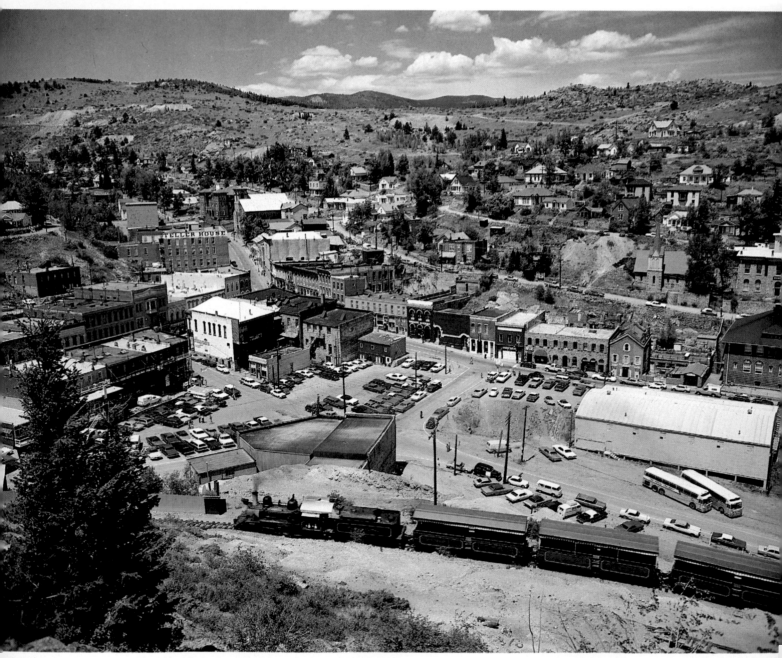

Tourist Towns of the Rockies:
PROMOTING WHOOPEE

Though it would be impossible to compare the rewards of the two industries in constant dollars, there is no doubt that the mining bonanzas that once were, spark a tourist business that still is.

Every summer once-remote Central City, Colorado, 8,500 feet high, draws thousands of visitors. They listen to hundreds of internationally acclaimed opera, jazz, and pop stars at the old opera house and in a dozen cabarets. They eat, they drink, they shop, and they prowl the spectacular hinterlands in four-wheel-drive vehicles that take them past quaint cemeteries, stout log ghost towns, and precarious mine ruins.

The theme is repeated with variations at any number of former mining camps up and down the Rockies. The pianos are playing, the donkeys are braying (and racing), the little trains are whistling, the barkers are barking. Gold, guns, garters, and ghosts—there's no legend like it.

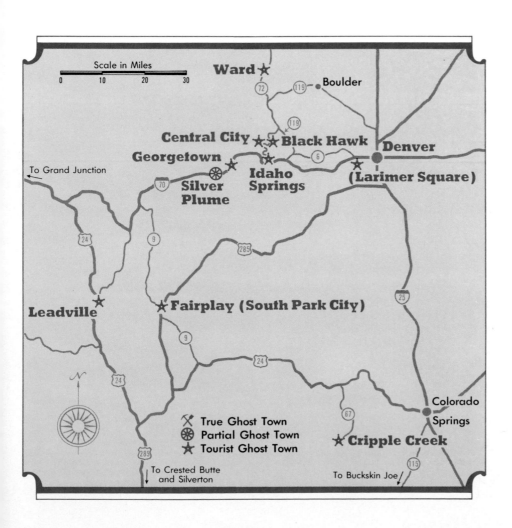

Scale in Miles
0 10 20 30

Ward ★
Boulder
Central City ★★ Black Hawk
Georgetown
Denver
To Grand Junction
Silver Plume
Idaho Springs
(Larimer Square)
Leadville ★
★ Fairplay (South Park City)
Colorado Springs
★ Cripple Creek
To Crested Butte and Silverton
To Buckskin Joe

✗ True Ghost Town
⊕ Partial Ghost Town
★ Tourist Ghost Town

Butte (World Museum of Mining
and Hellroarin' Gulch)

Three Forks

Pony

⊛ Partial Ghost Town
★ Tourist Ghost Town
--- Unimproved Road

Nevada City

Virginia City

Scale in Miles
0 10 20

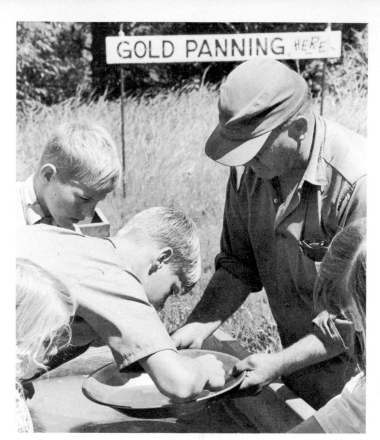

YOUTHFUL GOLD BUGS *get the word from an old hand at Virginia City, Montana. In its own madcap youth, the town attracted ten thousand gold seekers and became a "string town," stretching 17 miles along Alder Gulch, where the paydirt was.*

STROLL *along the boardwalk in Virginia City, Montana, and find yourself immersed in yesterdays. The wild mining camp became a ghost—and is now a veritable museum.*

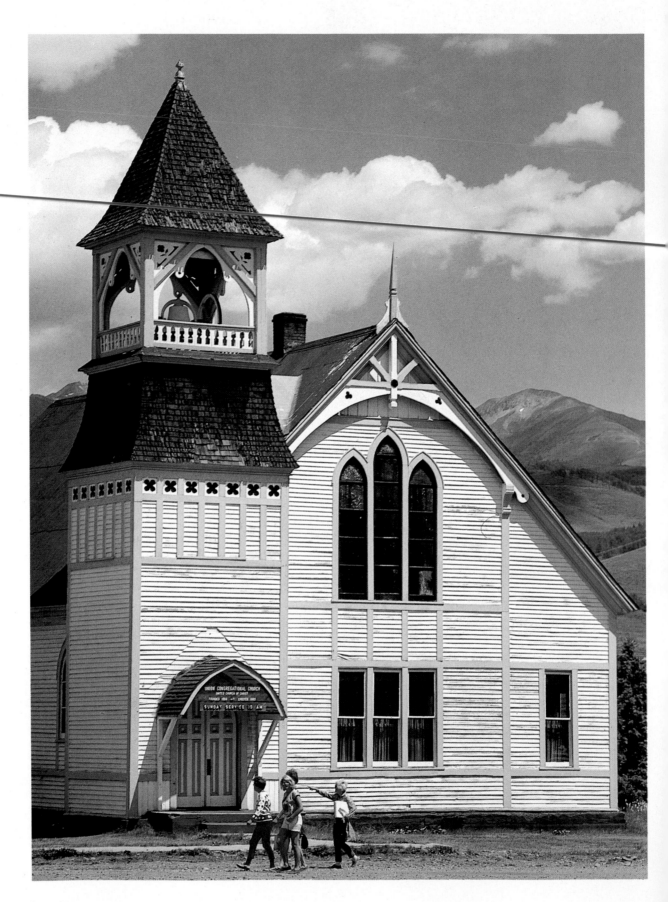

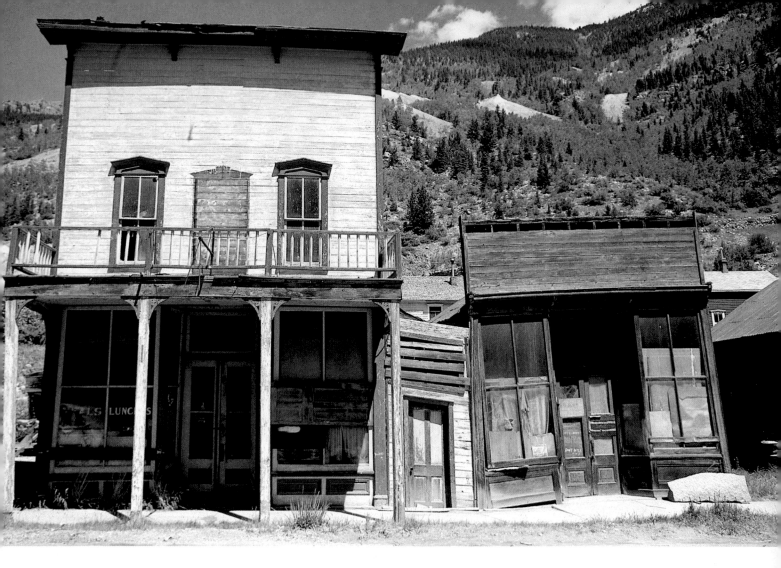

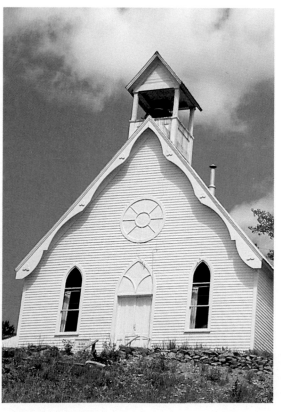

BLUE SKIES and sunshine, punctuated by brief showers, add to the beauty of Colorado's tourist ghost towns in summer. Distinctive architectural flair marks the churches at Crested Butte (far left) and Ward (left), while the store fronts of Silver Plume (above) have the classic false fronts common throughout the nineteenth-century West.

Jeep Country:
GETTING HIGH ON INCOMPARABLE COLORADO

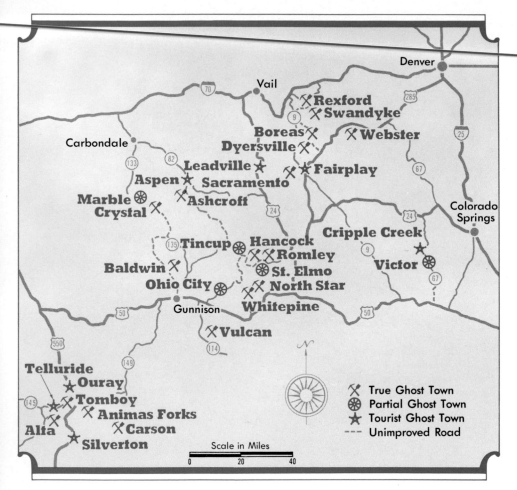

Carbondale

Vail

Denver

Rexford
Swandyke
Boreas
Dyersville
Webster
Leadville
Fairplay
Aspen
Sacramento
Marble
Ashcroft
Crystal
Colorado
Springs

Cripple Creek
Tincup
Hancock
Romley
Baldwin
St. Elmo
Victor
Ohio City
North Star
Gunnison
Whitepine

Vulcan

Telluride
Ouray
Tomboy
Animas Forks
Alta
Carson
Silverton

N

✗ True Ghost Town
⊗ Partial Ghost Town
★ Tourist Ghost Town
--- Unimproved Road

Scale in Miles
0 20 40

No doubt about it—there's something truly special about winding up Colorado's high roads to adventure in a four-wheel-drive vehicle. It's as if the ghost towns and rough, narrow roads had been purposely laid out to make sure you wouldn't miss the most dramatic views, the best stands of aspen and blue spruce, and the prettiest wildflowers in all of mid-continental America.

Only, don't expect to find entire towns with all the trimmings. With few exceptions the true ghost towns shown on our map at left consist of no more than a handful of structures stout enough to have survived a century of neglect. But they are soaked with a beauty and character impossible to find in the concrete-and-plastic world most of us inhabit these days.

Detailed, small-scale topographic maps are especially handy in such uneven terrain as this, and they are conveniently available at the U.S.G.S. regional office in Denver. County and National Forest maps are also of use.

And local word-of-mouth always turns out to be an invaluable source of current information. Carry plenty of gas and a compass, ask for directions often, and you may end up at someone's favorite ruin that's not in any book. But again: Please don't spoil someone else's fun by taking away anything except photographs.

LUSH MOUNTAIN SETTING surrounds the Lost Horse Mill
near the ghost town of Crystal, Colorado. Not far away is
the semi-ghost town of Marble, where you can see huge
abandoned quarries that shipped fine marble to all
parts of the U.S.

TUMBLEDOWN REMAINS of Tomboy are still fairly extensive, and the scenery is magnificent. Though the road up from Telluride has been described as ''a throat-clutching cliff-hanger,'' many conventional cars have made the trip. Lesser-known, nearby ghosts include Vanadium and Pandora.

WEATHERED cabins and wildflowers are strewn across the hill at Alta, along with commercial structures and debris. The large building just to the right of center in the picture is an old boarding house still in excellent shape. You can stay there in your sleeping bag—if you don't mind sharing the room with the occasional bears who wander in.

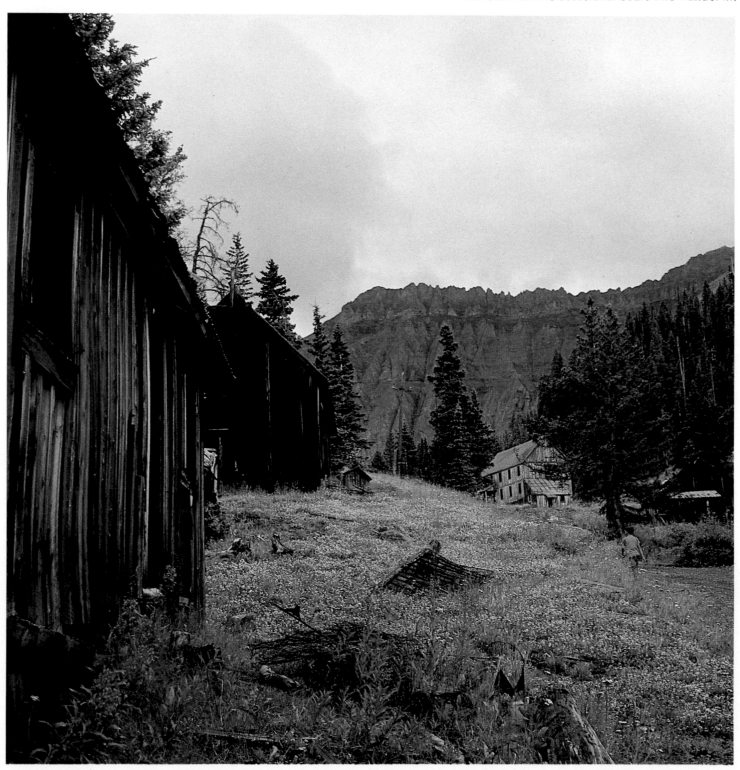

Georgetown's Hotel de Paris AND THE
AMAZING MONSIEUR DUPUY

Of all the surviving examples of elegance in the frontier mining towns, Louis Dupuy's "Hotel de Paris" in Georgetown is perhaps the most captivating. It was a highly individual creation—an island of warm, old-world grace, shadowed by some of the highest peaks in America.

At a time when the fortune hunters of the world were converging on the American West, Dupuy's own story was as unusual as anyone's. Christened Adolphus Gerard about 1844, he ran away from a Normandy theological seminary to become an agnostic intellectual and an apprentice to one of the leading chefs in Paris. He squandered his inheritance, then tried journalism in Paris, London, and New York, where he finally sold two plagiarized essays for $30. But the editor quickly discovered the hoax and chased him downstairs, shouting, "Stop! Thief!"

Gerard next joined the U.S. Army. In Wyoming he deserted, changed his name to Louis Dupuy, got a job in Denver as a mining camp reporter, and headed into the mountains with a burro named Fleurette. He quit to go into the mines—and was badly injured in an explosion. And so Louis became a cook again. Eventually he was able to buy the little Georgetown bakery-cafe where he worked, gradually enlarging it until, in 1875, he opened the doors of his hotel.

For the next 25 years the small establishment was famous throughout the West for its French cuisine and furnishings, and above all for the Dupuy personality. Cloaking his past in fanciful tales, he suavely seated his guests at small, candlelit tables around a tiny Italian fountain and offered them such delicacies as ptarmigan and quail, elk and venison, French mushrooms and truffles, and the finest European wines. Frontier dining had come a long way! After dinner, Louis liked to show off his massive library and treat his guests to an eloquent discourse on philosophy and art.

But he was also cantankerous. After suffering through an unrequited love affair, Louis became a woman-hater. He often turned away female guests, as he did anyone else who did not appeal to him. Yet for 20 years he kept as a "guest," Madame Galet, a French woman much older than himself. Their exact relationship remains a mystery, but she had her room on the second floor and did the housework, and gradually took over the running of the hotel. She inherited it when Dupuy died in 1900, but was buried beside him five months later.

Long closed to business, the Hotel de Paris has survived almost intact. It is now only an hour's drive from Denver. In the basement is Louis' wine cellar. The ground floor includes plush parlors, the fine library, the remarkably elegant dining room, and the large, typically French kitchen. Upstairs, the bedrooms are decorated with more restraint. The Colonial Dames of Denver own and show the place, with a personal touch which would doubtless have pleased old Louis, who, at his hotel's opening, told his guests, "Gentlemen: I love these mountains and I love America, but you will pardon me if I bring into this community a remembrance of my youth and my country . . . this house will be my tomb—and if, in after years, someone comes and calls for Louis Dupuy, show them this little souvenir of Alençon which I built in America, and they will understand."

The entire community of Georgetown is, in fact, saturated with antiquity. A private residence, the Maxwell House, is considered to be one of the finest Victorian structures in the United States. Another gem is the wonderful old fire station, "Alpine Hose No. 2." And the Hamill House, open to the public, boasts such elegant furnishings as silver and gold wallpaper, diamond-dust mirrors, a curved-glass conservatory, and, yes, even a fancy outhouse. Such was the prosperity of Georgetown.

NICETIES of life chez Louis
included the bridal suite's richly
embellished bedspread, and unique,
very French, corner basins in
virtually every room, including
downstairs lobbies.

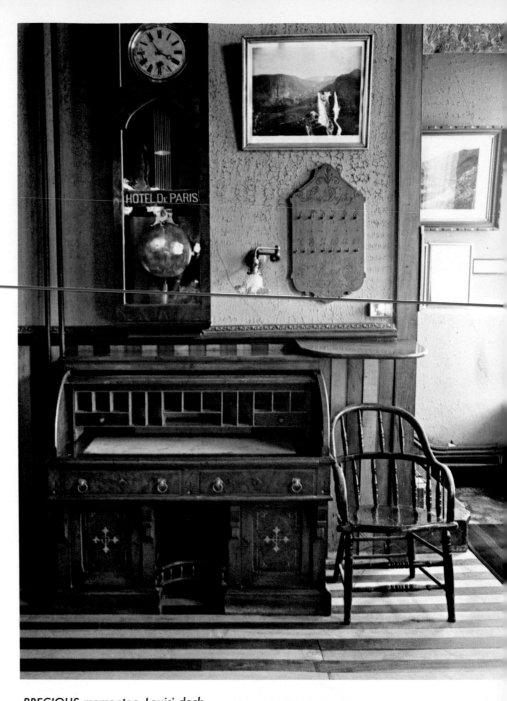

PRECIOUS mementos, Louis' desk, clock, pictures, and other objects occupy the same corner of the parquet-floored dining room as they did a century ago. Heart of the hotel, though, was its kitchen, where Louis prepared his gourmet meals in French pots on two charcoal stoves (right).

Hotel de Paris and Restaurant Dining Rooms.

ORDER BILL OF FARE.

Georgetown, _____ 187_

Porter House Steak	75	Tenderloin Steak	60
" " wit Onions	55	" " with Onions	70
" " with Mushrooms	1.00	" " with Mushr'ms	70
Sirloin Steak	40	Veal Cutlet	40
" " with Onions	50	" " Breaded	50
" " with Mushrooms	70	Mutton Chops	40
Ham	40	Pork Steak	40

FRIED.

Breakfast Bacon	25	Liver with Salt Pork	40
Mackerel	35	Ham and Eggs	40
Sausage	35	Pigs Feet	40
Tripe	35	Brains	40

GAME. FISH.

EGGS.

Boiled	25	Ham Omelet	40
Fried	25	Cheese Omelet	40
Scrambled	25	Jelly Omelet	50
Poached on Toast	25	Rum Omelet	50
Omelet, Plain	25	Mushroom Omelet	60

MISCELLANEOUS.

Cold Roast Beef	25	Apple Fritters	25
Cold Ham	25	Bread and Milk	25
Cold Tongue	24	Mush and Milk	25
Pigs Feet, Pickled	30	Welsh Rarebit	25
Pickled Tripe	35	Milk Toast	25
Wheat Cakes	10	Coffee, per cup	10
Corn Cakes	10	Tea,	10
Buckwheat Cakes	10	Milk, per glass	10
Toast	10	French Chocolate	25

POTATOES, 10c.

All orders above 25 cents are furnished with Bread, Butter and Potatoes

HOTEL DE PARIS

AND

Restaurant Dining Rooms.

ORDER BILL OF FARE.

OYSTERS.

Half Doz. Raw,	35c.	One Doz. Raw,	65c.
Half Doz. Stew,	40c.	One Doz. Stew,	75c.
Half Doz. Fried,	50c.	One Doz. Fried,	80c.
Coffee,	10c.	Milk, per Glass,	10c.
Tea,	10c.	French Chocolate,	25c.

PRESENTING oysters in the middle of the Rockies was no mean feat in the 1870's. Not listed here were Louis' other specialties, which often included exotic game dishes. He kept his perishables in a huge icebox (above left). After dinner, Louis would entertain his guests in his library or in the sumptuous lobby (left).

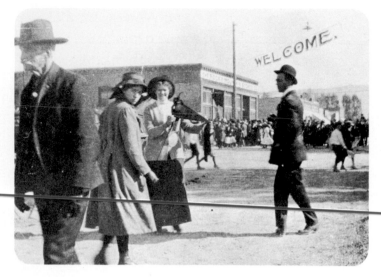

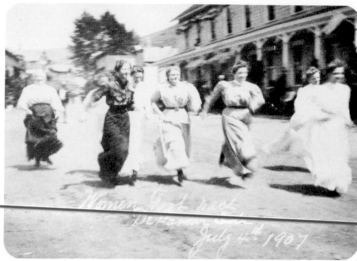

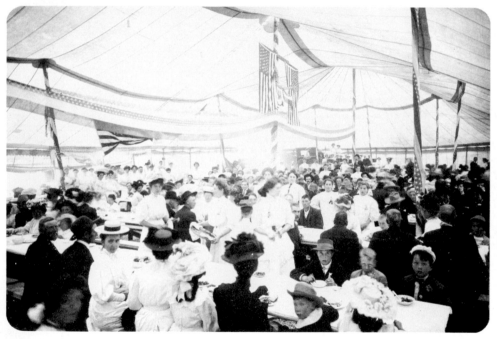

WHAT TIMES they were! The wonderful strawberry festival was barely over in Glenwood, Colorado (above), than the ladies of De Lamar, Idaho (top right), began unlimbering their petticoats for the Fourth-of-July foot race. Yet all this was as nothing compared to the allurements of Potato Day in Carbondale, Colorado (top left). Oh, if we could only know what tickled the picnicking misses at Boulder (right)! And that birthday party at booming Basalt, Colorado (far right)! People nowadays just don't know what a good time is.

Ladies Had Their Day: BOOMTOWN BUTTONS AND BOWS

For liberation they came West where they were scarcer and freer. One became a justice of the peace, another a stagecoach robber. Some felt free to change mates. Others made the men change their shirts; imposing Victorian values, they smoothed the rough edges of mining camp life.

LADIES' AID

BIRTHDAY PARTY.

I. O. O. F. Hall, Monday, May 18, 1896.

A Birthday Party, we're talking about,
And we could not bear to leave YOU out!
So we ask you kindly to come and see
The tip-top time, we'll furnish you free!
We promise to give you supper and song,
So please, dear friend, come right along.
We send you the cutest little sack
And we only ask you to bring it back,
Or send it, if you cannot come,
With as many cents as you are years old.
We promise your age shall never be told!

LADIES' AID.

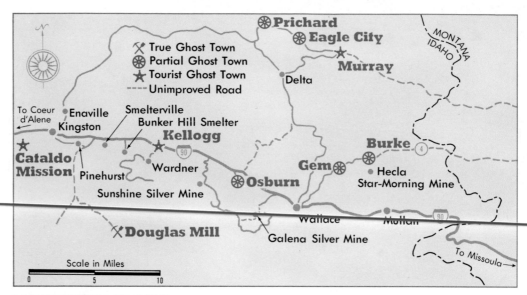

NORTHERN IDAHO

Idaho's Coeur d'Alene area holds special interest because its ghostly elements are mingled with a number of busy modern mining operations, some of which can be visited. Detailed aids to the back-country ghost-towner include the Idaho Transportation Department's Shoshone County maps and the Coeur d'Alene and St. Joe National Forest maps.

Ghost-town enthusiasts should seek out **Gem, Burke,** and **Murray.** The latter has become known in recent years for its "Bedroom Gold Mine," where, in 1973, Chris Christopherson, digging a shaft in an unused bedroom behind his store, pulled out an 8-ounce nugget worth at least $3,000. He and his wife, Lucille, still sell gas and groceries out front and will let you try your own luck at the mine during the summer. The abandoned **Douglas Mill** lies about ten miles up Pine Creek from Pinehurst, and other mining fragments dot the route from Wallace to Burke. Partially-living towns left over from the early mining period include **Prichard, Eagle City,** and **Osburn.** For information about current conditions, contact Greater Shoshone County, Inc. in Osburn.

The nation's largest silver producer is the Sunshine Mine. Plant tours are usually available for similar places such as the Bunker Hill Smelter and the Hecla Mine and Mill. Fine displays of mining and historical lore are on view at the Shoshone County Mining Museum in Wallace. **Kellogg** serves as a modern and historical hub for the whole area.

Idaho's oldest building, the **Cataldo Mission,** was restored for the Bicentennial and is now open to the public.

SOUTHERN ALBERTA AND EASTERN BRITISH COLUMBIA

For ghost-towners who think they've seen it all, the deserted farming and ranching towns of southern Alberta's plains offer a rich store of little-known discoveries. By con-

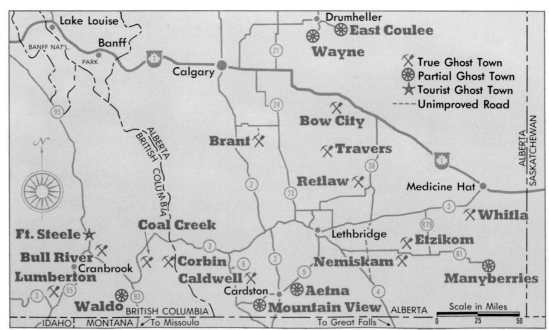

The Rockies

THE BLACK HILLS

Legendary folks like Wild Bill Hickok and Calamity Jane peopled Deadwood, South Dakota, in its free-wheeling boom days. Though the Black Hills had supposedly been reserved for the Sioux, politicians hardened by Custer's defeat had made a series of questionable "agreements" with the Indians which cleared the way for a frenetic gold rush in the 1870's. Before long the boom came under the sway of a single industrial giant—the Homestake Mining Company.

The best guide to the ghostly residue is the U.S. Forest Service map of the Black Hills National Forest.

The region's tourist highlight is **Rockerville**. It comprises a carefully reconstructed early mining town, plus a summer theater and plenty of relics. Still very much alive, **Deadwood** and **Custer** have interesting period buildings.

If you appreciate real ghost towns, don't miss **Mineral Hill, Tinton, Cascade,** and **Spokane**. A dozen or so empty houses, half a dozen mine buildings, and a large mill still used on occasion comprise Mineral Hill. Tinton, being well protected by a caretaker, has the most extensive remains of any of the Black Hills ghosts. Often photographed are the picturesque ruins of Cascade's W. Allen Bank, the Fargo Store, and the Cascade Club and bowling alley. Spokane has giant mine buildings and a schoolhouse.

Other ghosts of interest include coal-mining **Cambria**, with many collapsing houses and mine buildings; **Carbonate**, with its nearby Cleopatra mill and several cabins; **Maitland**, site of a few houses plus a shaft house and a mill; **Gold Incorporated**, a comparatively recent, deserted community built around an intact mill; and **Addie Camp**, with several cabins and houses around the old mines.

The musk of the past still lingers hauntingly around these communities which, though still alive, have declined steeply: **Rochford, Trojan, Central City, Galena, Moskee, Roubaix, Glendale, Dewey,** and **Old Buffalo Gap**.

trast, the ghosts of eastern British Columbia derive mainly from the extractive industries—mining and lumbering—and there's less left to see at those sites. Detailed maps of all portions of the provinces are available from the Department of Energy, Mines, and Resources in Ottawa.

The region's prime tourist-type ghost town is **Ft. Steele**. The settlement grew far larger than the fortress proper, and a large number of typical buildings have been painstakingly restored with period signs, furnishings, and museum relics.

The most extensive true ghost town in the whole area is probably **Whitla**. As late as 1976 it offered, in Harold Fryer's words, "a whole street of abandoned buildings" that comprised "a ghost towner's dream." **Travers**, with a number of deserted structures facing one another across a weedy road, comes a close second, followed by **Retlaw**, with its deserted Catholic Church, town buildings, and scattered farm houses, and by **Brant**, whose most prominent skeletons are a two-story hotel and an adjoining grocery store.

For those on the prowl for out-of-the-way places that are even more out-of-the-way, the area's second-string ghosts include **Bow City, Etzikom, Nemiskam, Caldwell, Lumberton, Corbin, Coal Creek,** and **Bull River**.

Quite a few denuded buildings can be found along with a tiny remaining population at the semi-ghosts of **Manyberries, Wayne, East Coulee, Aetna, Waldo,** and **Mountain View**.

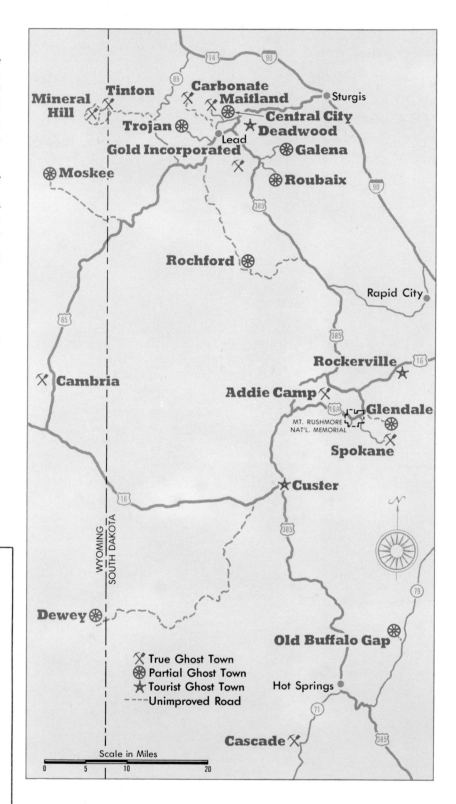

✗ True Ghost Town
⊛ Partial Ghost Town
★ Tourist Ghost Town
---- Unimproved Road

Scale in Miles
0 5 10 20

LIKE ANTS lured to an open jar of honey, "sourdough" prospectors labored over Alaska's treacherous Chilkoot Pass to reach the Klondike gold fields in 1898. Within two years the rush was over, and the roaring Klondike camps joined earlier northwestern boomtowns in heading rapidly toward ghost town status.

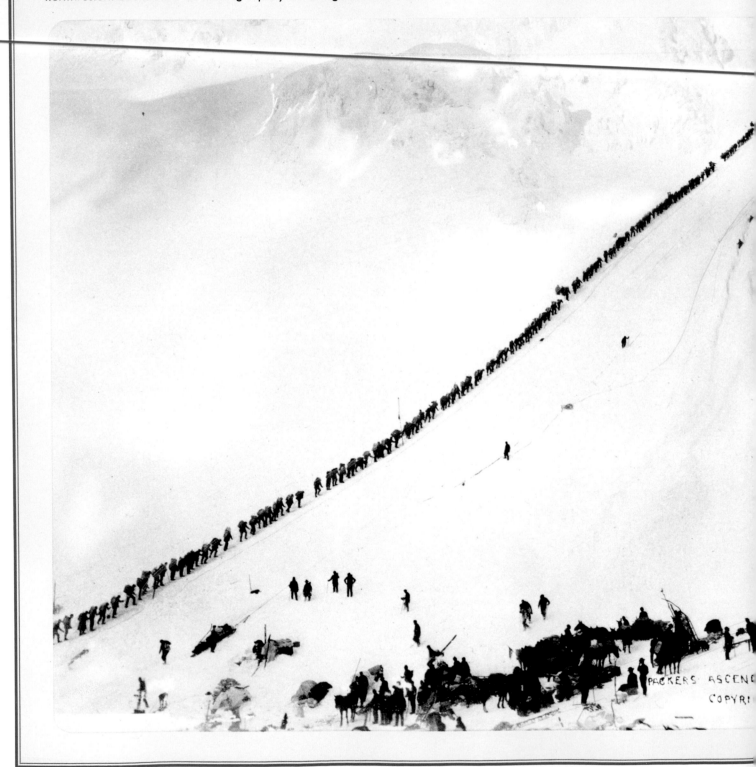

OF CHILKOOT PASS

THE NORTHWEST
WAS SOMETHING ELSE
1858...

IN THE FAR-FLUNG, geographically varied Northwest, the precious ores seemed distributed according to no discernible plan. The high hopes of pioneering prospectors were answered by no bonanza on the scale of a Central City or a Comstock. There occurred, instead, a series of lesser, isolated mining excitements. Widely scattered in space and time, and lacking any one clear trend, these moderate booms left a legacy of fascinatingly diverse ghost towns.

One early strike led to the "Cariboo Country" mania. In the spring of 1858, rumors of gold in the Fraser River area of British Columbia reached California. Suddenly the docks of San Francisco were groaning under the feet of thousands of miners waiting for ships to take them north. But within six months, most of the Argonauts returned, saying there wasn't enough gold in those remote woods to justify spending a long, freezing winter there. And yet there were eventually enough good-sized discoveries on both sides of the Canadian border to produce, in time, some fine relics of mining-camp days, such as the restored ghost town of Barkerville, B.C.

In 1862, southern Idaho flared into prominence when miners working the Rocky Mountains to the north got wind of a fabulous strike in the Boise Basin. Hurrying down, they impressed Hubert Bancroft, the great historian of the day, as

143

the most footloose of a footloose breed: "The miners of Idaho were like quicksilver. A mass of them dropped in any locality, broke up into individual globules, and ran off after any atom of gold in their vicinity." Center of the latest storm was the new town of Idaho City, which boasted two hundred fifty business buildings by 1865. Though it suffered four major fires, and though the "boomers" dug up the very streets and undermined the buildings in their frenetic search, Idaho City has survived as one of the most touristed of the State's former mining camps.

Scarcely a year after the Boise Basin rush, there were new discoveries a few miles farther south, in the Owyhee Basin. Out of this ferment grew the famous Silver City, whose graceful setting and extensive assortment of carpenter-gothic and other structures make Silver one of the finest ghost towns in all of the West.

Also in 1862, other Argonauts, rushing eastward across Oregon on their way to Idaho's gold fields, stumbled onto paydirt in the John Day area of northeastern Oregon. Within weeks, five thousand more of them came pouring in, to uncover an estimated $26 million in placer gold. Gradually this boom widened to include the Blue Mountains to the east, with the result that Oregon's thinly populated northeastern quadrant now holds the State's richest deposit of ghost towns.

By contrast, Washington was one of the least fortunate western states in terms of gold and silver resources. Washington's small-scale mining flurries occurred mainly in a north-central area adjoining the Canadian frontier. Here there are still a few former mining camps and abandoned homesteads of interest to ghost-town buffs.

Last of the major western mining rushes, the Klondike stampede of 1898 was also one of the briefest and most hectic. As many as a hundred thousand "sourdough" prospectors set out to cross Alaska's frozen wastes for the Yukon bonanza camp of Dawson. The harsh environment gave this gold rush a tough character, which is still evident in the region's partially abandoned way stations and defunct mining camps.

In the great and scattered Northwest, there can be few overall directions for ghost-towning. Winters, of course, can be severe. Considerable distances separate one region from another, so it's wise to explore one area thoroughly, rather than trying to encompass the scattered whole. Many of the ghost towns of Oregon, Washington, and Canada are in or near forests, with excellent prospects for fishing, hunting, and game watching. However, if you're traveling the Forest Service roads, reliable local advice and detailed, small-scale maps are a necessity.

THE NORTHWEST AND ITS GHOST TOWNS

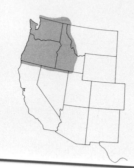

✗ True Ghost Town: Population at or near zero; contents may range from many vacant buildings to rubble and a few roofless walls. Places where only traces remain are marked "site."

⊛ Partial Ghost Town: Disused structures and mining remnants mingle with modern elements.

★ Tourist Ghost Town: Living town has significant elements from mining rush or other historic era; old structures may be spruced up or rebuilt to promote tourist atmosphere.

⓵⓪ Interstate Highways

⑧⓪ U.S. Highways

⑨⑤ State Highways & Secondary Roads

NOTE: Map is as accurate as present information permits. Refer to detailed maps for minor roads, and always inquire locally about road conditions.

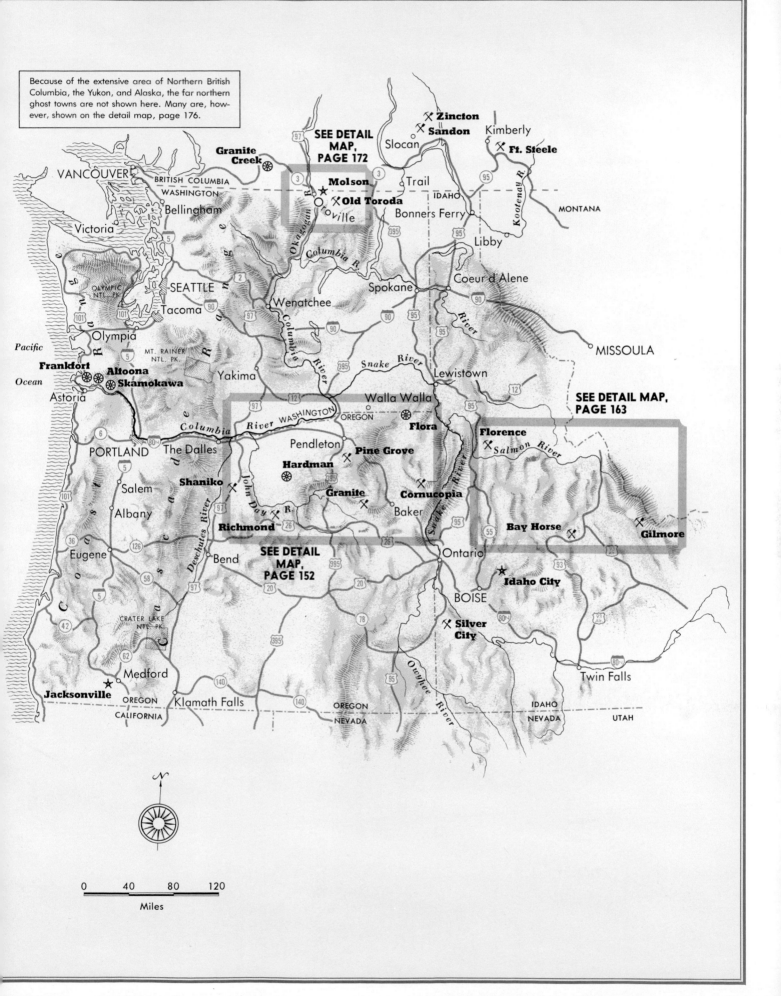

Because of the extensive area of Northern British Columbia, the Yukon, and Alaska, the far northern ghost towns are not shown here. Many are, however, shown on the detail map, page 176.

SEE DETAIL MAP, PAGE 172

SEE DETAIL MAP, PAGE 163

SEE DETAIL MAP, PAGE 152

VANCOUVER

Granite Creek

BRITISH COLUMBIA
WASHINGTON

Bellingham

Victoria

Molson

Oroville

Old Toroda

✗ Zincton
Sandon
Slocan Kimberly

Trail ✗ Ft. Steele

IDAHO Kootenay R.

Bonners Ferry MONTANA

Libby

OLYMPIC NTL. PK.

SEATTLE

Tacoma

Olympia

Wenatchee

Spokane Coeur d'Alene

River MISSOULA

Pacific

Ocean

Frankfort
Altoona
Skamokawa

Astoria

MT. RAINER NTL. PK.

Yakima

Columbia River

Snake River

Lewistown

Walla Walla

OREGON

Florence
✗ Salmon River

Flora

PORTLAND

The Dalles

Pendleton

Pine Grove

Hardman

Shaniko

Granite

Cornucopia

Baker

Richmond

Salem

Albany

Eugene

Bend

Snake River

Bay Horse ✗ Gilmore

Idaho City

BOISE

Silver City

Twin Falls

Crater Lake NTL. PK.

Medford

Jacksonville

OREGON
CALIFORNIA

Klamath Falls

OREGON
NEVADA

Ouyhee River

IDAHO
NEVADA UTAH

N

0 40 80 120
Miles

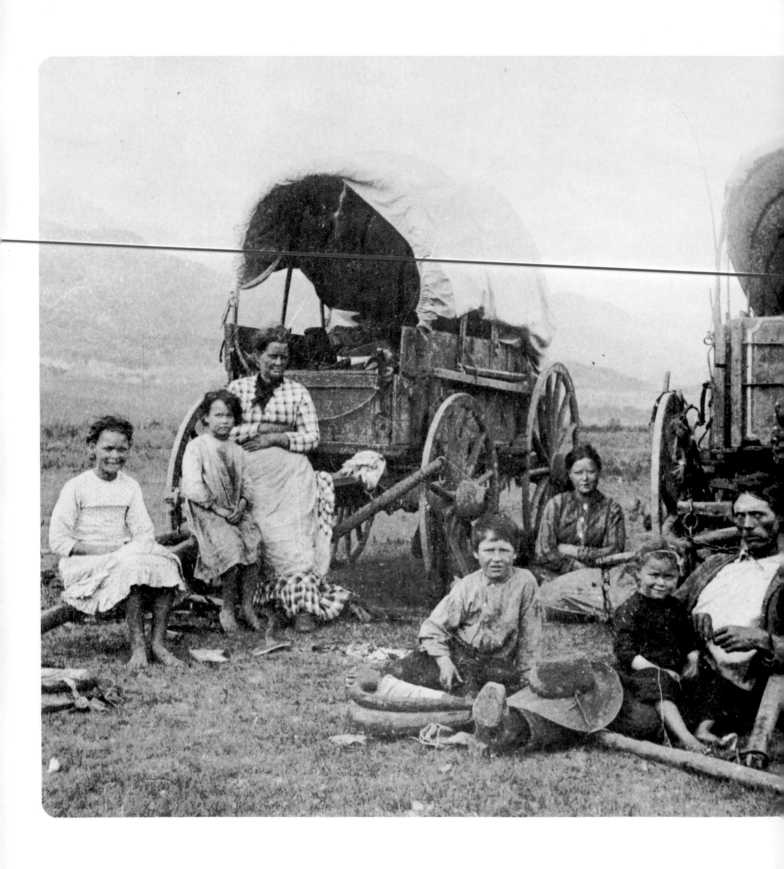

Ho! For Oregon! THE TREK THAT FED THE TOWNS

Bidding farewell to the lives they had known, increasing numbers of Americans undertook the overland trek to Oregon in the late 1830's. The famous Lewis and Clark Expedition had paved the way in 1804-5, and eight years later Robert Stuart, a Scotsman, blazed the more southerly route which would become known as the Oregon Trail. Next came a smattering of trappers, explorers, and missionaries. But not until a nation-wide depression in 1837 left millions nearly destitute were great numbers of settlers spurred to make the arduous journey west. Adding patriotic luster to the promise of free land in Oregon's fertile valleys was the widespread popular belief that it was the nation's "manifest destiny" to expand from sea to shining sea.

In the early 1840's, the trickle of wagons rolling west out of Missouri became a flood. But many of the pioneers were naively ill-prepared for the rigorous journey. Western geography confronted them with extreme challenges, from plunging mountain gorges, where wagons had to be lowered on ropes, to parched deserts, littered with the whited bones of those who hadn't made it. Quicksand claimed the lives of oxen; boulders cracked the wagons' axletrees; torrential rapids threatened to sweep away whole convoys. Dust, insects, wind, snow, and terrifying thunderstorms all added to the strain. Indians were sometimes friendly—often hostile. Buffalo, an important source of meat and hides, sometimes thundered across the plains in dangerous stampedes.

Less obvious, but just as severe, were the human problems. Unprepared for adversity, many immigrants fell to bickering over such questions as who should stand guard at night, or whose family and livestock should drink first at a water hole. Sometimes so much bitterness developed that the wagon train would split into separate groups, traveling miles apart. Strong, knowledgeable leadership was essential to guide the way, to overrule the bickering, and to enforce the one absolute law: keep going!

In their lighter moods, the travelers sang, danced, and prayed around their campfires. Although their five-month, two-thousand-mile journey would leave them exhausted and penniless, they were sustained by the promise of a new and better life ahead. Their rough-hewn optimism, sense of freedom, and capacity for hard work would become key qualities in that newly emergent American, "the Westerner."

DETERMINED to get there, these westering pioneers have paused to let their livestock graze, and to rest their own weary bones from the ceaseless jolting of the covered wagons.

HARDMAN, OREGON
ON AND OFF THE LINE

a GHOST TOWN worth seeing

From Pendleton, go twenty-three miles southwest on U.S. 395, then take State 74 thirty-seven miles to Heppner. Go eleven miles southeast on 206/207, take southern fork (207) another nine miles to Hardman. Alternate route north from Mitchell, on U.S. 26, passes ghost town of Richmond.

Transportation was Hardman's life—and death. From the 1860's on, stagecoaches and freight wagons labored ceaselessly across the plains east of the Cascades, supplying local farmers and miners and carrying their goods to market. Planted in an ocean of wheatfields, with pine forests brooding in the near distance, the little settlement of Dairyville became a favorite stopping point for the freighters and stage drivers. Dairyville became popularly known as "Raw Dog," and less than a mile away a rival settlement sprang up, known as "Yallerdog." At first, in the manner of so many frontier towns, the two struggled fiercely for supremacy. But eventually they amalgamated, to become "Dog Town." In the meantime a nearby farmer named David N. Hardman had been operating the post office out of his house. As the new community prospered and grew, he moved to town, bringing his post office with him. And so Dog Town changed its name again —to Hardman.

From sawmills in the nearby Blue Mountains came a steady supply of board lumber. After 1910, farmers from miles around brought their wheat to be ground in Hardman's big mill. To accommodate free-spending travelers, hotels went up, and when the railroad came puffing into eastern Oregon, everyone naturally assumed Hardman would be on the line.

But they were wrong, and as staging and wagon freighting inevitably declined, so did Hardman. Today, horses and sheep meander through its vacant streets, grazing in former front yards. Hens cluck angrily at unfamiliar visitors, and the post office that prompted Dog Town to change its name has recently closed its doors.

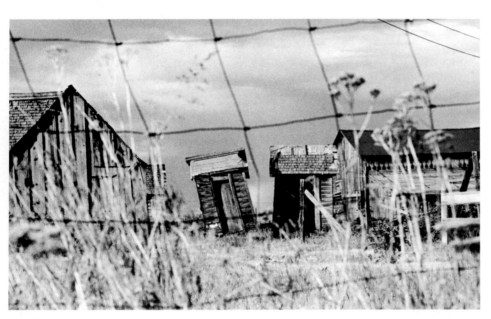

JUMBLE of frame structures, some intermittently occupied, comprise Hardman. Free-ranging animals add to the atmosphere of strangeness.

WARMING in the light of early morning, Hardman's Odd Fellows Hall rests beside the endless plains whose wheat once brought prosperity to the town

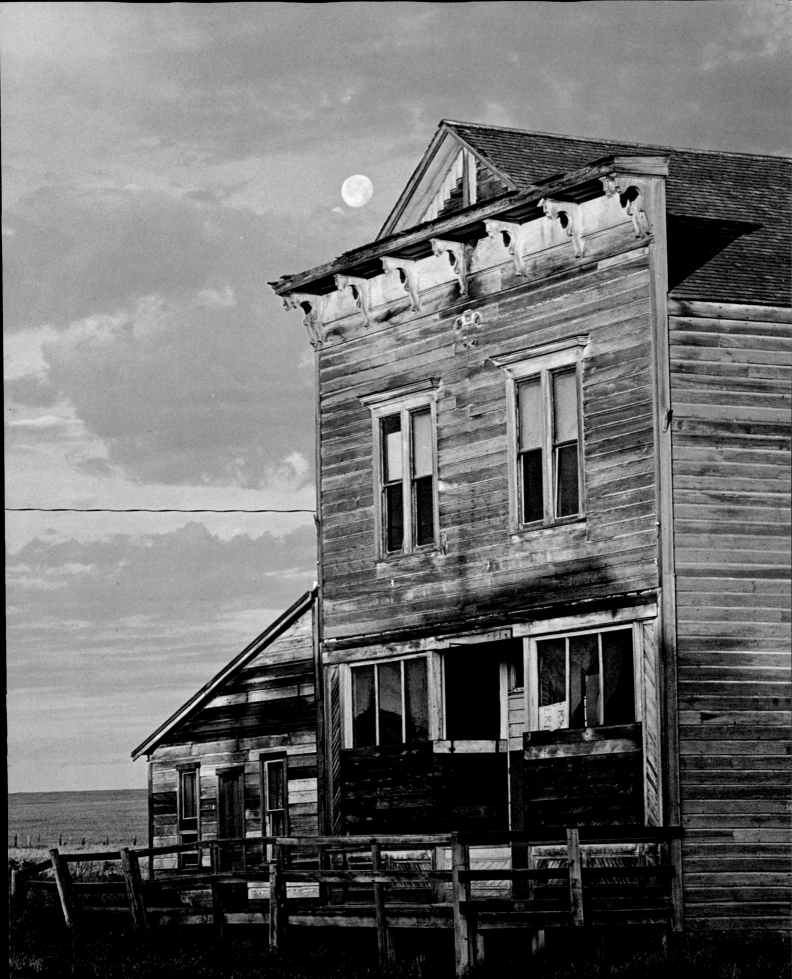

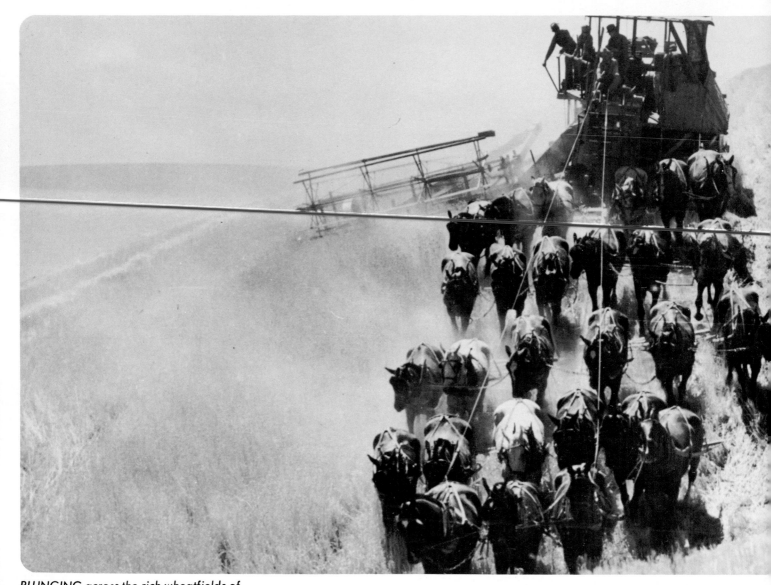

PLUNGING across the rich wheatfields of eastern Washington, a twenty-seven-horse team pulls a harvesting combine. In the nineteenth century, farming prospered east of the Cascades at first, but then declined, leaving agricultural ghost towns.

The Land Bloomed: LIFE AND DEATH OF FARM TOWNS

If mining was the dynamite of western expansion, farming was its wheel and axle. The cry, FREE LAND! drew thousands of immigrants to Oregon Territory in the 1840's and 50's. As the century progressed, agriculture rivaled mining as the West Coast's leading enterprise.

Many of the farmers had moved more than once. They had left New England's exhausted fields to settle in the Middle Atlantic States or Midwest, then pulled up stakes again to join the westering wagon trains. Many who pursued the Oregon Trail came to the rich Willamette Valley, near Portland. Although Oregon lost two-thirds of her adult male population to California's gold rush, Willamette agriculture boomed as hundreds of ships raced up from San Francisco, offering high prices for food. Wheat, previously declared a form of legal tender at a dollar a bushel, skyrocketed to six dollars a bushel.

After 1861 good Willamette land was becoming scarce, and wheat farmers followed the miners to the rolling plains of central and eastern Oregon. With the Columbia River providing a natural shipping lane, the movement quickly spread to eastern Washington, where the number of farms tripled in ten years. The coming of the railroads in the 1880's gave the farmers a further boost.

By the 1870's the cattlemen, too, were discovering good lands east of the Cascades. Many brought herds west over the Oregon Trail to these ranges, where the bunch grass grew stirrup-high and the cattleman was king—until the sheepherder arrived. Then came bitter range warfare, complicated by the appearance of land speculators and homesteaders.

But just when big-time promoters were starting to plan whole new agricultural communities, negative signs appeared: overproduction, uncertain market conditions, and two severe winters, which wiped out several herds and discouraged many farmers. One of them quipped:

> If I can make enough in time
> To take me out of this cold clime
> You bet your life I'll stomp away
> From Oregon and the John Day.

Soon the farmers saw their sons lured away to new enterprises in the rich forests and expanding cities. In the ten years after 1880, Oregon's farms dropped in value from about fifty percent to twenty-seven percent of the State's assessed wealth. The trend in eastern Washington was the same. And after the turn of the century, new waves of homesteaders, journeying from the East to eastern Oregon, found it impossible to live off the land, and either turned back or pushed on to the coast.

So it happened that agriculture, although not so fickle a mistress as mining, created some ghost towns of its own.

CLASSIC FIGURES, immigrant farmers toil the Oregon soil. The rich Willamette Valley was the destination for thousands of farmers whose eastern lands had become nearly exhausted.

Offbeat Oregon:
HIGH, WIDE, AND CREAKY

East of the Cascades, Oregon's high, dry plateau country stretches across wide-open spaces, then folds and greens into the Umatilla National Forest. Finally, the land wrenches upward into the precipitous peaks and canyons of the Wallowa Mountains. This whole region comprises the state's best quadrant for ghost towning. In the plateaus the creaky settlements derive from ranching and farming; in the forests they date back to the early mining excitements.

As the map below indicates, these ghosts and semi-ghosts are fairly evenly distributed. Invaluable further aids to the traveler include the U.S. National Forest Maps, the State Highway Division's County Maps, and the *Sunset Travel Guide to Oregon*.

The rusting ore carts and venerable mine shed (right) are at Cornucopia. Though heavy snows have collapsed many of the town's more fragile structures, there's still plenty to explore.

- ⚒ True Ghost Town
- ✳ Partial Ghost Town
- ★ Tourist Ghost Town
- --- Unimproved Road

Walla Walla

WASHINGTON
OREGON

Flora ⚒

Columbia River

To Portland

Pendleton

Olex ✳

Heppner

Pine Grove ⚒

La Grande

Joseph ★

Kent ✳

Hardman ⚒

Lonerock ✳

Cornucopia ⚒

Shaniko ★

Fossil ✳

Baker

Halfway

Granite ⚒

Bourne ⚒

Ashwood ✳

Richmond ⚒

Greenhorn ⚒

Sumpter ✳

Richland

Bonanza ⚒

Howard ⚒

John Day

Scale in Miles
0 10 20 30

Canyon City ✳

Huntington

To Boise

OREGON
IDAHO

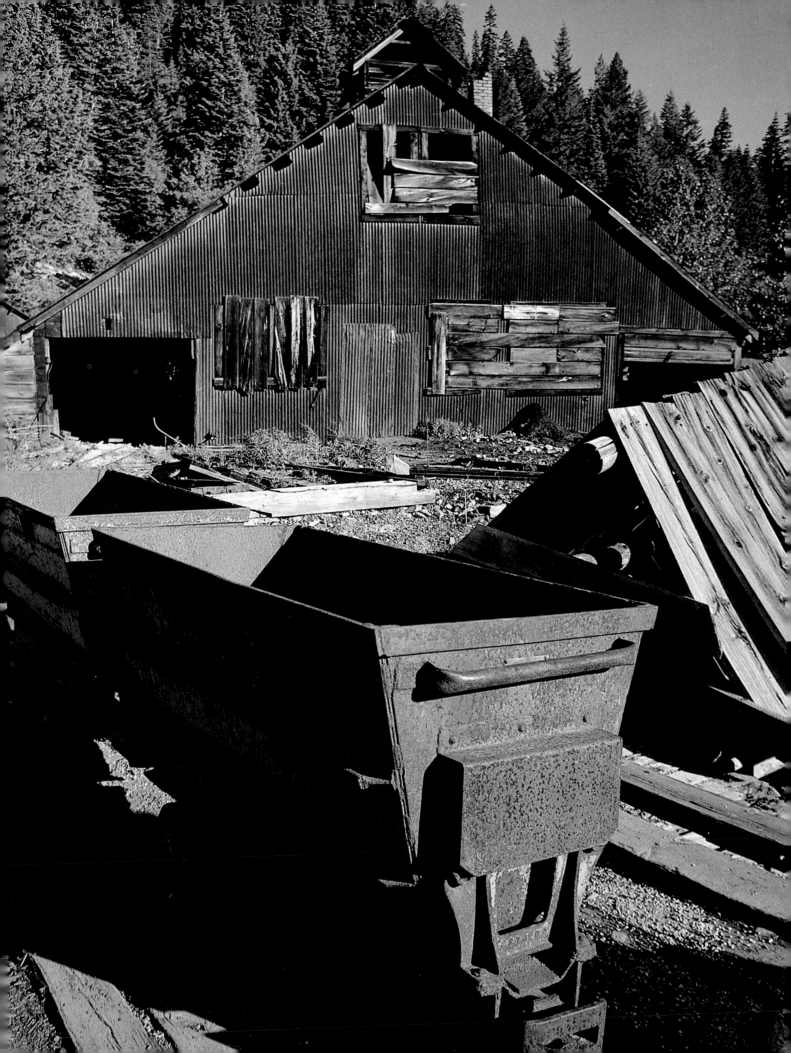

BAKED by the sun and shivered by the wind, the clapboards of Flora haven't seen paint in many a summer. This farm town of the 1890's recently comprised twenty-five souls, sixty-five buildings, and nine outhouses.

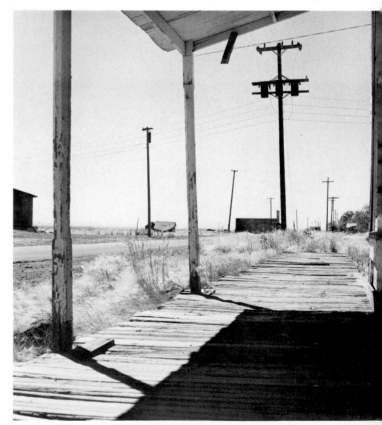

SPLINTERED BOARDWALK leads past blind windows and peeling posts to end nowhere-in-particular in the faded community of Kent. Sixteen miles north of better-known Shaniko, Kent retains its tiny post office but is a half-dead version of its former self.

WELL-KEPT Methodist Church stares across a little dell at a vacant schoolhouse in the true ghost of Richmond. The town's other three buildings are but dark and gutted shells.

LEFT OVER from the days when wool and grain shipping made Shaniko a frontier principality, this unusual schoolhouse stands some distance from the center of town. Though it has added some tourist-conscious elements, Shaniko remains a funky spot.

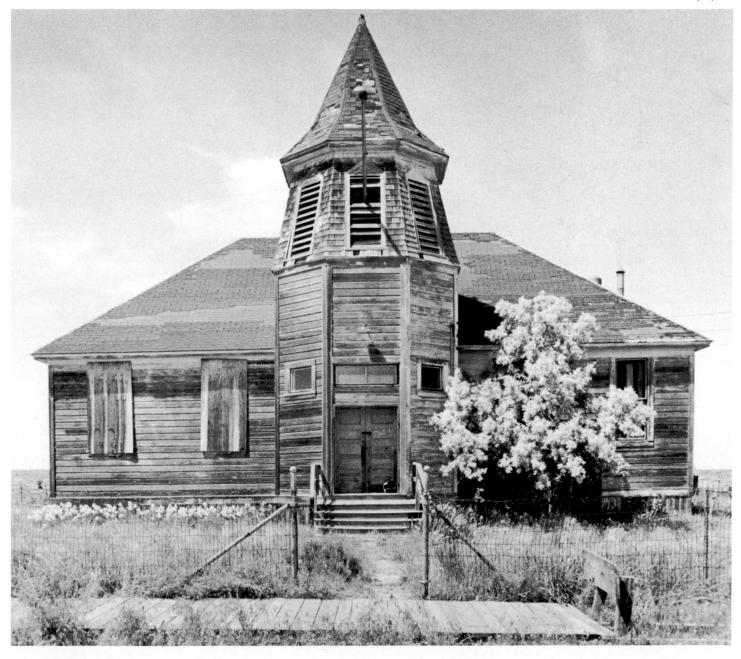

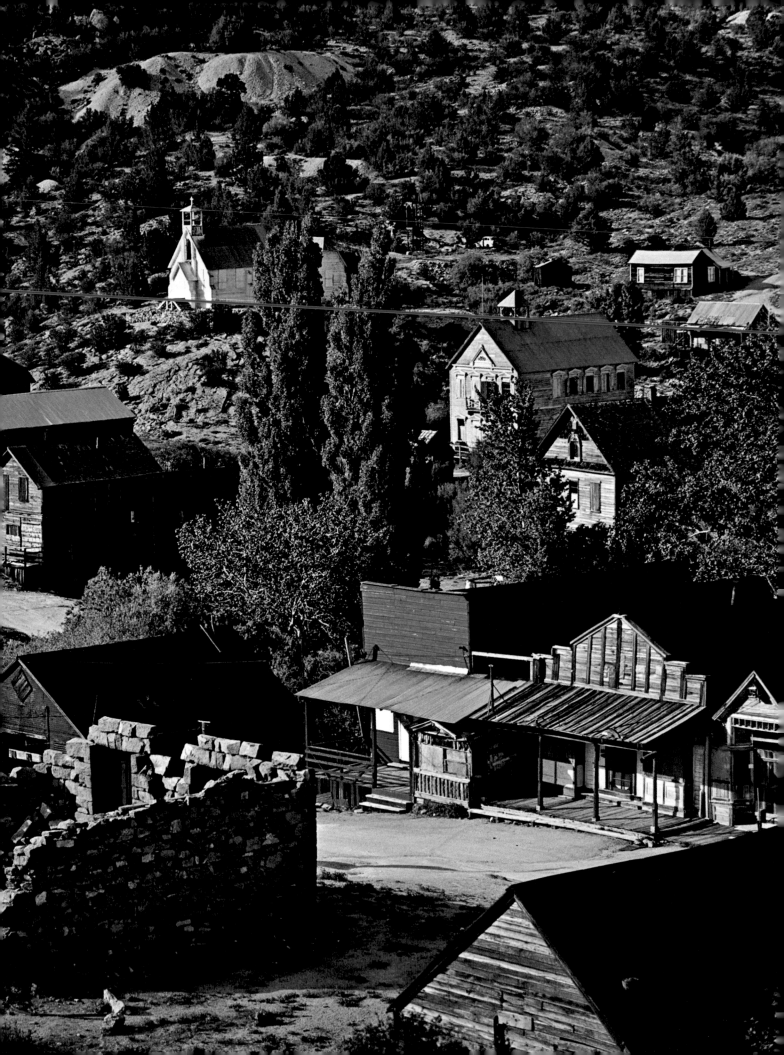

SILVER CITY, IDAHO
QUIXOTIC QUEEN OF GHOSTS

Happily, Silver may be saved. In 1977, after years of wrangling between hard-nosed companies, many-layered bureaucracies, idealistic historians, and a cantankerous part-time citizenry, excellent prospects were reported: no change.

The twisting, bumpy road into town would remain unimproved. The tottering Idaho Hotel—its second-story outhouses perched on stilts and connected to the main building by dizzying catwalks—would continue to offer meals but not rooms. The Owyhee County Cattlemen's Association would still clomp into town for its yearly wingding.

While grave architectural surveys, zoning restrictions, and environmental impact statements proceeded apace, just plain folks would look after their own places as always. After decades of deliberation, the owners of the gingerbready Stoddard house allowed as how they were refurbishing it and getting ready to show it off to tourists. All of this—especially the nice, bad road and lack of any new Gifte Shoppes—seemed to spell success in the struggle to maintain this old queen's spirited authenticity.

Her birth, a century ago, was explosive. But in the usual way of mining camps, the swollen population suddenly shrank when the ores appeared to dwindle. When the mines revived, Silver boomed anew, only to fade gradually, reaching ghost-town status by 1940.

If you continue down along Jordan Creek, you pass the sites of Ruby City and Dewey, and arrive at De Lamar. Here a very different scenario is being enacted: formerly more dead than Silver, De Lamar has suddenly sprung back to life. A mining company is reportedly taking out $1 million a month in gold and silver; a paved road from Jordan Valley is planned; and the picturesque old bunkhouse is being considered for preservation as a visitors' center.

a GHOST TOWN worth seeing

From Boise, go sixteen miles west to Nampa on U.S. 30, then twenty-eight miles south to Murphy on State 45. Here, get directions to either of two unpaved roads, both rather rough, leading to town of Silver City.

SILVER CITY, IDAHO, 1971

1. Church
2. School
3. Stoddard Mansion
4. Masonic Hall
5. Tin Shop
6. Avalanche Newspaper
7. Idaho Hotel
8. Hotel
9. Bar and Store
10. Lippincott Building
11. Post Office
12. Cemetery
13. Chinese Laundry
14. I.O.O.F. Hall
15. Bank
16. Saloon
17. Store
18. Court House
19. Ice House
20. Butcher Shop
21. Leonard's Store
22. Barber Shop
23. Undertaker and Hotel Rooms
24. Miners' Union Hospital

LOOKING NORTH, you see the barber shop and Leonard's Store in the right foreground. The large gray building to right of center is the schoolhouse; to the left and up the hill is the Catholic Church.

DRESSED UP in their Sunday best—perhaps for a wedding—these
good friends pose on the front porch of a Silver City cabin
in the days when the town was still very much alive.

BIG-HATTED members of the Owyhee County Cattlemen's Association still gather one weekend a year at Silver City, Idaho, for a little serious business and a lot of hell-raising. Business is handled in the old schoolhouse (below); the rest goes on day and night, wherever the spirits are flowing.

SHAPES OF YESTERYEAR grace the second floor of the schoolhouse, which has been turned into a museum.

CARPENTER-GOTHIC touches on a number of Silver's quaint buildings were largely the contribution of a craftsman who came to Silver City from Germany.

GINGERBREAD of the photogenic Stoddard house is beginning to crumble. Entrepreneur J. W. Stoddard owned mining shares, a sawmill, and a cattle ranch.

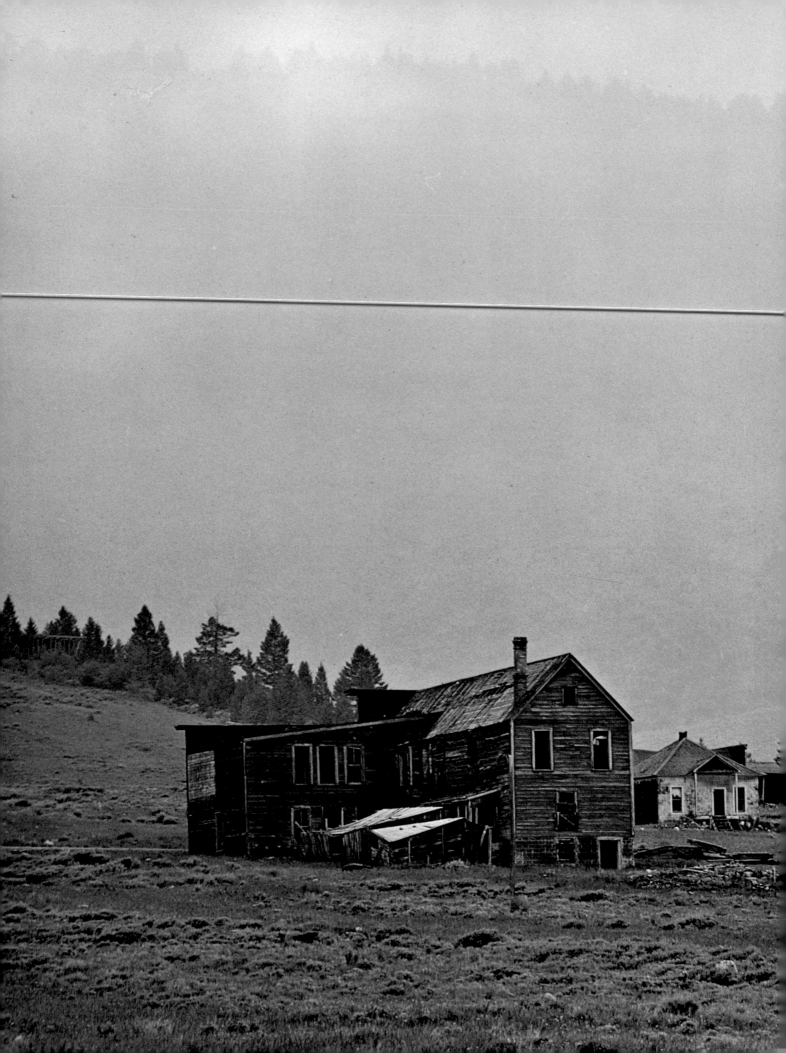

The Other Idaho:
SOME OFFBEAT SURPRISES

Famous for whitewater rivers and pristine forests, central Idaho's mountain wilderness also shelters some very offbeat ghost towns.

Pictured on these and the following pages are some of the better-known ones. Florence, though no longer a ghost, nevertheless holds historic interest. Abandoned dredges, mills, and such, rather than actual towns, remain at Millers Camp, Warrens, Marshall Lake Mines, and the Werdenhoff/Red Metals area north of Big Creek (they require four-wheel drive). Chief survivor at Stibnite is a big recreation hall. Roosevelt's buildings are best seen on a windless day—for they are under water! Whether the many 1940's-vintage, empty buildings at partly occupied Cobalt make it a ghost town depends on your definition of one.

Map legend:
- ✘ True Ghost Town
- ⊛ Partial Ghost Town
- ★ Tourist Ghost Town
- --- Unimproved Road

Scale in Miles
0 10 20 30

Map locations: Florence, Marshall Lake Mines, Warrens, Werdenhoff Mill, Millers Camp, Yellow Pine, McCall, Stibnite, Roosevelt; Dewey and Sunnyside Mines, Yellowjacket, Cobalt, Shoup, Ulysses, Leesburg, Salmon, Bannack, Cascade, Ivers, Custer, Bonanza, Bay Horse, Challis, Leadore, Gilmore, Nicholia Charcoal Kilns, Montana/Idaho

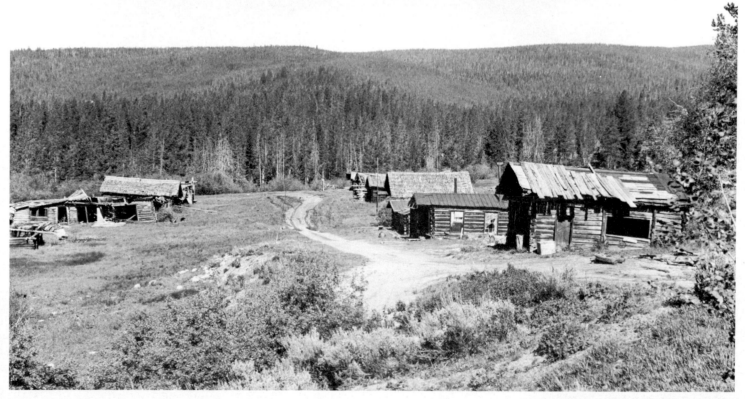

SPLINTERED AND SAGGING with age, the old cabins of Leesburg still present a brave front to the dirt road that winds through this scenic part of Idaho.

REMOTE Gilmore crouches under foggy, forested hills (left). Some $12 million worth of lead and silver ores had been shipped from here by 1929, but the Depression killed the town. Building at center is Jaggers Hotel.

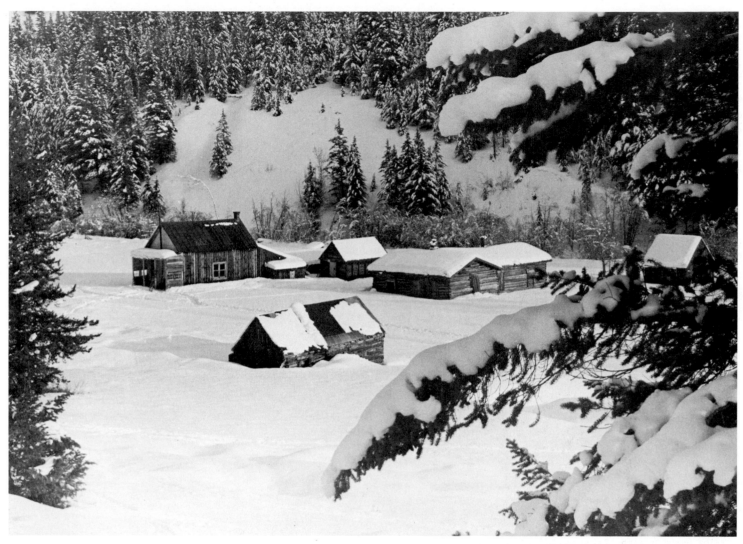

SNOWS OF WINTER nearly eclipse the once-thriving mining camp of Custer. For summer tourists, the town's focuses of interest are the McGown museum, housed in a former schoolhouse, and a large gold dredge on the road to Bonanza, another ghost town.

ESTLED in a narrow canyon, ay Horse is one of Idaho's etter-known ghost towns. esides several structures in arying stages of collapse, ere are beehive coke ovens, huge old mill, and other emorabilia.

a GHOST TOWN worth seeing

From Trail, B.C., go thirty-one miles northeast on Prov. 13 to South Slocan, then cut north on Prov. 6, forty-two miles to New Denver. Turn east on gravel road for six miles, then right again on an even poorer road for two miles to Sandon.

Hacked out of the sheer cliff wall, the narrow road snakes north only yards above gleaming Slocan Lake. All around you, snow-capped mountains loom higher and higher. In 1892, a Virginian named Johnny Harris came this way by canoe. When it overturned he made his way up into the rugged mountains on foot—and struck a rich vein of silver. To follow in his footsteps, turn right at the little outpost of New Denver. When the unpaved road drops into a dark canyon, you find yourself in Sandon, the town Johnny Harris founded.

Or what's left of it. The site is strewn with battered planks and logs, and Carpenter Creek churns through what used to be Sandon's downtown. Originally, the main buildings were huddled against the side of the narrow canyon; but in 1900, following a disastrous fire, Harris flumed and narrowed the stream and built boardwalks over it, thus transforming Carpenter Creek into Sandon's main street. Fifty-five years later, with the former mining camp already a virtual ghost, the log-jammed water suddenly burst from its confines, ripping away the boardwalks, upending buildings, undermining others, and scattering wreckage everywhere. Incredibly, some of the buildings survived, and are still well worth seeing.

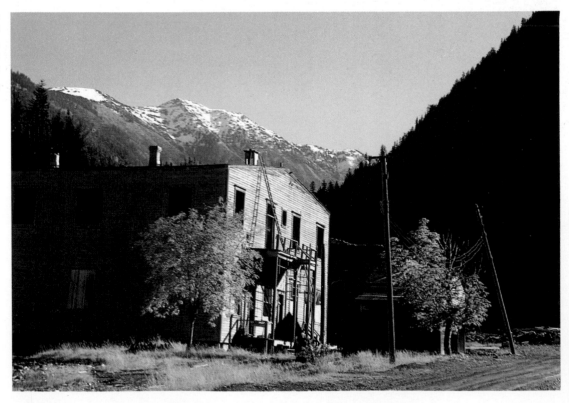

FALL SNOW caps Paddy Peak, rising to the east of Sandon. The slopes between are pocked with abandoned mines. Building in foreground is Johnny Harris's "Virginia Block."

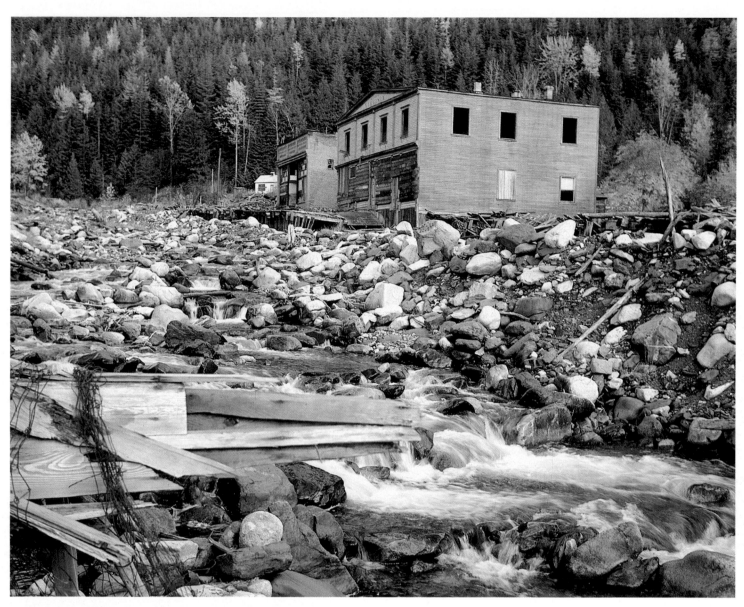

RUSHING WATERS of Carpenter Creek destroyed much of Sandon, including the boardwalk that once covered the creek, in the flood of 1955. Among the buildings that survived are the office building of the town's founder, Johnny Harris (two-story structure, above), and Hunter's General Store (behind it).

HUDDLING along roaring Carpenter Creek in 1898, Sandon was a perfect fire trap, and two years later fire wiped out more than fifty downtown buildings. The town was rebuilt according to a unique plan that called for boardwalks to cover portions of the creek.

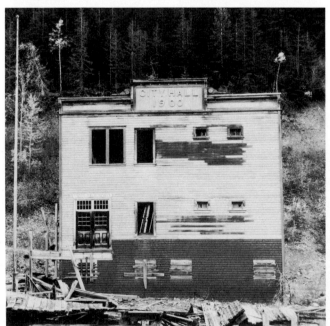

REBUILT after the 1900 fire, most of Sandon's larger buildings were wiped out for good by the 1955 flood. The City Hall was one of the few to survive this second disaster.

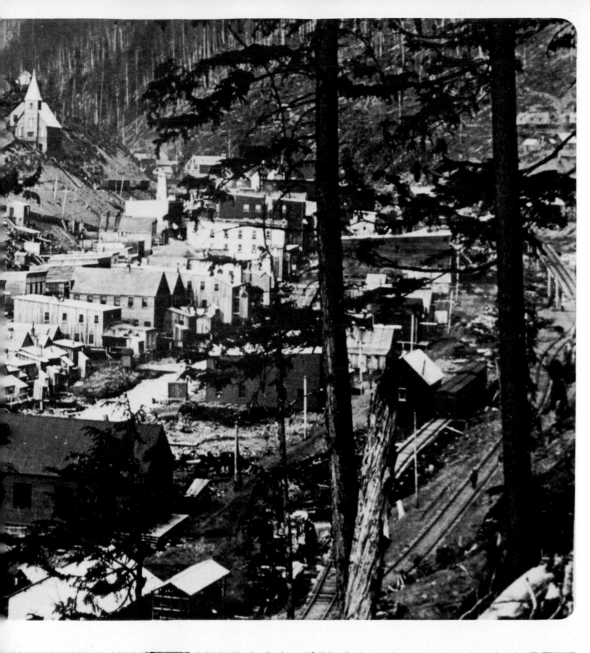

RED LIGHT section escaped the raging flood in 1955 because it was built on higher ground, apart from the rest of town.

Signs of the Times: BOOSTING THE BOOMTOWNS

The boisterous individualism of the exploding West
found ready expression in the sign-maker's craft.
Plastered with posters and placards, wallside pitches
and false-front pronouncements, today's wry
ghost towns trumpet their exuberant yesterdays.

BRICK, metal, wood, cardboard, bottle tops—anything would do. Resounding through silent streets, these ghost-town-criers still carry the boisterous accents of the Old West.

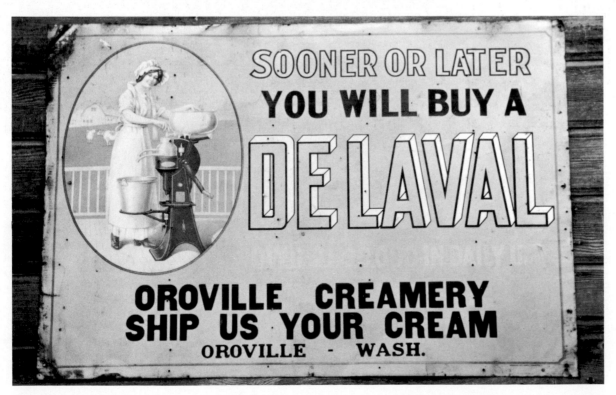

Oroville's Orbit: GHOSTS OF NORTHERN WASHINGTON & SOUTHERN BRITISH COLUMBIA

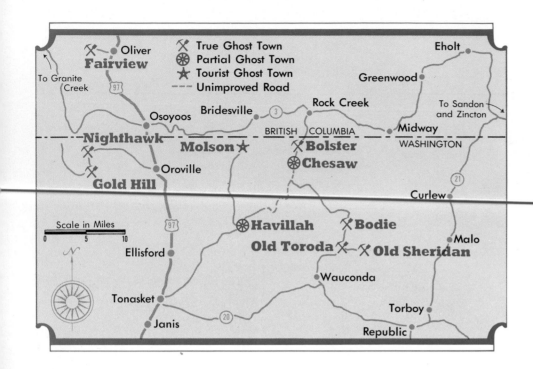

Map legend:
- ✗ True Ghost Town
- ⊛ Partial Ghost Town
- ★ Tourist Ghost Town
- --- Unimproved Road

Map locations: To Granite Creek, Oliver, Fairview, Eholt, Greenwood, Osoyoos, Bridesville, Rock Creek, To Sandon and Zincton, Nighthawk, Molson, Bolster, Midway, BRITISH COLUMBIA, WASHINGTON, Oroville, Chesaw, Gold Hill, Curlew, Havillah, Bodie, Old Toroda, Old Sheridan, Malo, Ellisford, Wauconda, Tonasket, Torboy, Janis, Republic

Scale in Miles: 0 5 10

Washington's Okanogan Valley and high-lands, and the adjoining parts of Canada, are wonderful areas to visit in autumn. Most of the fishermen and other visitors have gone home. The throaty wildfowl have come back to honk and splash down in the lakes. Washington's premier apples are sweet and snappy. Crisp nights tint the larches and birches a brilliant gold, and the ghostly old homesteads and tiny mining camps are perfect for photography.

Except for the apples, this has always been a marginal region for agriculture. The scattered record of homesteaders who farmed and failed in the first decades of this century is plain enough: dilapidated fences, sagging barns, hollow-eyed houses. At Molson, an abandoned frontier village that has been turned into a historical mu-seum, you can see steam-powered threshers, old-time offices, and personal artifacts.

Farther off the beaten track are pure ghosts for which such navigational aids as the Okanogan and Colville National Forest maps, and the Department of Highways' Okanogan and Ferry county maps, are strongly advised. (Obtain them well in ad-vance.) For Canada, detailed topographic maps may be ordered from the Department of Mines and Technical Surveys, Ottawa.

TYPICAL LOG CABIN CORNERS

VARIETY of notching styles appeared in log cabins throughout the West as a result of mingling cultural influences and the Yankee habit of improvising. Even in a single structure there might be two different types of notches.

SADDLE NOTCH, TOP AND BOTTOM

REGULAR V-NOTCH

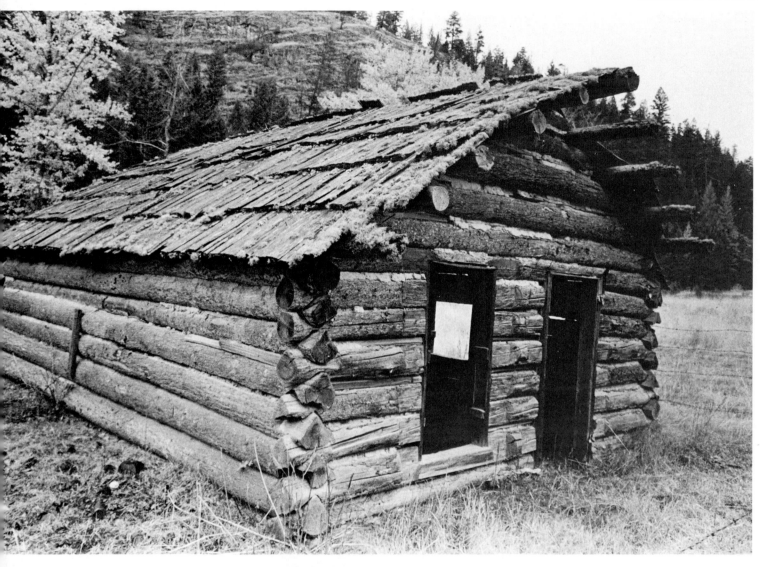

MOSS gathers on an abandoned log cabin near Old Toroda, in Washington's Okanogan National Forest, southeast of Oroville.

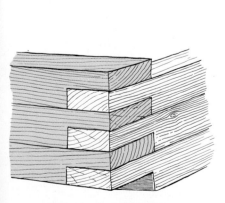

OVERLAPPING HALF-NOTCH

DOUBLE LOCKING NOTCH

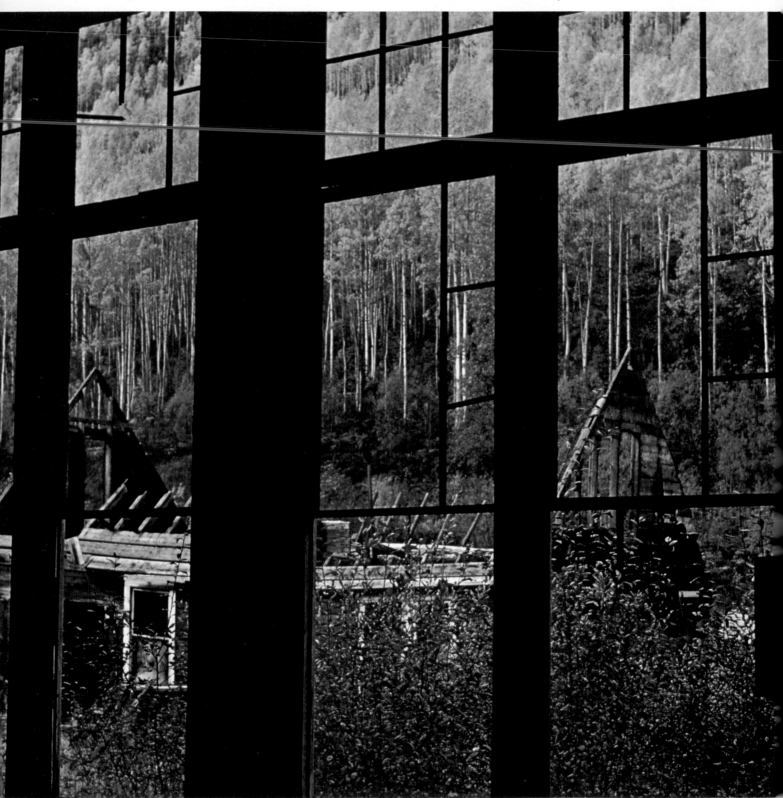

SPLENDOR OF FALL COLOR is framed in the punched-out
windows of the ore mill at Zincton, B.C. As its name implies,
the town produced zinc and other base metals.

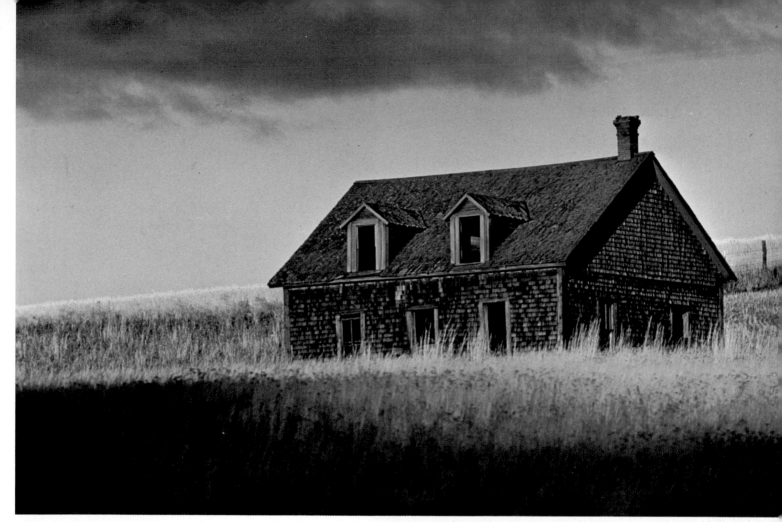

MYSTERY SHROUDS this and many another abandoned farmhouse east of Oroville, Washington, in a ghostly, remote strip just below the Canadian frontier.

GLOW of autumn permeates a log dwelling at Granite Creek, B.C. Though it boomed only from 1885 to about 1912, the gold camp was then the third largest community in the province.

Ghosts of the Far North:
STILL A FRONTIER

Mark "largely unexplored" on the maps below. For although our information is considered reliable, no one has been able to check all the Alaska ghost towns in person, and some probably are still unreported.

The Yukon and southern Alaska, of course, had their own gold rush in 1898. The ghosts of that brief stampede, and of the recent abandonment of the Yukon River as a commercial artery, are well documented (see map, page 183).

But the far-flung ghosts of central Alaska derive from varied times, cultures, and enterprises. Iditarod, for example, sprang up about 1910 as a commercial center for the newly opened gold mines on nearby Otter Creek. Long a total ghost, by 1972 it had sixteen buildings left.

But Iditarod is extremely remote. It is built in the middle of a vast swamp overlying permafrost. Its temperature varies from 90° above to 90° below zero. As noted by one official report: "It is very dangerous to go there in the hot summer months without adequate equipment and insect repellent . . . The insects are hazardous to both mental and physical health of individuals. Because they are so numerous, they have been known to kill dogs and drive men crazy."

By contrast, other northern ghosts are associated with copper booms or with the construction of the Alaskan Pipeline. Some are deserted Eskimo villages. The Aleutian Islands are dotted with remains of World War II air bases.

If you do go exploring on Alaska's ghost town frontier, we'd like to know what you find.

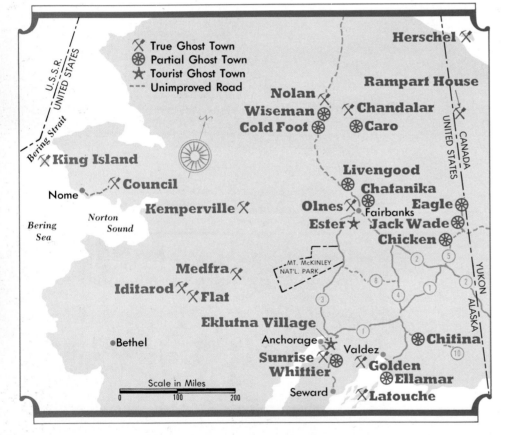

HIGH ADVENTURE rewards *few ghost town explorers w* *approach the deserted Eski* *village on tiny King Islan* *It lies in the Bering Sea,* *miles west of Alaska and 1* *miles southeast of the mainla* *of Russ*

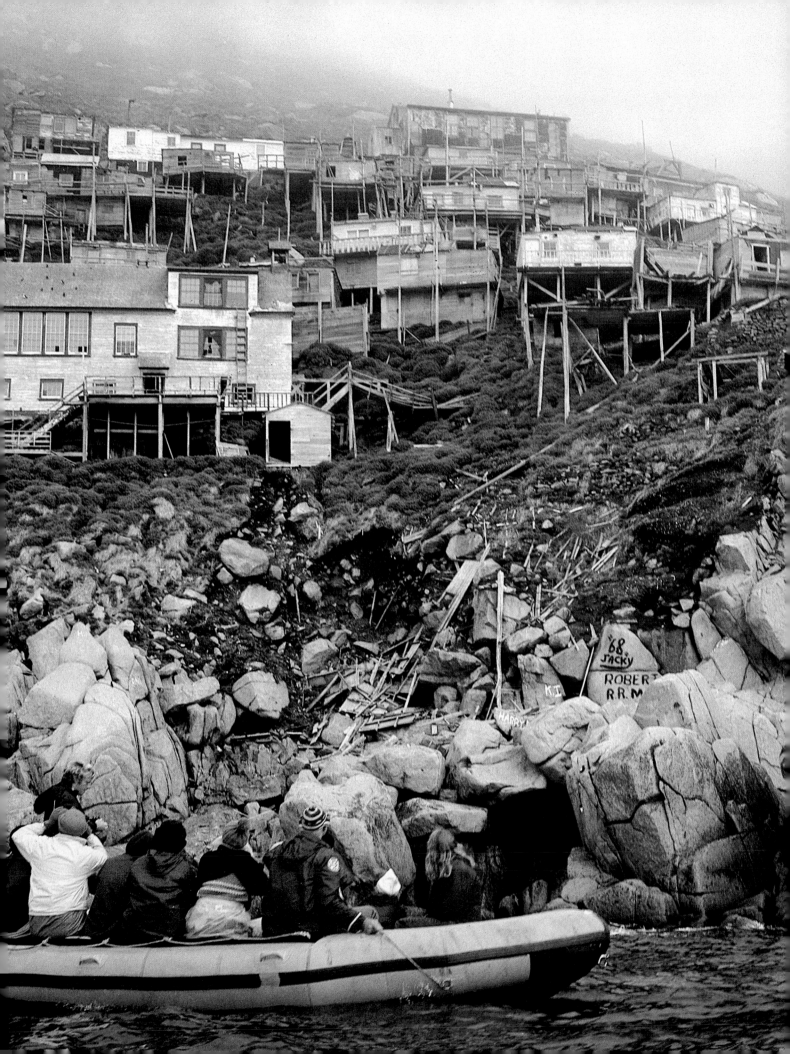

FAÇADE WITH FLOWERS marks
the ghost town of Discovery,
near Atlin, B.C., which is due
east of Skagway, in southern
Alaska. (See map, page 183.)

GORGEOUS SETTING over-
looking Lake Bennett inspired
Klondike gold rushees to start
building this Presbyterian
Church at Bennett, B.C. (see
map, page 183). So fickle were
the fortunes of those times,
however, that the pretty
building was never finished.

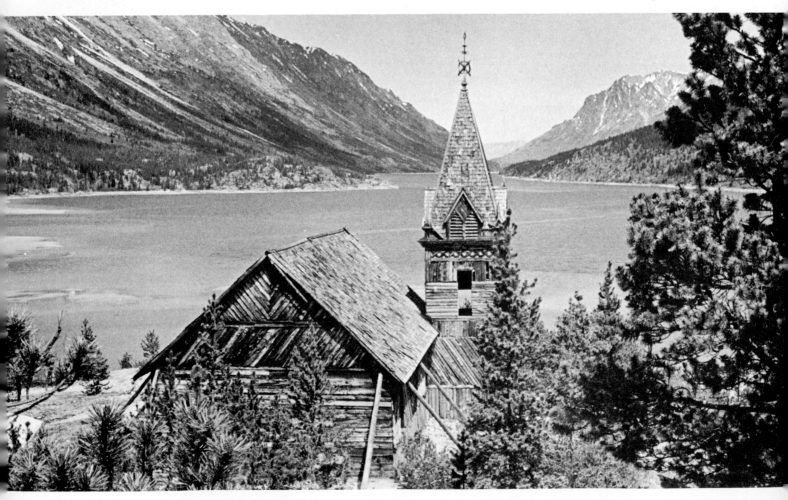

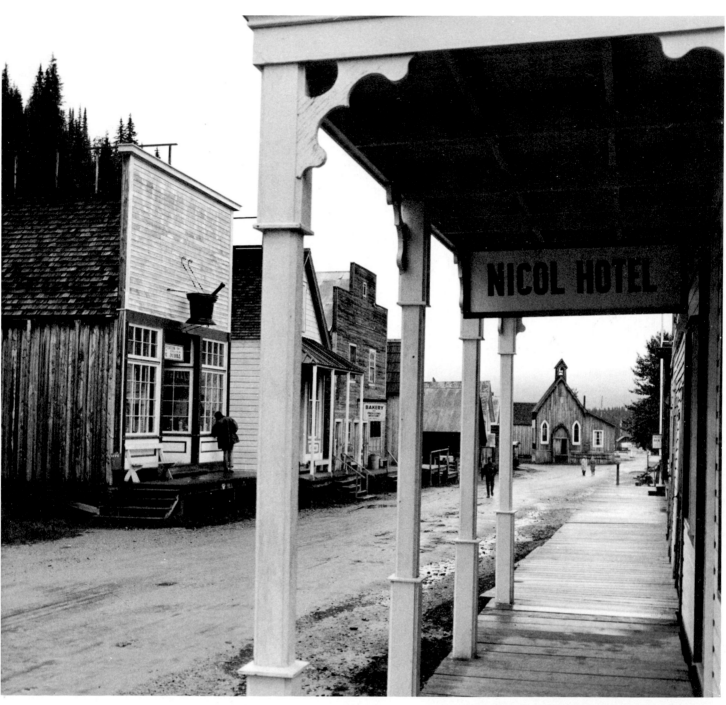

AMONG THE BEST PRESERVED of all ghost towns is Barkerville, B.C. Following the abortive Fraser River gold rush, the British pushed the ''Great North Road'' 400 miles up into the Cariboo Country, where it reached the fabulous gold camp of Barkerville in 1865. Little by little, this meticulously restored tourist attraction is expanding. (See map, page 182.)

STOUT YUKON GHOSTS have survived many heavy winter snows. Silver City, on Lake Kluane (below), lies quite close to the recently completed Alaska Highway. Fort Selkirk, on the Yukon River (below, right), is a highlight of the canoe journeys which are becoming increasingly popular. (See map, page 183.) Most remote is abandoned Rampart House (right), which lies on the Porcupine River, north of the Arctic Circle, at the U.S.-Canadian frontier. (See map, page 176.)

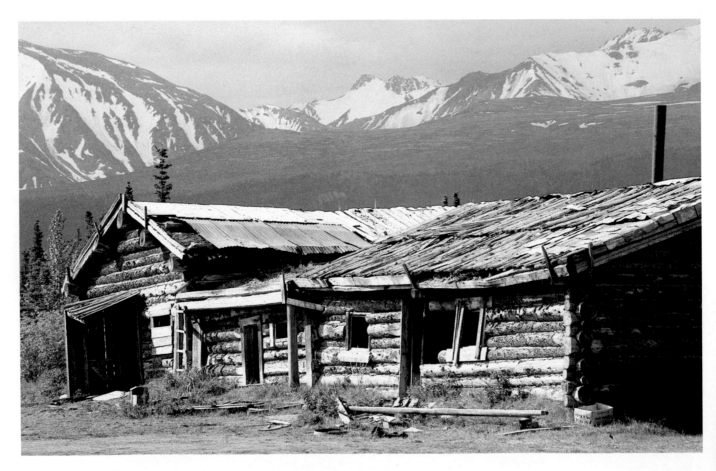

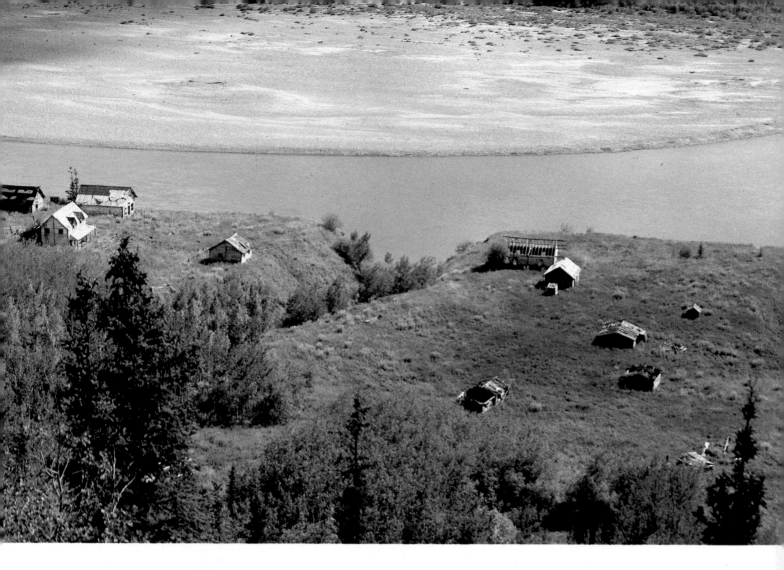

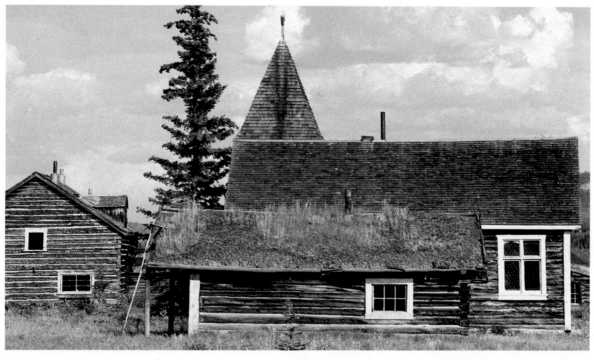

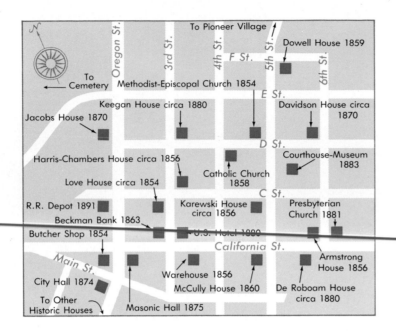

JACKSONVILLE, OREGON

Among several reminders of early mining days in southwestern Oregon, **Jacksonville** is the real standout. Booming as a mining camp in the 1850's, then evolving as a busy agricultural center and county seat, it declined gradually in this century but never actually died. For the past generation its residents have been working hard to preserve its wonderful architectural character. Situated just north of the map section is a recent addition: "Pioneer Village," a collection of relocated historic buildings which have been well stocked and surrounded with memorabilia illustrating life in the early days. Among some eighty existing structures which have been marked and dated in Jacksonville proper, those shown on the map are standouts.

Ghost town purists will want to know, as well, about the true ghost towns of Golden, Greenback, and Placer, all northeast of Grants Pass. Of secondary interest as a tourist ghost is the reconstructed mining camp of Kerbyville at Kerby.

CENTRAL BRITISH COLUMBIA

The far-flung ghosts of this sparsely populated land recall many eras, many enterprises. As our map shows, some are accessible by road, others may require a boat or even an airlift.

Easily the regional star is **Barkerville** (see photo, page 179). Once the gold rush capital of British Columbia, it is now among the best-restored ghosts anywhere, with over seventy historic structures and many tourist activities. Off-the-beaten-path buffs may also search out the scantier remains of nearby **Grouse Creek**, **Quesnell Forks**, and **Bullion**. The broad Fraser Plateau country to the southwest is dotted with such semi-ghosts as **Anahim Lake** and **Redstone**.

Log-walled **Fort St. James** is a prime attraction just off the scenic Yellowhead Highway, which leads to the Pacific after crossing the Rockies. This historic Hudson's Bay trading post is authentically restored to the period of the 1890's, with fur pelts hanging from the rafters. Farther west is the reconstructed Gitksan Indian village of 'Ksan. Fine totem poles can also be seen at nearby **Kispiox**, **Kitwancool**, and **Kitwanga**.

The large, remote Queen Charlotte Islands hold many natural beauties for the adventurous hiker and boater. Several deserted settlements can also be explored. **Marble Island** has an abandoned radar station; **Naden** and **Rose Harbour** are defunct whaling outposts; and **Ikeda** shelters a deserted radio station and copper mine. Abandoned logging camps include **Moresby** and **Aero**. But the Queen Charlotte Islands' unique, if dwindling, treasures are her deserted Indian villages, of which totem-fronted **Ninstints**, **Skedans**, and **Tanu** are the most notable.

The Northwest

THE YUKON TRAIL

Though the gold rush of 1897–98 was the most glamorous ghost-maker of the far north, the subsequent, less heralded steamboat era, which lasted half a century in these parts, left a residue that is today more clearly visible. Not until the 1950's did the completion of the Alaska Highway doom commercial traffic on the Yukon River. This famous artery fell silent for twenty years—until reawakened by the explosion of recreation in the 70's. Some of its ghost towns may be preserved as part of the new Klondike Gold Rush International Park, which extends from Skagway to Dawson.

Historic spots associated with the Klondike gold rush are **Skagway** itself and the ghost towns north of it along the Chilcoot Pass trail—**Dyea**, with its historic Slide Cemetery; **Canyon City**, with its big steam boiler and other relics; brush-clogged **Sheep Camp**; artifact-strewn **Lindeman**; and **Bennett** (see photo, page 178). Though not a great deal remains of these one-time settlements, **Dawson City**, far to the north, sports its rough-and-tumble past with quite a number of fine old structures and history-conscious activities geared to the tourist.

To the east of Skagway are the remains of some waterside ghosts which have been less vandalized than many because they require canoe or boat travel to reach. The names alone have a ring of the fabled north about them: **Ben-My-Chree, Engineer, Scotia Bay, Taku,** and **Tutshi**. Better known and easier of access are **Conrad**, near Carcross, and **Surprise** and **Discovery**, near Atlin (see photo, page 178).

Sprinkled along the Yukon River's canoeing lanes are creaking remnants of earlier times, from ghost town cabins to Indian cemeteries to old steamboats. The towns that once were include **Upper Laberge** (Laberge Creek), **Lower Laberge, Hootalinqua, Big Salmon, Yukon Crossing, Minto, Fort Selkirk** (see photo, page 181), **Isaac Creek, Coffee Creek, Kirkman Creek, Thistle Creek,** and **Fortymile**.

Ghosts near Dawson City (see above) include the abandoned Indian village of **Moosehide**, reachable by trail or by tour boat, and **Bear Creek**, a once-important community most of whose antique buildings burned down about 1970. Lying not on the Yukon River but on roads accessible chiefly in summer are **Sixtymile, Sulphur, Dominion, McQuesten, Minto Bridge,** and **Gordon Landing**. As with so many remote ghosts, the unpredictability of what may still remain when you get there is half the fun of going. Over the frontier in Alaska are two steeply declined settlements associated with the early mining era, **Jack Wade** and **Chicken**.

Relatively accessible **Silver City** is pictured on page 180. Its many remaining structures include a former fox ranch, and not far away is a very old Indian village and cemetery. Silver City lies right on the Alaska Highway, and so do the lesser ghosts of **Dalton Post, Beloud Post,** and **Quill Creek**. The abandoned Indian village of **Little Salmon** has a number of empty cabins plus an old cemetery with interesting "spirit houses." Adventurous travelers will appreciate the isolation of remote **Donjek** and **Snag**. **Aishihik** is a deserted Indian settlement with many cabins and a small log church.

DOGGEDLY TRUDGING in the footsteps of the old Spanish gold seekers, early American prospectors set out into New Mexico's arid Cerrillos hills. Lying to the south of present-day Santa Fe, the Cerrillos became the first important mining district in the Southwest and is today the site of several ghost towns.

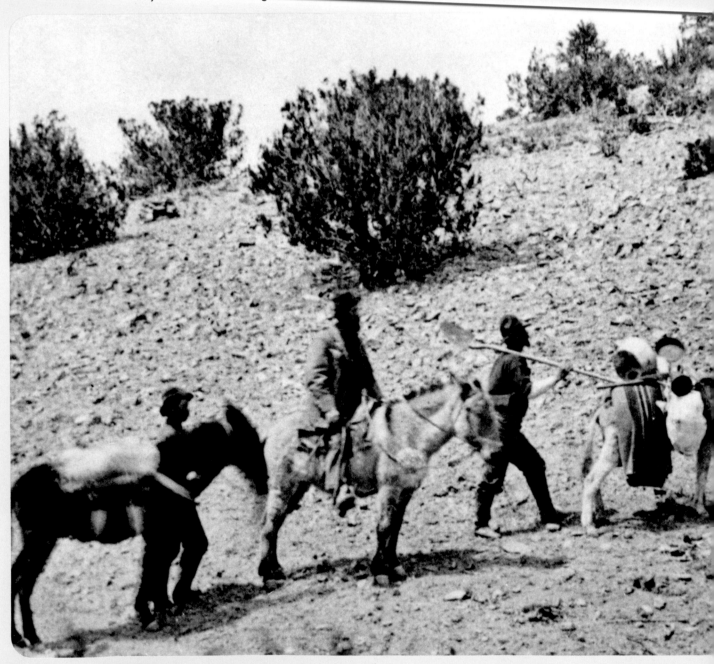

THE SOUTHWEST
TOO TOUGH TO DIE
1860...

TOTING WATER AND A SIX-GUN, the man who chose to tramp across the wasted reaches of Arizona and New Mexico, looking for gold, left later generations plenty of colorful lore with which to shape our image of the western hero. For he braved threats more deadly than those faced by prospectors anywhere else in the West: bitterly hostile Indians, extreme scarcity of water, searing heat, stubborn ores, merciless border bandits, and fragile lines of supply. No wonder towns were slow to appear in the Southwest. And no wonder they became famous for their toughness.

Spanish fortune hunters had passed this way before, only to meet eventual failure. Coronado, marching north through the Rio Grande Valley in the early 1540's, never found his fabled cities of gold. Spaniards of the seventeenth century, reputedly forcing Indian slaves to dig for silver in the hills south of present-day Santa Fe, ultimately faced revolt. In 1828 and for a few years after, while still under the Mexican flag, the same hills played host to "America's first gold rush," though this petered out because of political intrigue and the shortage of water. But in the generations following Coronado, peaceful Spanish farmers had settled in New Mexico, and the dustblown residue of their gentle adobe settlements—some think Cabezón flourished as early as 1775—created some of the most unusual ghost towns in the West.

THE SOUTHWEST AND ITS GHOST TOWNS

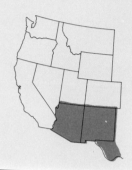

By the time of the major mining rushes farther north, no one doubted that there were valuable ores in the Southwest. The question was how to get them out—how to travel there in the first place, how to extract the "pay" from the recalcitrant gravels and rocks, and how to survive the experience. Not long after the last portions of Arizona and New Mexico were brought under U.S. sovereignty by the Gadsden Purchase of 1853, however, the Americans started arriving. The mining towns they built—and then abandoned—trace their slow, painful subduing of the hostile environment. Today's ghosts thus reflect the evolution of the Southwest from its earliest and wildest days right down to the industrialized present. New Mexico, scene of the earliest activity, boomed and then declined in fairly classic fashion. But Arizona, last of the western mining states to develop, kept right on going, increasing her base-metal yield until her mining industry far outstripped that of her more precocious neighbors.

It's a long drive between southwestern ghost towns—they are not as concentrated as in California's gold rush regions, or Colorado's—and the topography is surprisingly varied. A precariously perched mountain ghost such as Mogollon, New Mexico, can be snowbound while its southern cousins are still baking in the sun. Such differences make for an interesting range of building styles and materials. They also mean that the prospective ghost-towner will do well to refresh his knowledge of southwestern geography before striking out. Very few of the better haunts require off-the-road travel, but many of them are tough on springs and shock absorbers. And some of those basics which were crucial to yesterday's prospectors are still important: reliable transportation, all-weather clothing, and emergency water.

✗ True Ghost Town: Population at or near zero; contents may range from many vacant buildings to rubble and a few roofless walls. Places where only traces remain are marked "site."

✹ Partial Ghost Town: Disused structures and mining remnants mingle with modern elements.

★ Tourist Ghost Town: Living town has significant elements from mining rush or other historic era; old structures may be spruced up or rebuilt to promote tourist atmosphere.

🛣 Interstate Highways

🛡 U.S. Highways

◯ State Highways & Secondary Roads

NOTE: Map is as accurate as present information permits. Refer to detailed maps for minor roads, and always inquire locally about road conditions.

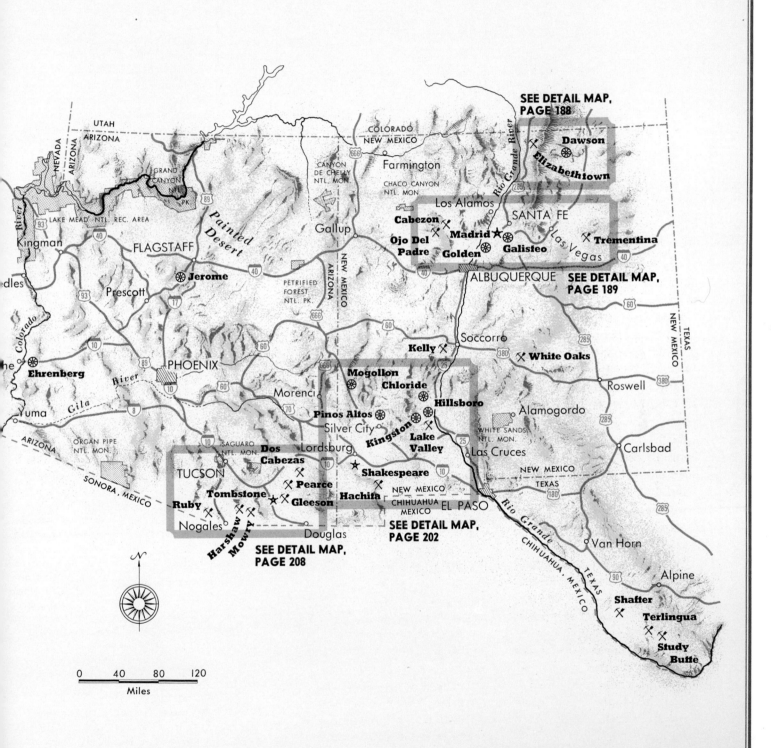

UTAH
ARIZONA
NEVADA

GRAND
CANYON
PK.

LAKE MEAD NTL. REC. AREA

Kingman

Painted
Desert

FLAGSTAFF

⊛ **Jerome**

Prescott

PETRIFIED
FOREST
NTL. PK.

COLORADO
NEW MEXICO

Farmington

CANYON
DE CHELLY
NTL. MON.

CHACO CANYON
NTL. MON.

Gallup

**SEE DETAIL MAP,
PAGE 188**

Rio Grande River

⚔ **Dawson**

Elizabethtown

Los Alamos

Cabezon

**Ojo Del
Padre**

Madrid ★
Golden ⊛ **Galisteo**

SANTA FE

Las Vegas

⚔ **Trementina**

ALBUQUERQUE

**SEE DETAIL MAP,
PAGE 189**

Soccorro

Kelly ⚔

⚔ **White Oaks**

Roswell

Colorado River

River

PHOENIX

Ehrenberg

Yuma

Gila

ORGAN PIPE
NTL. MON.

SONORA, MEXICO

Morenci

Mogollon

⊛ **Chloride**

Pinos Altos ⊛
Silver City

⊛ **Hillsboro**

Kingston

**Lake
Valley**

Alamogordo

WHITE SANDS
NTL. MON.

Las Cruces

Carlsbad

NEW MEXICO
TEXAS

SAGUARO
NTL. MON.

**Dos
Cabezas**

Lordsburg

TUCSON

Ruby

Tombstone

Pearce

★ ⚔ **Gleeson**

Shakespeare

Hachita

NEW MEXICO
CHIHUAHUA
MEXICO

EL PASO

Rio Grande

Nogales

**Harshaw
Mowry**

Douglas

**SEE DETAIL MAP,
PAGE 208**

**SEE DETAIL MAP,
PAGE 202**

CHIHUAHUA, MEXICO

TEXAS

Van Horn

Alpine

Shafter

Terlingua

**Study
Butte**

N

0 40 80 120
Miles

The Textures of Time:
GHOSTS OF NORTHERN NEW MEXICO

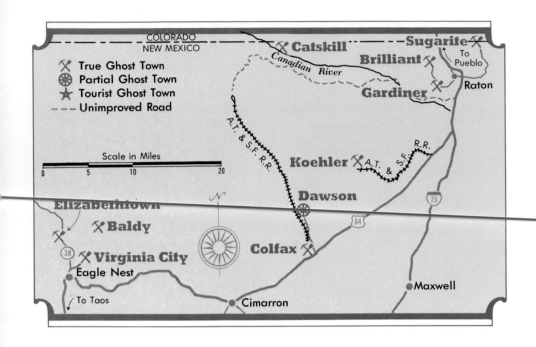

MAP LEGEND:
- ✗ True Ghost Town
- ⊕ Partial Ghost Town
- ★ Tourist Ghost Town
- – – – Unimproved Road

Scale in Miles: 0, 5, 10, 20

Labels on map: COLORADO / NEW MEXICO, Catskill, Sugarite, Brilliant, To Pueblo, Canadian River, Gardiner, Raton, A.T. & S.F. R.R., Koehler, A.T. & S.F. R.R., Dawson, 25, 64, Elizabethtown, Baldy, Virginia City, 38, Eagle Nest, Colfax, Maxwell, To Taos, Cimarron

While New Mexico's missions express the colonial heritage in a relatively sophisticated form, the earthy lives of the pioneer Spanish settlers can be sensed in the few Spanish-style ghost towns that have survived.

Typically, the simple houses had earthen floors, few metal fittings, and rooms set in a single line without interior doors. Such dwellings, many now roofless, can be seen at ghost towns such as Trementina and Cabezón (see following pages).

But please realize that they are as precious as they are rare. From about 1600 until the coming of English-speaking settlers, New Mexican colonial architecture changed hardly at all. Because they utilized adobe and other perishable materials, virtually no early, simple houses have survived. In some remote places, however—such as at these ghost towns—the old style lingered on almost up to the twentieth century. So the scanty ruins offer rare evidence of a life style that endured on our soil for nearly three hundred years.

NATURAL HARMONY of desert colors unifies the dozens of dry-rock shells that comprise Trementina, a former farming community near Corazon Peak.

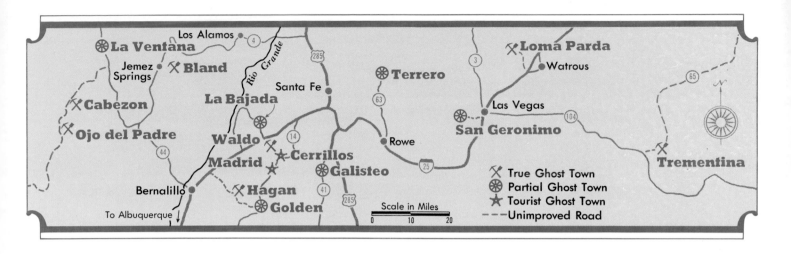

APPEALING Catholic Church and its quaint cemetery are still in use at the semi-ghost of Golden. Though much of the structure has since been replaced, the church may date from 1830.

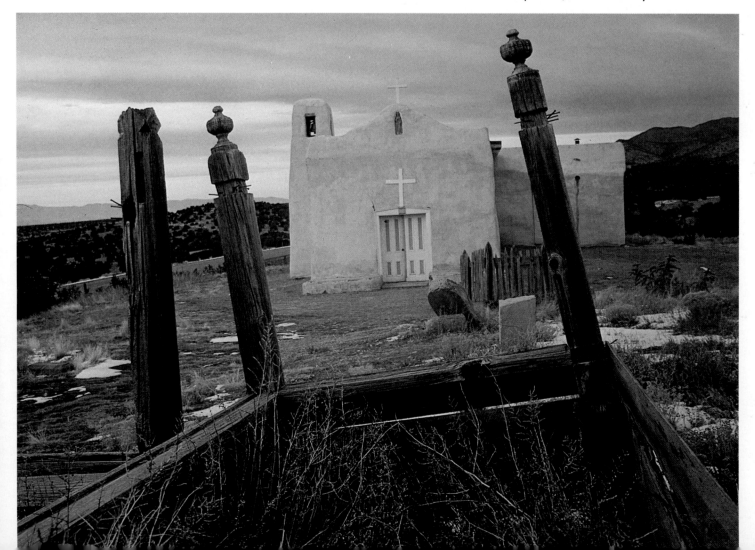

CABEZÓN, NEW MEXICO
FOR TWO HUNDRED YEARS, SE HABLA ESPAÑOL

a GHOST TOWN worth seeing

From Albuquerque go north eighteen miles on Interstate 25, then forty-five miles northwest on State 44 to State 279, a gravel road which exits west and reaches Cabezón after about five miles.

The Navajos called the mountain "The Giant's Head" and used it to define the eastern edge of their nation. By 1767, the Spaniards were coming to ranch and farm under its lofty gaze. They founded a little town and, translating the Navajo term approximately as "Cabezón" ("Big Head"), they gave their settlement this name. Then the Navajos objected to the white man's presence. Over the years, they attacked again and again; but always the Spaniards returned. Not until Kit Carson defeated the Navajos in 1863 could the settlers really settle.

Then they were confronted by water problems. Either the Rio Puerco was a dismal muddy trickle, or it raged down the arroyo, shattering the works of nature and man alike. In time, the Spaniards learned to build dams. But when even these were carried away by flooding in the 1930's and 40's, the people finally gave up. After so long a struggle, Cabezón succumbed.

The silent town faced a new peril: vandals. They smashed through locked doors to steal what they could find; they broke every window pane in town; they even attacked the church and attempted to steal its bell. But "cabezón" also means "stubborn," and again the West's most venerable ghost acquired a Spanish-speaking defender—rancher Stacey Lucero. He owns property in Cabezón, and he is armed. However, if you get on the good side of Stacey, he may prove hospitable. As one visitor found, "Stacey tells you of livelier days in Cabezón: of the spirited cowboy, who when feeling his liquor, would ride his horse right into the bars and dance halls, and who once rode into the schoolhouse and roped the teacher. He speaks of an old man who long ago lived across the river, a solitary man who buried gold under the posts of his corral. The corral is still standing today and perhaps the gold is still under one of those decaying posts."

BROODING introspection of Cabezón is accentuated by its adobe church (right) and churchyard (above). Unlike Yankee boot hills, this camposanto is in the middle of town.

TOWN'S NAME and much of its character derive from nearby Cabezón Peak, an ancient volcanic plug whose cinder cone fell away. Dominating the landscape for miles around, the mountain inspired legends among many Indian tribes

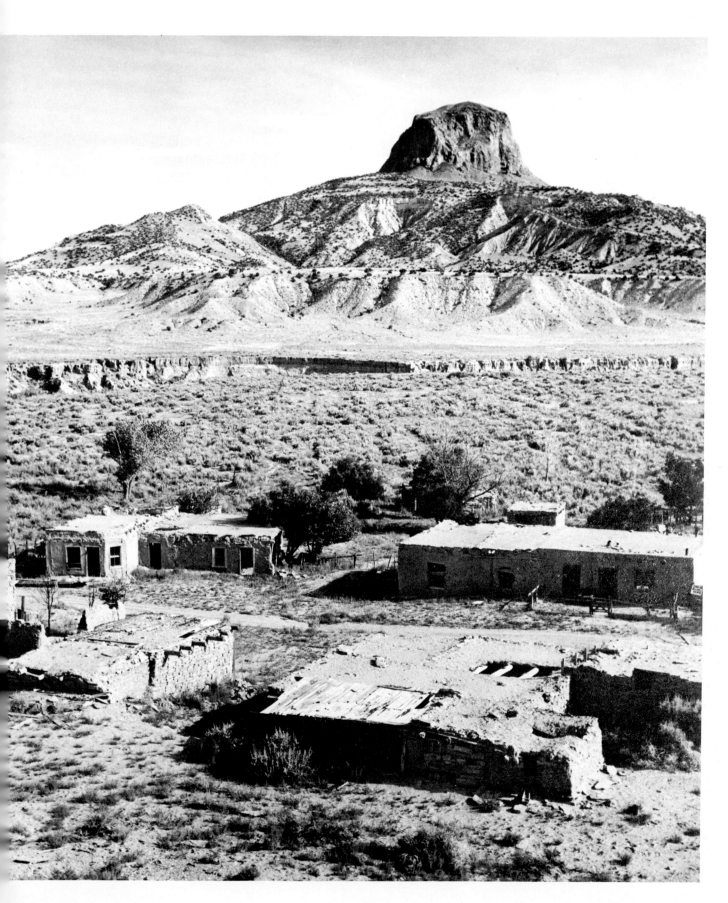

Warpath: THE INDIAN THREAT TO THE MINING CAMPS

The hostile Indian relations which had marked the Spanish rule were passed along, and sometimes aggravated, as the Southwest came more and more under Yankee influence. Not all southwestern Indians were dangerous or savage by any means, and not all white men were prejudicial to Indian interests; but there was enough ignorance and hostility on both sides to engender serious strife well into the 1880's. The main tribes threatening both Americans and Mexicans were the Navajos and Apaches, who fought, not as organized defenders of territory in the manner of the Sioux and Plains Indians, but as raiders and plunderers.

The U.S. Army's systematic campaign against the Navajos in 1860 and 1861 was interrupted by the Civil War—with an interesting side effect. To replace the regulars recalled for war duty, units of the "California Volunteers" were garrisoned in Arizona. Once a miner, always a miner: the old Californians couldn't resist sampling the relatively untouched ores in their off-hours. After the war, a number of them stayed on, bringing inspiration and know-how to a fledgling industry.

Meanwhile, Kit Carson was brought in to fight the Navajos. By 1863 he had taken most of them prisoner, and in 1868 the Navajos signed a peace treaty, living quietly on their reservation thereafter. But the Apaches were harder to subdue. Adept at guerrilla tactics, and split into many sub-tribes which occasionally fought one another, they could not be dealt with as a whole. They attacked the early mining camps repeatedly and were largely responsible for the wholesale abandonment of the gold community of Pinos Altos in southern New Mexico (after subsequent ups and downs, Pinos Altos is again a virtual ghost). The hard-to-pin-down Apaches could only be fought little by little; and not until the final surrender of Geronimo in 1886 was the Indian threat overcome.

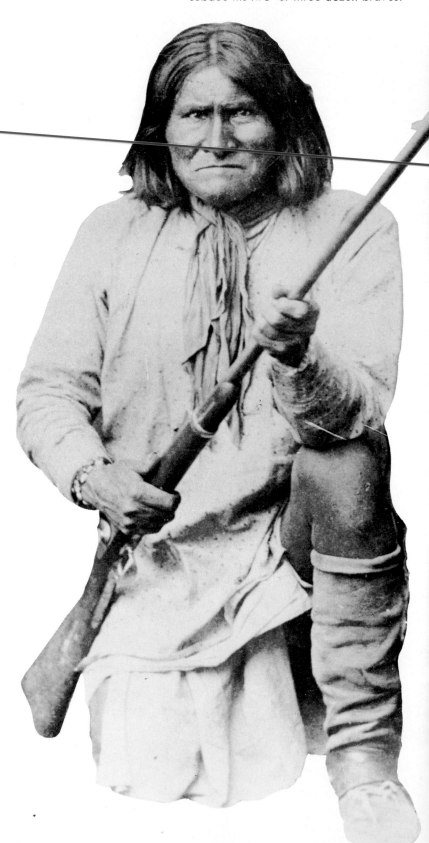

FAMOUS APACHE, Geronimo, took over his Chiricahua tribe in 1881 and terrorized both sides of the U.S.-Mexican border for five years. So wily and unpredictable was he that thousands of troops were needed to subdue his two- or three-dozen braves.

KIT CARSON roamed the West leading Army units against Indian tribes. His adobe home at the semi-ghost town of Rayado, New Mexico, includes a fortress-like watchtower.

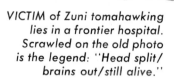

VICTIM of Zuni tomahawking lies in a frontier hospital. Scrawled on the old photo is the legend: "Head split/ brains out/still alive."

GHOST TOWN of Oatman, Arizona, was named for Olive Oatman and her family. Apaches killed the parents, enslaved Olive and her sister and tattooed them (note chin). The sister died, but Olive was ransomed after five years, married a New Yorker, and lived happily to the age of 68.

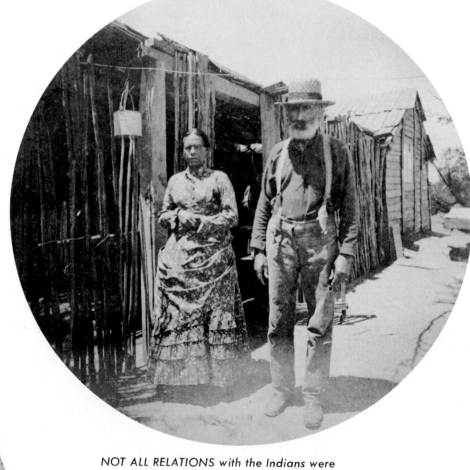

NOT ALL RELATIONS with the Indians were hostile. Many a grizzled Yankee pioneer lived with an Indian squaw. This couple was photographed in 1889.

ELIZABETHTOWN, NEW MEXICO
FIGHTING FOR LIFE

a GHOST TOWN worth seeing

From Taos, go thirty-two miles northeast on State 64 to Eagle Nest. Turn left on State 38 and continue five miles to Elizabethtown, which consists of scattered structures a few hundred yards west of the road.

For ghost-towners with plenty of imagination, "E-town" offers clues to a rough-and-tumble past. Born in 1867 with the discovery of gold on nearby Baldy Mountain, it was one of the first mining camps in the Southwest to successfully brave the water shortage, Indians, and badmen. Elizabethtown profited from an influx of miners disillusioned with played-out prospects in Colorado, and in 1870 it became the first town to be incorporated into the territory of New Mexico.

E-town's tussle with the water problem reached a peak in 1869, when an ambitious system of flumes and ditches brought water to the placers from the Red River, some forty miles away. Though a remarkable achievement in its time, the waterworks disappointed its inventors by delivering only a small fraction of the volume they had counted on. Scattered remnants of the old flumes can still be found today.

The other peril — violence — came in many forms. While the U.S. Army was helping to subdue the Apaches, the townspeople organized their own militia. A vigilante committee also sprang up, but wild events seemed to snowball. The worst was the case of Charles Kennedy, who for years lured visitors to his dinner table and then killed them with an ax, throwing their bodies into the cellar. Finally the E-towners lynched him, cut off his head, and took it to Cimarron, where it was posted on a stake in front of a saloon as a warning to all and sundry wrongdoers.

After 1875 Elizabethtown died and revived several times before becoming the total ghost it is today. The husk of only one substantial building—the town hall—remains. But you can poke around among the few sagging shacks and widely strewn artifacts; prowl the silent gold gulches with names like Grouse, Pine Tree, Michigan, St. Louis, and Humbug; look over the slopes of Baldy Mountain for old mines; and muse over a fabled lode in the very center of the mountain, which was often sought—but never found.

CLASSICALLY ARCHED portals of Elizabethtown's town hall frame the shoulders of Baldy Mountain. This stone edifice is the town's only surviving commercial structure.

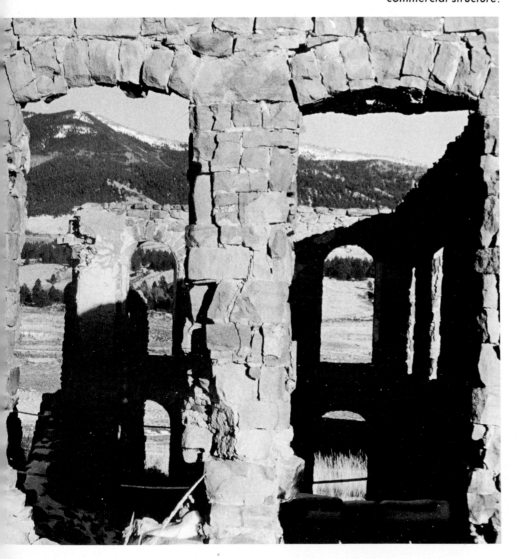

"IT MAKES ONE LONESOME to walk the streets of Elizabethtown," wrote an editor as early as 1882: "a sort of graveyard stillness, deserted buildings . . ." Year by year, the bunch grass has continued to reclaim those buildings.

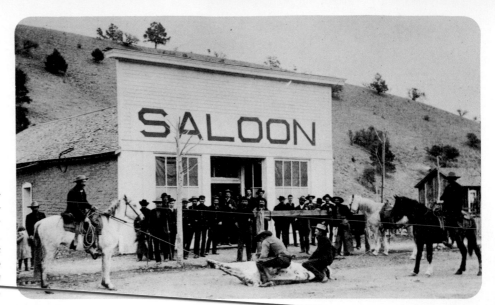

BULLDOGGING a steer revealed the cowboy heritage of Chloride, New Mexico, now a ghost town. Note that the Americans have grafted a wooden false front onto an existing adobe building.

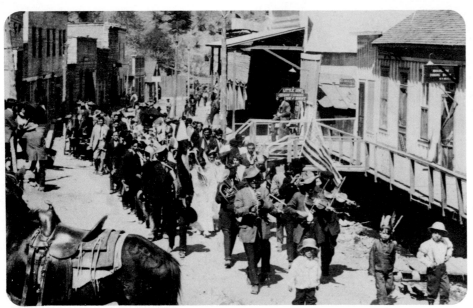

GAILY PARADING down the main street of Mogollon, New Mexico, Mexican miners celebrate the traditional holiday of "Cinco de Mayo" (Fifth of May).

Swinging the Doors: FUN WAS WHERE YOU FOUND IT

In the isolated towns of the Southwest, there was little in the way of ready-made entertainment. Thrown on their own resources, the citizens amused themselves with sports and celebrations that were usually as vigorous as they were simple.

UNIVERSAL SPORT throughout the early West was prizefighting, and sometimes the match took place in a saloon. Here in Mogollon, the referee distinguished himself from the rabble with a Victorian mustachio and lack of hat.

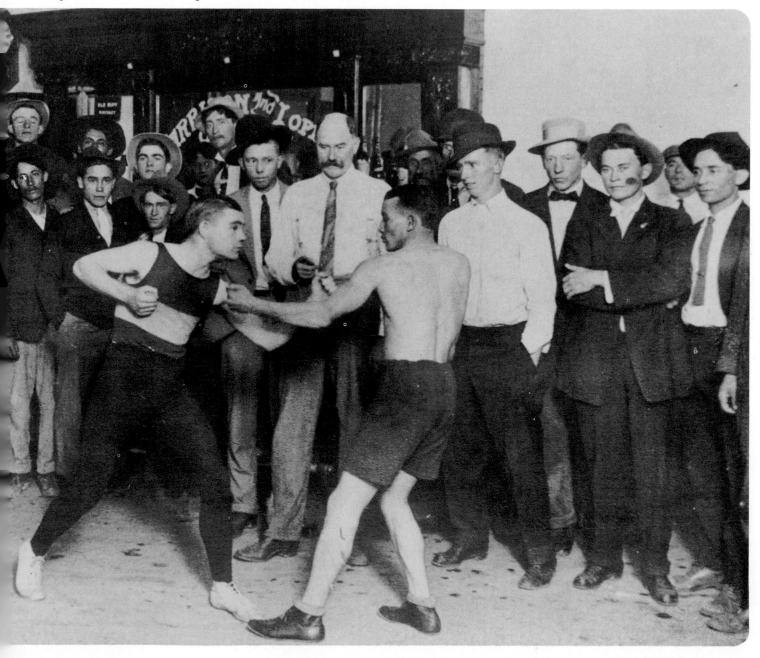

MADRID, NEW MEXICO
RAILROADS BUILT IT—RAILROADS KILLED IT

a GHOST TOWN worth seeing

From Santa Fe, go southwest ten miles on Interstate 25, then turn south on State 10 and continue seventeen miles south to Madrid, which straddles the highway. Historic Cerrillos is on the way, and the partial ghosts of Galisteo and Golden are also nearby.

One of America's classically pure ghost towns, Madrid has history all its own. Although situated in the Ortiz Mountains, among many remnants of the early gold-digging days, Madrid neither came early nor dug gold.

Instead, blessed with an extremely rare combination of both hard and soft coal deposits, Madrid fed the railroads and was fed by them. The *Atchison, Topeka and Santa Fe* ran the town in the late 1880's and early 90's. From then on there was a succession of operators and owners. The biggest year was 1928, when the mines shipped over 180,000 tons of anthracite and bituminous. Then came the depression, plus increasing competition from other fuel sources. During World War II, Madrid perked up again, as a laboratory called Los Alamos began buying huge amounts of coal for purposes the townspeople could only guess at. But when the war ended, the atomic station changed over to natural gas. And when the railroads switched from coal to diesel, Madrid succumbed.

Ghost town buffs will recognize all the features of a typical company town: long rows of identical frame dwellings, an orderly layout so different from the helter-skelter sprawl of other mining camps, and the obvious centralization of enterprise. The present owners charge a small fee to let you meander at will among an outstanding collection of artifacts, both outdoors and in. The great mine structures by the mountain are off-limits, and it takes luck and persistence to get directions to the cemetery. But Madrid is readily accessible and well worth a visit.

PROUD SURVIVOR of years of abandonment, this picturesque rooming house was the first home in America for many of the European immigrants who were brought over to work in Madrid's coal mines.

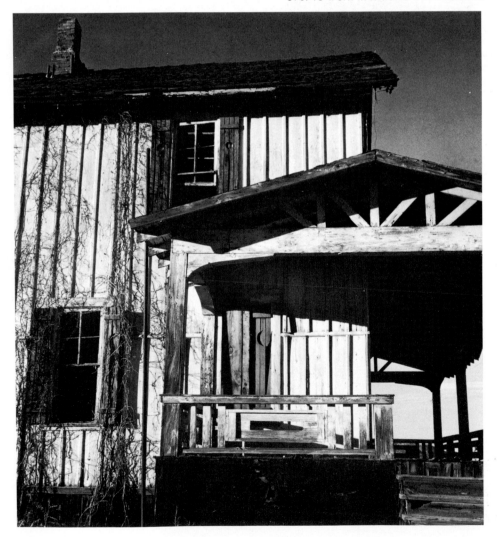

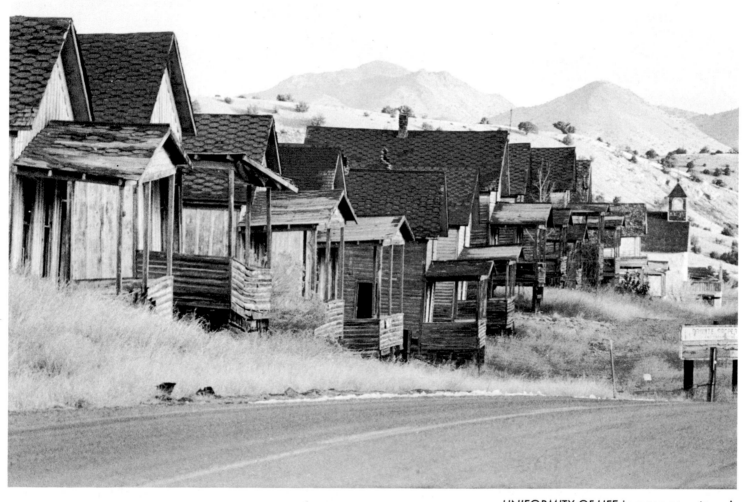

UNIFORMITY OF LIFE in a company town is emphasized by these long rows of tract houses still standing. They rented for $2 per room per month, including coal, with an extra charge of 50¢ for electric lights.

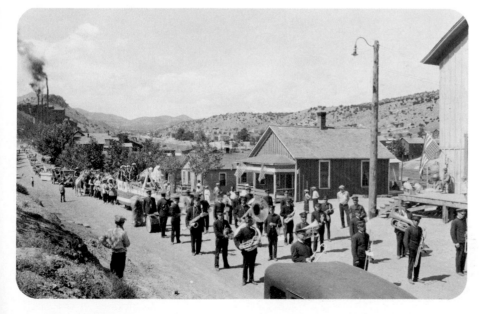

ELABORATE celebrations were a source of special pride in Madrid. Her Christmas lighting gained national fame, and the Fourth of July parade (left) stretched the length of the main street. Yet even on a holiday the mill belched smoke. And was the upside-down flag the work of a wag or someone in international distress?

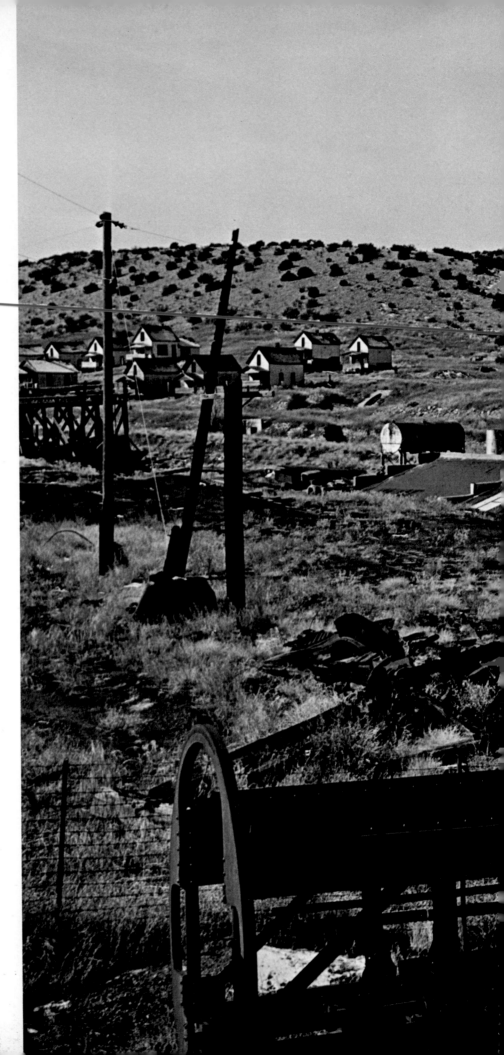

...MADRID, NEW MEXICO

RUSTING steam engine watches over Madrid. The Atchison, Topeka, and Santa Fe operated this coal town for some years, and the West's burgeoning railways were always prime customers. But when they changed over to diesel fuel, Madrid died.

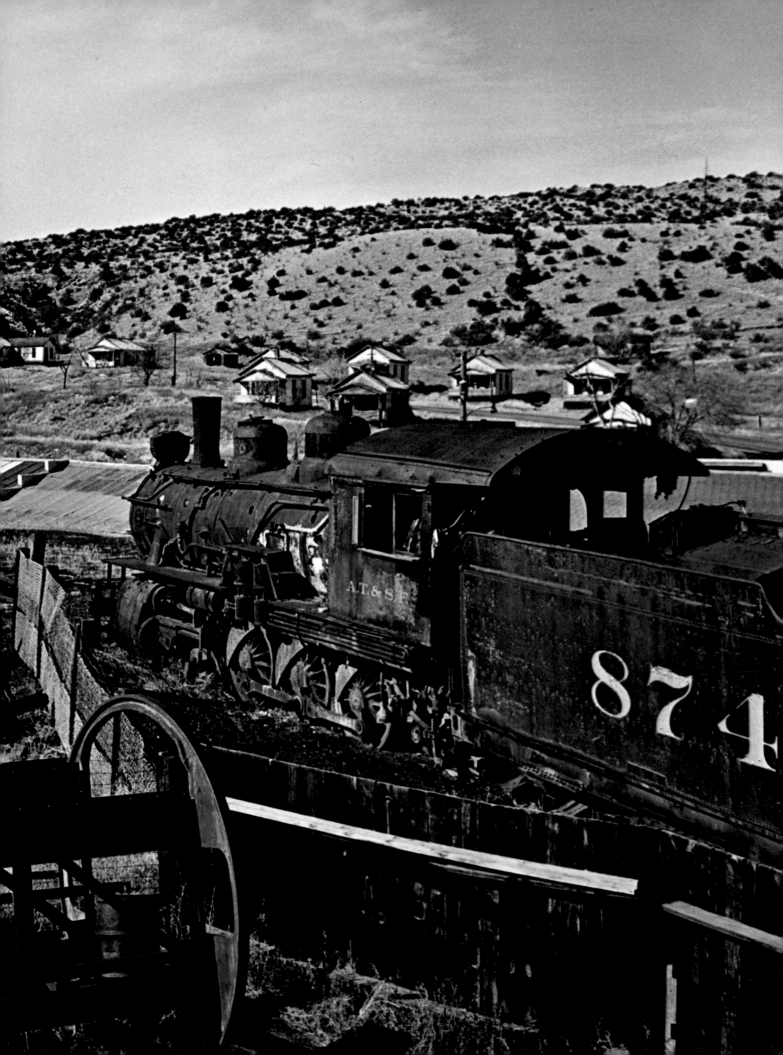

A Vanished Grit:
GHOSTS OF SOUTHWESTERN NEW MEXICO

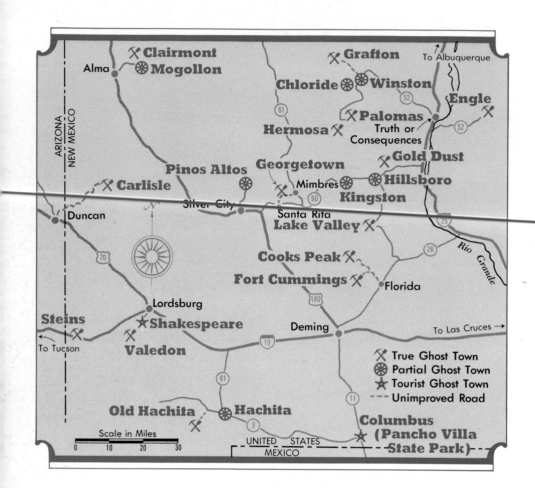

An indefinable mood of mystery still pervades the ghost towns of this region. New Mexico's first important group of American mining camps sprang up here, in the hills around Pinos Altos. The Apaches were far from kind, and time has been even less kind, to these flinty settlements.

Cheek-by-jowl with those better-known early settlements that have gradually evolved into half-occupied retreats—such as Chloride, Kingston, Hillsboro, Mogollon, or Shakespeare—are some remote and desolate pure ghosts that may well require four-wheel drive, special maps, and plenty of time to track down—places like Hermosa and Cooks Peak and Clairmont.

Bear in mind that both the landscape and the weather can be problematical in these parts. The northwestern third of the map at left is occupied by the precipitous Black Range and Mogollon mountains, a primitive area whose lesser roads are apt to be impassable in winter. Much of the rest is high desert country where you can lose your Stetson to a hot twister in July or to a freezing flurry in January. Somehow it all adds to one's sense of the Apaches' ferocity, and of the dread the settlers must have felt as they huddled behind their rude false fronts or within their dark adobes.

STRUGGLE FOR WATER in an arid land left this battered windmill looming over the ghost town of Lake Valley, in the foothills of the Black Range Mountains.

BROODING on past glorie[s] and defeats is this empty stor[e] at Chloride. Is it the sam[e] building as is pictured o[n] page 196? We aren't sure[.]

MOGOLLON, NEW MEXICO
BAD PROBLEMS, GOOD ORE

a GHOST TOWN worth seeing

From Lordsburg, take U.S. 70 and State 90 northeast to Silver City. Take U.S. 180 sixty-four miles northwest to Glenwood; continue another five miles to State 78, turn right, go ten miles to Mogollon. Maps show State 78 crossing the mountains from the east, but this route should never be tried without local advice.

SHARP TURNS—STEEP GRADE—TRAILERS OVER 20 FT. UNSAFE bellows the big sign as you start up the western slope of the Mogollon (pronounced "mo-gee-yon") Range in Gila National Forest. If you're a normally cautious driver, don't be dissuaded. And yet the unfenced hairpin turns, which overlook vertical precipices, may make you wonder what life was like for the early freighters. Inching along a narrow shelf hacked out of the cliffs by convict labor in 1897, the twenty-mule teamsters charged $50 a ton to haul out raw ore assaying at perhaps $200 a ton. Once down on the flatlands, they encountered more problems: there, the clay mud was sometimes so deep that it took whole days to move a few hundred yards. Mogollon profited greatly when better ways were found for concentrating and extracting low-grade silver and gold at the source.

The Indian problem was also severe. Having chosen these mountains as their final stronghold, the Apaches killed many miners. Yet, blessed with some of the State's richest precious metal deposits, Mogollon struggled through, and by 1914 its payrolls neared $1 million a year. Business was good until 1926; after that came the familiar story of declining ups and downs until after World War II, when everything closed for good.

Today there are many old mine structures scattered over the steep hillsides; a section of broken-out houses above the town; and among the abandoned buildings of the town proper, a lunch counter and post office, a quaint, kerosene-lighted museum, and a couple of artists-in-residence. If you haven't come to plunder, the slow-going locals are friendly and knowledgeable about Mogollon's colorful past—just so long as you pronounce it right.

PATCHWORK of sheet metal serves as the facade of a tiny, unnamed structure dozing between J. P. Holland's General Store and the tumbledown Mogollon Theatre.

"UNDER NEW MANAGEMENT" proclaims the sign. But the star performers are the rodents who scamper across the floorboards, and the mesquite-scented winds that rattle the sheet-metal siding

FATE of J. P. Holland General Store again hangs in the balance now that the Gila National Art Gallery no longer graces these premises. Two dozen or more buildings, plus some collapsing shacks, still stand along the main street. For views of livelier days in old Mogollon, see page 196.

HUGE MILL COMPLEX
of the Little Fanny Mine commands a view
of the precipitous approach to Mogollon
from the Frisco Valley, beyond. The chalky
white tailings resulted from treating gold
ore with cyanide.

CORE SAMPLES (far left) are among the scattered debris of the Little Fanny Mine. Cyanide boxes from Canada were used to build a shed (left). Use of the chemical, one of the few that dissolves gold, marked advance in refining technology.

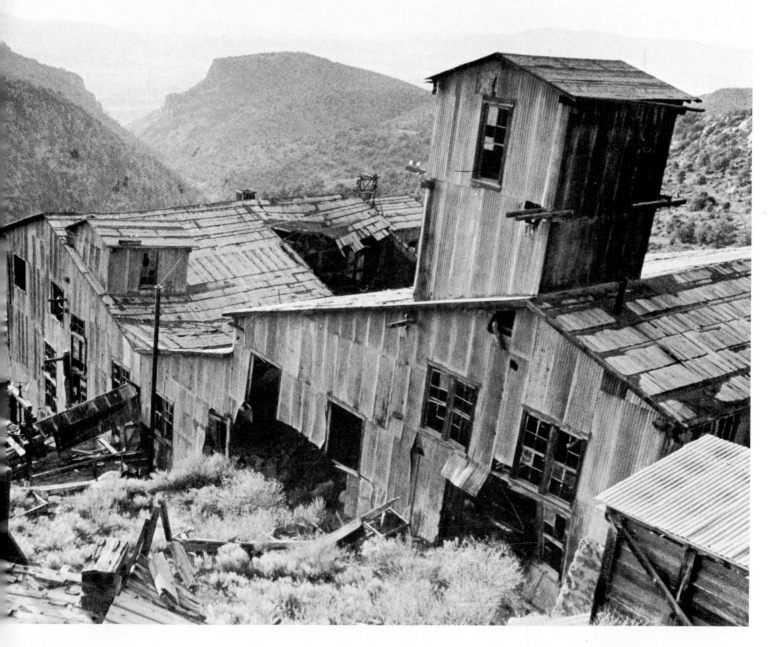

Forgotten Dreams:
GHOSTS OF SOUTHEASTERN ARIZONA

WHAT GOES UP must come down, and in the case of this old slide on the schoolyard at Ruby, the descent is more vertical than it used to be. Despite efforts to protect the town, it has been gradually decimated by vandals.

Lawlessness, Apache trouble, border bandits, the glamour of gold—all the fabled romance of the Old West seems to have been packed into the history of Cochise County and its near neighbors, Santa Cruz and western Pima counties. Not coincidentally, this far-out corner of southern Arizona also offers the state's richest harvest of ghost towns.

Except for touristy Tombstone, though, much of what remains speaks not of the fables but of the everyday reality of ordinary people trying to eke a living out of a hard but promising landscape. Bunkhouse ruins at Hilltop, collapsing houses at Harshaw, plaster-faced adobe-brick walls and an old stage stop at Dos Cabezas, a couple of old stores at Courtland—all tell a more muted tale than the Hollywood gunmen who once bit the dust at the movie set known as Old Tucson.

The current ups and downs of copper mining, plus an increasing awareness of the value of its past, can be glimpsed at Bisbee in the form of one of the world's greatest open pit mines alongside a town struggling not to become a ghost. All in all, this is an area not to be missed by anyone interested in the lore and/or reality of the late and early West.

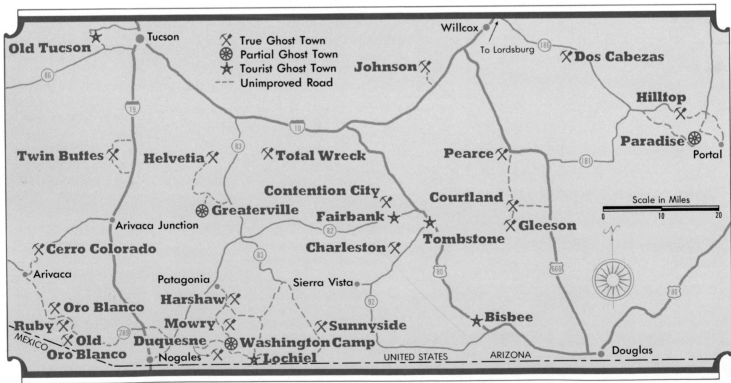

Old Tucson ★ • Tucson

⚒ True Ghost Town
⊕ Partial Ghost Town
★ Tourist Ghost Town
--- Unimproved Road

Willcox •
To Lordsburg
⚒ **Dos Cabezas**

Johnson ⚒

Hilltop ⚒

Paradise ⊕
Portal •

Twin Buttes ⚒ **Helvetia** ⚒ ⚒ **Total Wreck**

Pearce ⚒

Courtland ⚒

Scale in Miles
0 10 20

Contention City ⚒

⊕ **Greaterville** **Fairbank** ★

Gleeson ⚒

Arivaca Junction

Charleston ⚒ **Tombstone** ★

Cerro Colorado ⚒

• Arivaca

Patagonia • Sierra Vista •

★ **Bisbee**

⚒ **Oro Blanco** **Harshaw** ⚒

Mowry ⚒ ⚒ **Sunnyside**

Ruby ⚒

⚒ **Old Oro Blanco** **Duquesne** ⊕ **Washington Camp**

MEXICO Nogales • ⚒ ★ **Lochiel**

UNITED STATES ARIZONA • Douglas

*STUBBORN SYMBOL of hope and achievement
is this archway of the old school building at Gleeson.
A few other ruins remain.*

a GHOST TOWN worth seeing

From Tucson, go forty-four miles southeast on Interstate 10 to Benson, then twenty-six miles southeast on U.S. 80 to Tombstone. Mining buffs will also want to see the spectacular open-pit copper mine at Bisbee, twenty-six miles south.

Ghost town purists may turn up their noses at Tombstone: it's an out-and-out commercialized restoration like those at Columbia, California; Virginia City, Nevada; and Central City, Colorado. Yet a fabled history *does* walk these streets, and it's worth considering, as you perch in the gloom of the old Bird Cage Theatre or swagger in the hot glare of the O.K. Corral, what Tombstone might have been like, had it been allowed to crumble into the dust.

"Some day you'll find your tombstone," a soldier at Fort Huachuca, Arizona Territory, told the lone prospector in 1877. But Ed Schieffelin would not be dissuaded. Born—perhaps prophetically—in 1848, he had grown up in California, and searched for gold and silver in Nevada, Utah, Oregon, and Idaho before deciding to try his luck in this new, raw frontier. The soldiers were combing the countryside for Geronimo's Apaches, and Schieffelin rode with them until he learned the lay of the land.

Then he struck out alone, heading east into the San Pedro Valley. Camping on the highest hill for security, he suddenly spotted an outcropping of silver ore. Though excited, Schieffelin realized he would need money to work the claim. He went to his brother, who was mining farther north, for help. An assayer valued the ore at $2,000 a ton and promptly staked the brothers. The three returned to the strike—and found a lode assaying at $15,000 to the ton. Word got out; the rush was on. With typical frontier humor, Schieffelin had named his first claim the Tombstone, and the camp soon acquired the same name. As the mines poured out their millions, it swelled to a city of 15,000.

Tombstone boasted five newspapers, including one of the most famous in the West, the *Epitaph*, which is still going. The saloons were fancy, the strumpets brazen, the restaurants elegant, the characters fabulous, and the theaters among the best in the West. Even when the mines declined, Tombstone never entirely died. The county seat until 1929, it was by then already becoming a tourist center. Since 1964, over $3 million has been spent on its careful restoration.

COVERED BOARDWALKS of downtown Tombstone lead visitors to the pure and puerile of Western Americana. Besides the commercial shops, there are well-restored buildings and fine collections.

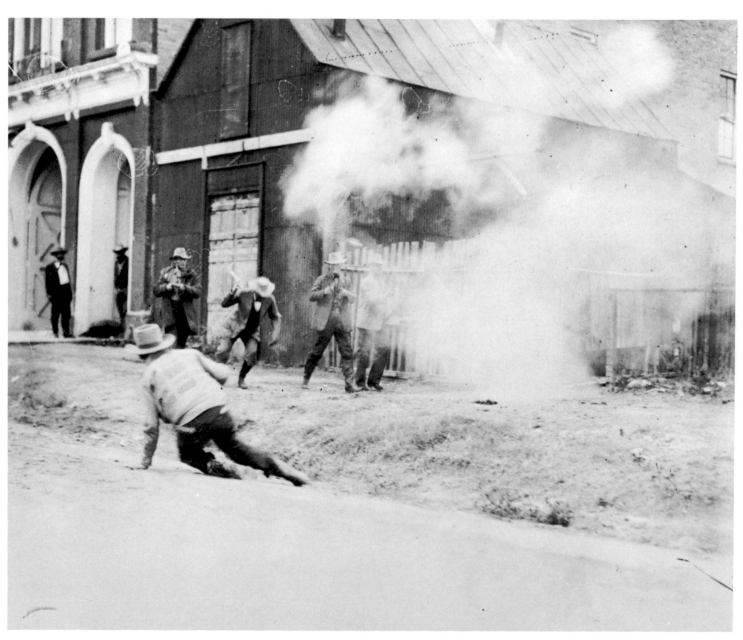

MOST FAMOUS SHOOTOUT in the history of the West erupted at the
O.K. Corral as the climax to a bitter feud between Marshal Wyatt
Earp and the Clanton outlaws. Tombstone still celebrates such
wild doings in its annual "Helldorado Days" and other events. This
photograph was taken in 1930.

Good Guys, Bad Guys, AND A BAD GAL

Every corner of the Old West spawned its share of highwaymen, cardsharps, claimjumpers, good marshals, bad marshals, and vigilantes. But the Southwest drew the roughest customers of all. The renegades of the Dodge Cities and Virginia Cities came pouring into this final frontier as if bent on one last shootout.

WYATT EARP: card-sharp, gunman, deputy marshal, Tombstone, Arizona.

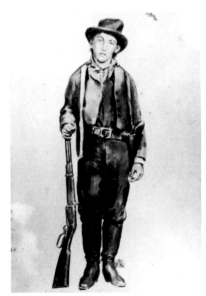

BILLY THE KID: alias William Bonney. Hired gun to both sides in cattle wars. Killed 15 by age 17. Eluded man-hunts, broke out of jail, was shot dead at age 21.

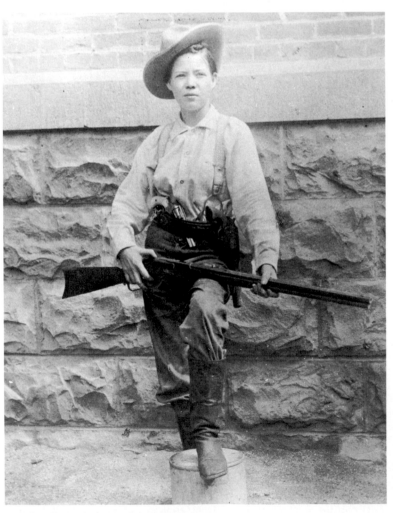

PEARL HART: disguised as a man, allegedly committed the West's last stagecoach robbery in 1899.

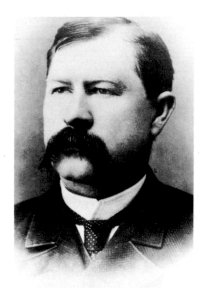

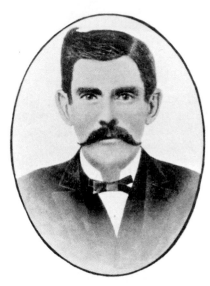

VIRGIL EARP: marshal,
Tombstone, Arizona; crippled
by buckshot wounds.

DOC HOLLIDAY: dentist,
gambler, coldest blooded
killer of Earp faction.

BLACK JACK KETCHUM:
train robber, liked to beat own
head with six-shooter.

JEFF MILTON: Texas Ranger,
Wells Fargo Messenger,
U.S. Customs and Border Agent.

JOE PHY: deputy sheriff,
killed in gunfight, Tunnel
Saloon, Florence, Arizona.

ROBERT PAUL: Wells Fargo
Special Agent, U.S. Marshal,
Arizona Territory.

a GHOST TOWN worth seeing

From Phoenix, take Interstate 17 seventy-four miles north to Camp Verde. Then take State 279 sixteen miles northwest to intersection with U.S. 89 Alternate; turn left, go ten miles farther northwest to town of Jerome.

BELIEVE IT OR NOT,
a candlelit gourmet restaurant, the House of Joy, stands right across the street from this scene. Jerome's strangely juxtaposed elements vary from pure-ghost, to hip-artist, to garden-variety tourist.

Whether approaching from the Verde Valley below, or down the mountains from Prescott, you can't help but realize a key fact about Jerome long before you get there: it is perched precariously on a steep hillside. Serpentine switchbacks carry you past the mouldering hulks of big old wooden houses and concrete buildings, most of them clearly of twentieth-century vintage. The highest are 1,500 feet above the lowest—at best an approximate figure, since Jerome's structures, including the old concrete jail, have a bothersome habit of slithering down the 30° incline.

As you explore this sober, broad-shouldered ghost, you begin to see that it lived, not among the zany speculations of get-rich-quick prospectors, but under the careful control of big corporate enterprise. Consider, for instance, that the ground you stand on is undercut by some 80 miles of tunnels. Consider that Jerome pulled eight hundred million dollars out of that ground between 1885 and 1953—mostly in copper ores, but also in silver and gold. And consider that the barren, surrounding slopes, including blackened Cleopatra Hill directly above the town, were forested in oak and pine until the deadly smelter fumes and lumber saws did their work.

The setting is nevertheless spectacular, and Jerome has begun to capitalize on its picturesqueness by attracting artists, weekenders, and others. There are two good museums, a Methodist church sheathed with powder boxes, a huge old hospital, and many other attractions. Happily, there's a minimum of hokum, and Jerome's description of itself as "the largest ghost city in America" may still be valid.

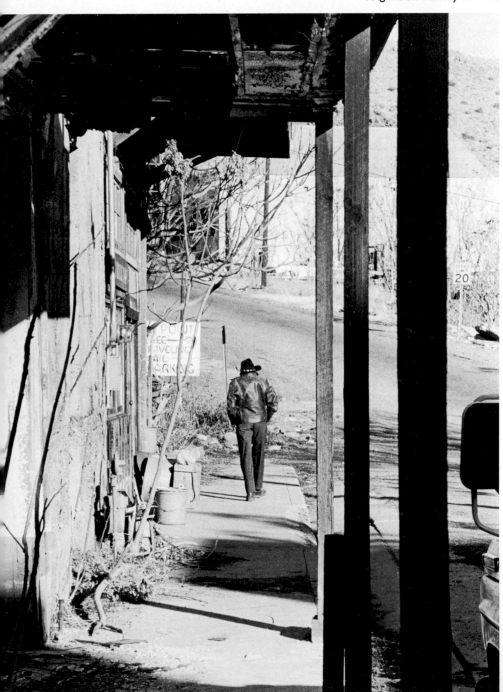

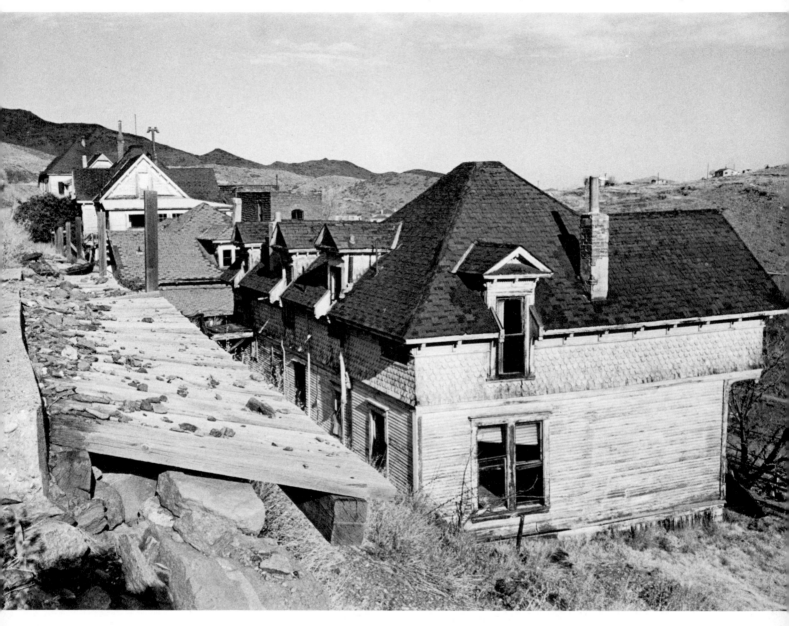

SPECTACULAR VIEW across
the Verde Valley to the red
cliffs of Oak Creek Canyon was
afforded guests of the Little
Daisy Hotel, which now rests in
lonely isolation near the
abandoned mine for which
it was named.

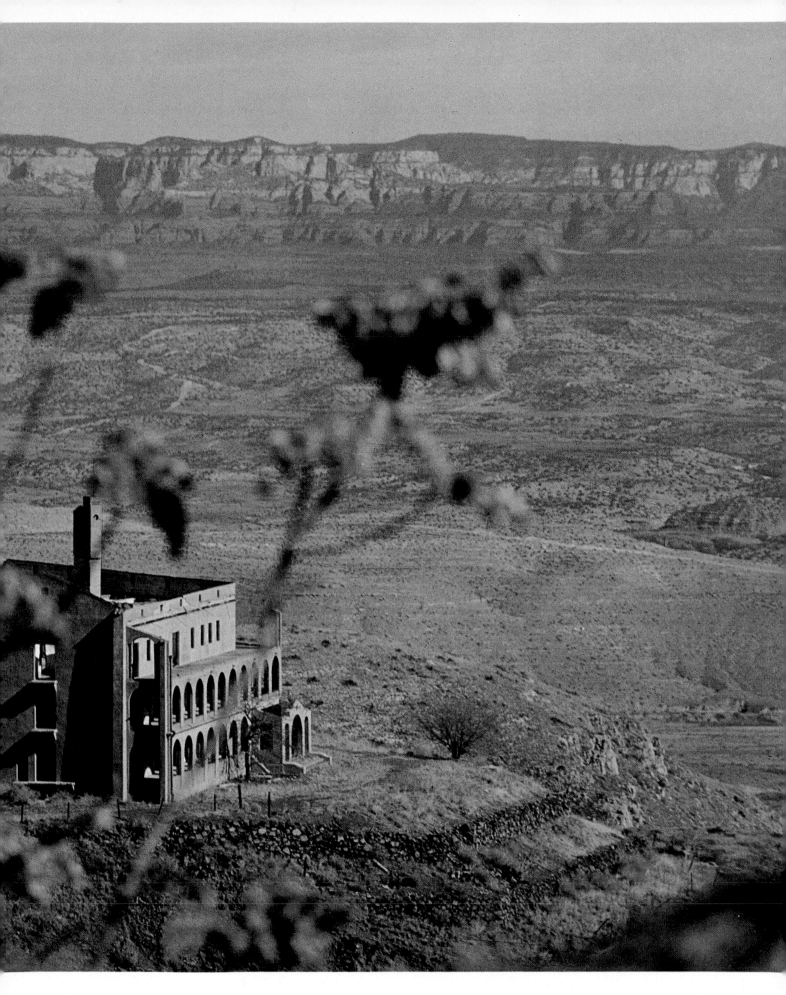

RANCHOS DE TAOS, NEW MEXICO ARROYO HONDO, NEW MEXICO

DAWSON, NEW MEXICO MADRID, NEW MEXICO

ELIZABETHTOWN, NEW MEXICO CERRILLOS, NEW MEXICO

Ghost Markers: THE RICH JOTTINGS OF BOOT HILL AND CAMPOSANTO

From the period of Spanish colonial settlement, through the meteoric rise and fall of the first American mining camps, and on into the era of sober industrial growth, the long history of Southwestern America is retold in its grave markers.

JEROME, ARIZONA

QUESTA, NEW MEXICO

GOLDEN, NEW MEXICO

SETTLERS of Spanish origin carved beautiful wooden gravemarkers. Early Yankee boot hills also showed some interesting carving (Elizabethtown, Cerrillos). Miners from Europe preferred classical gravestones (Madrid, Jerome). Metal was used in the mass burial of miners killed in an explosion (Dawson) and in some homemade markers (Golden).

WESTERN ARIZONA

Dating from the years when the Colorado River was a key artery of commerce, the mining remnants and ghosts of the mountainous deserts of western Arizona offer a variety of nostalgic impressions. A fair amount of mining is still going on, and the working mines and back roads, as well as many of the early ruins, are clearly marked on the detailed Mojave and Yuma County maps, available from the Arizona Highway Department.

Most easily accessible to the casual visitor are **Oatman** and the **Old Yuma Prison**. The gold-mining ghost of Oatman, which was active until 1942, has several authentic buildings; a number of wandering, heehawing burros; staged shootouts on Sunday afternoons; and a growing number of residents and tourist-oriented businesses. Nearby is the truer ghost of **Goldroad**, comprising scattered, roofless rock and adobe hulks. The Old Yuma Prison at Yuma, open to tourists, offers a sobering perspective on one aspect of the lives of the oft-romanticized early Western bad guys.

In the northern sector, **Cerbat** has a ruined mill that operated as late as the 1950's, along with mine ruins and rock walls; **Mineral Park**'s current mining activities are interspersed with some stone and adobe remnants of the early days; and **White Hills** comprises only cemeteries, debris, and the remains of an old reservoir. **Chloride** is a living town of about 300 population but includes a number of authentic buildings from its century-long history, plus the ruins of mills and mines.

In the central sector, **Signal**'s remains include an old saloon, a cemetery, mill ruins, and assorted rubble. **Alamo Crossing** contains the vestiges of a five-stamp mill, wooden houses, and other features of this old camp that saw a revival during the short-lived manganese boom of the 1950's. **Cedar** consists of minor stone ruins and foundations strewn for half a mile along its valley; **Harqua Hala**'s deserted buildings and ruins have now been partly reoccupied; and **Swansea** comprises smelter walls, old vacant adobe homes, dangerous open mineshafts, and a cemetery. Though very little is left at **La Paz**, the site lies within the Colorado River Indian Reservation, whose tribal council has been excavating with the aim of eventually making this historic gold center and river port a tourist attraction. **Bouse**, a living town, has an old quartz mill on a knoll and numbers several historic structures among its occupied buildings.

In the southern sector is **Kofa**, whose claim to fame was the rich King of Arizona mine; its remains are still there, along with some other ruins. The little community of Clip grew up on the Colorado River around an ore-processing mill, but has completely vanished; eight miles to the southeast, though, at the edge of the Yuma Proving Grounds, is the old **Clip Mine**, with the remains of a 100-ton stamp mill. Ghosts such as these are subject to unpredictable change and are recommended only for true-blue ghost-town addicts with adequate vehicles.

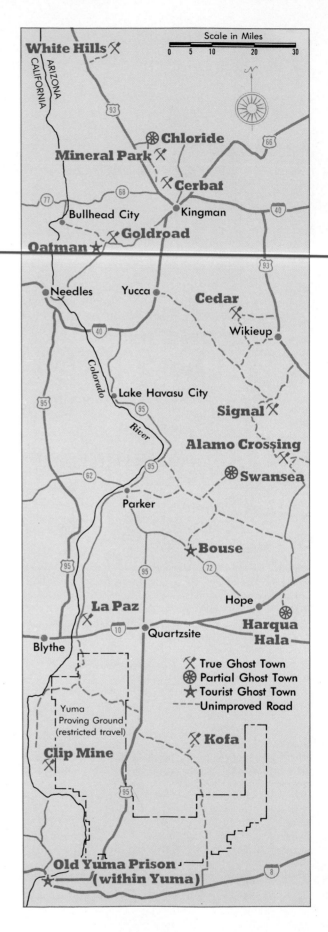

The Southwest

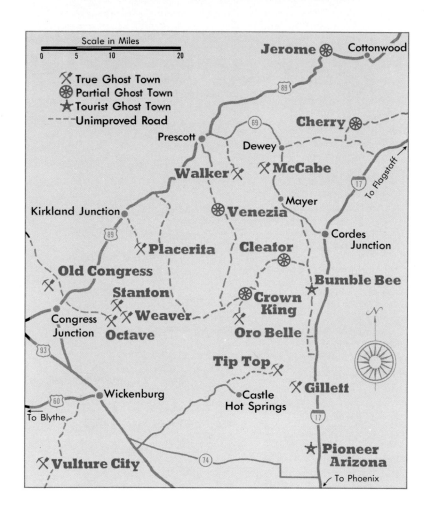

Scale in Miles
0 5 10 20

✗ True Ghost Town
⊕ Partial Ghost Town
★ Tourist Ghost Town
----- Unimproved Road

NORTH OF PHOENIX

Within an easy drive north of Phoenix are a number of ghosts, semi-ghosts, let's-pretend ghosts, and non-ghosts. Adding to the atmosphere is a landscape that is generally dry and bleak but occasionally flares into desert colors. Most helpful are the twelve Yavapai County maps.

A must-see for anybody interested in historic towns is **Pioneer Arizona—A Living History Museum.** Encompassing 550 acres, this non-profit, non-commercialized center is an authentic reconstruction of an 1870 village. The buildings were either moved here from actual early settlements or constructed from original plans by builders using the original tools and methods. Guides wear period costumes, the furnishings are antiques, and such activities as blacksmithing, pottery-making, and butter churning are carried on for real.

A benevolent caretaker welcomes visitors at **Vulture City,** one of Arizona's best-preserved true ghost towns. A dozen or more buildings, including the stone-walled Vulture Mine offices and the hulking ball-mill structure, still stand. The famous semi-ghost of **Jerome** is featured on pages 214–217. **Bumble Bee** is a privately owned ghost which has been gussied up for tourists, with a group of buildings constructed as a frontier street scene.

The withered, bleached Stanton Hotel and a few tumble-down relics comprise **Stanton.** There are much slimmer pickins at neighboring **Weaver** and **Octave.** You can hunt out mining remnants and other traces of the glory that was at the straggling canyon of **Tip Top; Gillett's** roofless, adobe Burfind Hotel; the sagging shacks of **Oro Belle;** the ruined buildings and graves of **Old Congress; Placerita's** three buildings and rubble; and rubble-strewn **McCabe.** Towns like **Walker, Crown King, Cleator, Cherry,** and **Venezia** have been partially reoccupied.

EAST OF PHOENIX

While many of the ghosts in this area are within easy reach of the main highway (U.S. 60), at least one of them—Cochran—is difficult to reach even with four-wheel drive. The Pinal County maps are recommended.

Crouching under the shoulder of the Superstition Mountains, **Apacheland** is no ghost, but an old Western movie set, spruced up and expanded into an entertainment center. There are dirt streets, horses to rent, craft shops, musicians, and old-timey buildings.

Surviving only in the form of some of the old mineshafts, stopes, timbers, a few concrete foundations, and a curio shop, **Goldfield** is a defunct mining town from the mid-1890's. At **McMillen** there are cabins and ruins. A single creaking, two-story building that once housed the mine offices is all that is left at **Silver King.** Foundations and ruins of old mines and mills scattered near the original townsites mark the locations of **Copper Hill** and **Bellevue.**

A number of houses and other deserted structures still survive at **Reymert,** which was active until the 1950's. While the town of **Cochran** itself has long since vanished, an interesting collection of beehive ovens rewards off-road enthusiasts hardy enough to find their way there. The off-again, on-again copper town of **Christmas,** which came back on again in 1956 with the reopening of the mine, remains as a partial ghost.

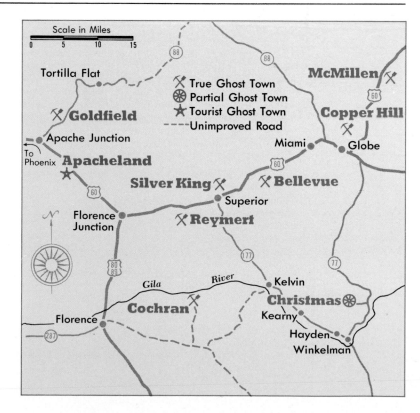

Scale in Miles
0 5 10 15

✗ True Ghost Town
⊕ Partial Ghost Town
★ Tourist Ghost Town
----- Unimproved Road

221

SELECTED READINGS

GHOST TOWN BOOKS

Automobile Club of Oregon. *Oregon Ghost Towns*. Portland: Oregon State Motor Association.

Balcom, Mary G. *Ghost Towns of Alaska*. Chicago: Adams Press, 1976. Historical information only—not a guidebook.

Barlee, N. L. *Gold Creeks and Ghost Towns*. Summerland, B.C.: Canada West Magazine, 1970. Covers southern British Columbia.

Brown, Robert L. *Colorado Ghost Towns—Past & Present*. Caldwell, Idaho: The Caxton Printers, Ltd., 1973.

_____. *Ghost Towns of the Colorado Rockies*. Caldwell, Idaho: The Caxton Printers, Ltd., 1973.

_____. *Jeep Trails to Colorado Ghost Towns*. Caldwell, Idaho: The Caxton Printers, Ltd., 1968.

Carr, Stephen L. *The Historical Guide to Utah Ghost Towns*. Salt Lake City: Western Epics, 1972.

Eberhart, Perry. *Guide to the Colorado Ghost Towns and Mining Camps*. Chicago: Sage Books, 1959.

Florin, Lambert. *Ghost Town* _____. Seattle: Superior Publishing Company. Extensive series of pictorial books, largely reporting on ghost towns in the 1950's.

Fryer, Harold. *Ghost Towns of Alberta*. Langley, B.C.: Stagecoach Publishing Co., Ltd., 1976.

Jenkinson, Michael, and Kernberger, Karl. *Ghost Towns of New Mexico*. Albuquerque: University of New Mexico Press, 1968.

Johnson, Robert N. *California-Nevada Ghost Town Atlas*. Susanville, California: Cy Johnson & Son, 1974. Handbook of maps.

_____. *N.W. Gem Fields and Ghost Town Atlas*. Susanville, California: Cy Johnson & Son, 1975. Handbook of maps.

_____. *Southwestern Ghost Town Atlas*. Susanville, California: Cy Johnson & Son, 1975. Handbook of maps.

Looney, Ralph. *Haunted Highways: The Ghost Towns of New Mexico*. New York: Hastings House, Publishers, 1968.

Martin, Cy & Jeannie. *Gold! and Where They Found It*. Corona del Mar, California: Trans Anglo Books, 1974.

Meleski, Patricia F. and Richard P. *Echoes of the Past: New Mexico's Ghost Towns*. Albuquerque: University of New Mexico Press, 1972.

Miller, Don C., et al. *Ghost Towns and Mining Camps: Selected Papers*. Washington, D.C.: Preservation Press, 1977. Five papers on techniques for ghost town preservation.

Miller, Don C. *Ghost Towns of Montana*. Boulder, Colorado: Purett Publishing Co., 1974.

Mines of _____. Glendale, California: La Siesta Press. A series of small books by various authors on the history and remains of special mining areas of California, such as the San Gabriel Mountains. See also the series on jeep trails by the same publisher.

Morley, Jim, and Foley, Doris. *Gold Cities: Grass Valley and Nevada City*. Berkeley, California: Howell-North Books, 1965.

Murbarger, Nell. *Ghosts of the Adobe Walls*. Los Angeles: Westernlore Press, 1964.

_____. *Ghosts of the Glory Trail*. Los Angeles: Westernlore Press, 1956.

Nadeau, Remi. *Ghost Towns and Mining Camps of California*. Los Angeles: The Ward Ritchie Press, 1965.

Oregon Historical Society. *Oregon Ghost Towns and Some Historic Communities*. Portland, 1970.

Paher, Stanley W. *Colorado River Ghost Towns*. Las Vegas: Nevada Publications, 1976.

_____. *Death Valley Ghost Towns*. Las Vegas: Nevada Publications, 1973.

_____. *Nevada Ghost Towns and Mining Camps*. Berkeley, California: Howell-North Books, 1970.

_____. *Northwestern Arizona Ghost Towns*. Las Vegas, Nevada: Gateway Press, 1970.

Parker, Watson, and Labert, Hugh K. *Black Hills Ghost Towns*. Chicago: Sage Books, 1974.

Paterson, T. W. *Ghost Town Trails of Vancouver Island*. Langley, B.C.: Stagecoach Publishing Co., Ltd., 1975.

Ramsey, Bruce. *Ghost Towns of British Columbia*. Vancouver: Mitchell Press Ltd., 1963.

Sawatsky, Don. *Ghost Town Trails of the Yukon*. Langley, B.C.: Stagecoach Publishing Co., Ltd., 1975.

Sherman, James E. and Barbara H. *Ghost Towns and Mining Camps of New Mexico*. Norman, Oklahoma: University of Oklahoma Press, 1975.

_____. *Ghost Towns of Arizona*. Norman, Oklahoma: University of Oklahoma Press, 1969.

Sparling, Wayne. *Southern Idaho Ghost Towns*. Caldwell, Idaho: The Caxton Printers, Ltd., 1976.

Sunset Books. *Gold Rush Country*. Menlo Park, California: Lane Publishing Co., 1972. Covers Highway 49 area.

Weis, Norman D. *Ghost Towns of the Northwest*. Caldwell, Idaho: The Caxton Printers, Ltd., 1974.

_____. *Helldorados, Ghosts, and Camps of the Old Southwest*. Caldwell, Idaho: The Caxton Printers, Ltd., 1977.

Wolle, Muriel Sibell. *The Bonanza Trail*. Bloomington: Indiana University Press, 1955.

_____. *Montana Pay Dirt*. Denver: Sage Books, 1963.

_____. *Stampede to Timberline*. Chicago: Sage Books, 1974. Revised edition. Ghost towns of Colorado.

RELATED GUIDEBOOKS AND PICTORIALS

Carey, Neil G. *A Guide to the Queen Charlotte Islands*. Anchorage: Alaska Northwest Publishing Co., 1976.

Clemson, Donovan. *Living with Logs*. Saanichton, B.C.: Hancock House Publishers, 1974. Log structures in British Columbia.

de Visser, John, and Kalman, Harold. *Pioneer Churches*. New York: W. W. Norton & Co., Inc., 1976.

Friedman, Ralph. *Oregon for the Curious*. Caldwell, Idaho: The Caxton Printers, Ltd., 1974.

Miller, Mike. *Off the Beaten Path in Alaska*. Juneau: Alaskabooks, 1976.

Nevada Map Atlas. Carson City: Nevada State Highway Department.

Sande, Theodore A. *Industrial Archeology*. Brattleboro, Vermont: The Stephen Greene Press, 1976.

Satterfield, Archie. *The Yukon River Trail Guide*. Harrisburg, Pennsylvania: Stackpole Books, 1975.

Sunset Travel Guide to Oregon. Menlo Park, California: Lane Publishing Co., 1976.

United States Bureau of Mines. *Mining and Mineral Operations in the Pacific States: A Visitor Guide*. Washington, D.C.: U.S. Government Printing Office, 1976.

HISTORICAL WORKS

Browne, J. Ross. *A Peep at Washoe and Washoe Revisited*. Balboa Island, California: Paisano Press, 1959. Reprint of 19th century classic.

Bunting, Bainbridge. *Early Architecture in New Mexico*. Albuquerque: University of New Mexico Press, 1976.

DeQuille, Dan. *The Big Bonanza*. New York: Apollo, 1969. Reprint of 19th century classic.

Elliot, Russel R. *Nevada's Twentieth-Century Mining Boom*. Reno: University of Nevada Press, 1966.

Granger, Byrd H. *Arizona Place Names*. Tucson: University of Arizona Press, 1960.

Greever, William S. *The Bonanza West*. Norman, Oklahoma: University of Oklahoma Press, 1963.

Gudde, Erwin G. *California Gold Camps*. Berkeley, California: University of California Press, 1975.

Love, Frank. *Mining Camps and Ghost Towns*. Los Angeles: Westernlore Press, 1974. Mining history along the lower Colorado.

Paul, Rodman W. *California Gold: The Beginning of Mining in the Far West*. Lincoln, Nebraska: University of Nebraska Press, 1947.

_____. *Mining Frontiers of the Far West 1848–1880*. New York: Holt, Rinehart & Winston, 1963.

Pearce, T. M., ed. *New Mexico Place Names*. Albuquerque: University of New Mexico Press, 1965.

Potter, Miles F. *Oregon's Golden Years*. Caldwell, Idaho: The Caxton Printers, Ltd., 1976.

Rensch, H. E., and Hoover, Mildred. *Historic Spots in California*. Stanford, California: Stanford University Press, 1966.

Sloan, Howard N. and Lucille N. *A Pictorial History of American Mining*. New York: Crown Publishers, Inc., 1970.

Smith, Duane A. *Rocky Mountain Mining Camps*. Bloomington, Indiana: Indiana University Press, 1967.

Wagner, Jack R. *Gold Mines of California*. Berkeley, California: Howell-North Books, 1970.

Watkins, T. H. *Gold and Silver in the West*. Palo Alto, California: American West Publishing Co., 1971.

INDEX

This book was lithographed and bound by Kingsport Press Inc., Kingsport, Tennessee, from film prepared by Solzer & Hail, San Francisco, and Graphic Arts Center, Portland, Oregon. Paper for the body is Velvo Enamel made by Westvaco, Luke, Maryland.